www.sorryeverybody.com

sorry everybody

an apology to the world
for the re-election of George W. Bush

Hylas Publishing
First published in 2005 by Hylas Publishing
129 Main Street, Irvington, New York 10533

Copyright © Hylas Publishing 2005
Foreword © Ted Rall 2005

First American Edition published in 2005
02 03 04 05 10 9 8 7 6 5 4 3 2 1

ISBN: 1-59258-163-3

Set in Minion and Andale Mono.

Printed and bound in Italy by
Milanostampa/AGG
Distributed by National Book Network

www.hylaspublishing.com

Sean Moore

Karen Prince

f-stop fitzgerald

Edwin Kuo

Lori Baird

Gail Greiner

Gus Yoo

Joaquín Ramon
Herrera

Marian Purcell

www.sorryeverybody.com

sorry everybody

an apology to the world
for the re-election of George W. Bush

HYLAS
PUBLISHING

ACKNOWLEDGEMENTS

Sorryeverybody.com was a team effort. I don't speak for all of us, but if I have the chance to thank people, I'll do it. I'd like to thank my professors for putting up with this and my family for putting up with me.

Thanks to the Nerd Herd: Andrew, Andy, Aristotle, Charles, Graham, Jon, José, Juliana, Micah, and Mikkel. Without you, the site would be very sorry indeed.

Thanks to Sean Moore and Karen Prince, our esteemed Publisher and Creative Director, respectively. Thanks also to our editor, Gail Greiner, our art director, Gus Yoo, our designers Joaquín Hererra and Marian Purcell, and Darren Creutz, wizard, sys admin and webmaster for Hylas, for helping manage the sorryeverybody site while we had finals, and to everyone else at Hylas Publishing who worked their tails off to get this book out by Inauguration Day.

Thanks to the friends of Hylas: Jodi Kahn for tracking me down, and Ann Gollin for all her work behind the scenes.

Thanks to Tim for telling me to create an Internet phenomenon (wish I'd thought of it) and thanks to Ethan for everything he's done and everything he does.

Thanks to Dr. Burton Roger, for challenging me, and thanks to Dr. Adam Sowards for waking me up.

Thanks to Susie for publishing me first.

Thanks to Justin Beach for EarthU.

Thanks to Nick Cooper and indymedia for understanding and helping in a time of need.

Thanks to Steve Momorella and KAB.

Thanks to Ken Gouldthorpe, Barry Provorse, and Elizabeth Wales.

Thanks to the Jasons and all of Rackspace; they are excellent hosts.

Thanks to Jeff Ridgeway at CafePress.

Thanks to Hilary for keeping me honest.

Thanks to Gabe, who knows why.

Thanks to everybody who offered help, everybody who submitted to the site, everybody who supports us, and those who may not support us but offered truly valid criticism.

Lastly, thanks to R. Stevens and all of Dumbrella. Did I do it right, guys?

To everybody—of course.

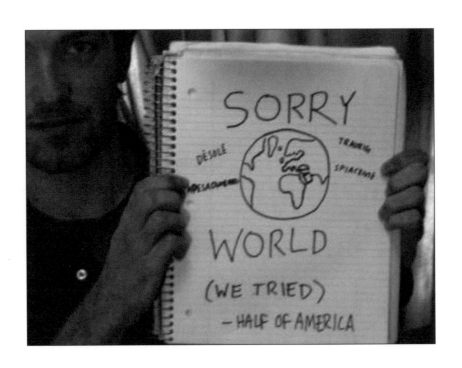

PREFACE

This was all supposed to be a joke.

And there's something inherently absurd about it, isn't there? Who accounts for years of massive abuses of power with a little handwritten sign that says "Sorry, world, we tried!" A college kid, that's who. I took a picture of myself holding the silly little sign, bought the domain name because I had twenty bucks lying around, and sorryeverybody.com was born on November 4, 2004. At first it was a laughable showcase of my meager skills at Web design, and the only ones to see it were the denizens of an Internet message board. They told some friends, who told some friends, who linked to it on their Web sites. When entries began to trickle in, I was overjoyed that the site had received any attention at all.

A group of brilliant and irreplaceable friends designed me a better Web site and programmed me a database. A few links showed up on some political Weblogs the very same day. We had a tidy little Web site going, nothing more. This wasn't supposed to be a grand political statement. This wasn't supposed to be an international movement. This was supposed to be some absurdist humor between a few like-minded folks. But it's not about that anymore.

Later that day, the site was overwhelmed by visitors. And I do mean overwhelmed. In our search for more robust hosting, we almost crashed three different servers. Over the course of the next few weeks, sorryeverybody.com received 26,000 picture submissions and 75 million hits. We were featured on CNN, the BBC, the Associated Press, and in countless other media sources. It turns out that a lot of people were sincerely sorry. And so, I discovered, was I.

I've been asked a thousand times what I have—what we have—to be sorry about. I'm sorry I haven't written enough letters to my congressmen. I'm sorry I didn't research the judicial nominees before I voted. I'm sorry I didn't vote in the primaries. I'm sorry I didn't volunteer for the Kerry campaign. I'm sorry I didn't donate what I could. I'm sorry I didn't volunteer at a polling place. What does it mean to have a political opinion if you do so little about it?

I'm sorry we haven't enacted real campaign finance reform. I'm sorry we snubbed the Kyoto Protocol. I'm sorry for the Defense of Marriage Act. I'm sorry for the Patriot Act. I'm sorry for failing to act. I'm sorry for the deceptively named Healthy Forests Initiative.

I'm sorry for the unconscionable mistakes of the Bush administration. But I'm also sorry for the mistakes of the Clinton administration and the Reagan administration. I'm sorry for Star Wars and I'm sorry for the "Contract with America."

We've been parodied endlessly. Counter-sites have sprung up, with their own photo galleries (featuring lots of men with firearms). I've been called a traitor and a weakling. I've been told to leave America, if I'm so ashamed of it.

But I believe that holding my country accountable for its actions does not amount to treason, and apologizing does not make us weak. I believe that America's strength is in its tolerance, and that as a powerful part of a beautiful world, we have responsibilities as well as rights. I believe that with communication, Americans can understand the rest of the planet and the rest of the planet can understand us. Most of all, I believe that with effort and civility, Americans can respect and understand each other. I am lucky to live in my country, and I'm proud of what we stand for. I believe we must remain vigilant to make sure we continue to stand for it.

And I'm not sorry for that at all.

—*James Zetlen*

FOREWORD

It's a safe bet that few if any of the Americans who contributed to this book voted for George W. Bush. Most of them are probably Democrats, many marched against the war in Iraq, and a significant number mucked up their shoes with stains from suburban grass while passing out his opponent's campaign literature. So what do they have to be sorry about?

Losing isn't shameful in and of itself. What's shameful is failing to fight as hard as you can. Democrats, the left, progressives, whatever name you prefer to assign to the portion of the public that puts people before profits, can take pride in the 2004 campaign. Twentysomething Deaniacs swallowed their disappointment and worked hard for Kerry; Democrats haven't been as unified in decades. For the first time in memory, the Democrats raised as much money from individuals as Republicans did from corporations. They registered record numbers of new voters, who turned out in staggering numbers. And the stars lined up in Kerry's favor. Michael Moore, Bruce Springsteen—even Kitty Kelly!—had it out for Bush.

We kicked ass and we lost. That's difficult to accept. We did a great job; they did an even better one. But we couldn't afford to lose The Most Important Election in Our Lifetimes. We *had* to expel the madman in charge of the world's most dangerous rogue state. It was our moral imperative to reject his policies of perpetual war, arrogance, and irresponsibility. We also had to avert four more years of mayhem.

The original sin of the Bush Administration, the way it seized power during the election crisis of November–December 2000, set the tone for a gangster presidency whose legitimacy derived from cheating and bullying, not from the people.

Every day that George W. Bush has awoken in our White House has been an affront to electoral democracy—because the United States Supreme Court, a federal body, didn't have jurisdiction to hear Bush v. Gore, a state election dispute; because Bush declared himself the winner weeks before the Supremes appointed him, while the recount was still going on; because the Bush campaign hired goons to beat and threaten election officials; because he put James Baker III on television to imply the threat of a coup unless his man got the big job. Had Bush's interregnum been characterized by peace and prosperity, patriotic Americans would have still had a duty to reject him in 2004, if only to defend the principle that the candidate with the most votes takes office in a democracy. Bush's "reelection" tacitly endorsed an incumbency he didn't earn in the first place. How can the United States claim to promote democracy abroad when most of its own people vote for an imposter?

Generalissimo El Busho, as I call him in my cartoons, revealed himself after 9/11. The United States had been attacked by 19 Saudis and Egyptians who were mostly trained in Pakistan and were recruited by a group in Egypt that was financed by Saudi Arabia and Pakistan. So what does the Great Avenger do? He invades Afghanistan and Iraq, which had little and nothing to do with 9/11, respectively. Meanwhile, he funneled U.S. taxpayer dollars and weapons to Saudi Arabia, Egypt, and Pakistan. Three thousand Americans still cry for justice as Bush's rabid "neoconservative" ideologues build their new oil- and blood-soaked Raj.

John Kerry once asked how one could ask a man to be the last to die for a mistake, but Afghanistan and Iraq weren't mistakes. Smearing

Ben-Gay on your toothbrush is a mistake. Buying a Ford Focus is a mistake. Unleashing the most fearsome military machine ever created in human history on thousands of innocent people with only avarice as a reason isn't a mistake. A study published in the respected British medical journal *The Lancet* found that the United States had killed at least 100,000 Iraqi civilians during the first year after the fall of Baghdad. General Tommy Franks estimated that his troops killed an additional 30,000 Iraqi soldiers, who died defending their country from our invasion. CNN believes that at least 10,000 Afghan civilians and at least as many Afghan soldiers have been killed by the U.S. intervention. Damaged infrastructure—contaminated water, looted hospitals, electrical outages, bombed-out roads—are murdering thousands more. And nobody knows how many more Afghans and Iraqis have been injured in wars fought for one reason: Dick Cheney, Donald Rumsfeld, and Paul Wolfowitz believe that the American economy, and thus corporate profits, require a foreign policy based on "total energy dominance." (Google "Project for a New American Century" to learn what these guys are all about.)

It's a crime. It's mass murder. It's genocide. It's incomprehensible in scale and it is monstrous—and 51 percent of the American electorate (minus an unknown number of electronic ballots added by chicanery) said that it was okay with them.

As the world's sole remaining superpower, the wealthiest nation to have ever existed, its largest arms supplier and exporter of popular and consumer culture, the United States has an outsize influence, and thus responsibility, to other nations. Instead, Bush and those who support him see our power as justification to do whatever the hell we want. When he announced that the POWs we captured in Afghanistan weren't subject to the Geneva Conventions, who could force him to comply with international law? When the Secretary of Defense ordered U.S. troops to torture detainees, some of them to death, what world body could bring him to justice? Sure, the hundred-plus nations that signed the Kyoto Protocol on global warming were disgusted that the U.S., the number-one producer of greenhouse gases, refused to join them. But might makes right. Right?

So much was—is—at stake. We marched, we voted, we argued with our friends and neighbors, but it wasn't enough. This was a year when we had to win no matter what. We could have argued a little harder, written a few more letters, worked the phones later. I had a fantasy: Millions of Americans could have surrounded the White House during the last four years to demand that Bush get the hell out of Al Gore's home. There's always more you can do—a lot more.

And so, like many other Americans who look into the future with trepidation and embarrassment, I'd like to say to the world: I'm really, really sorry. And please go easy on the penance thing.

—*Ted Rall*
December 2004

Ted Rall, a cartoonist and columnist for Universal Press Syndicate, is the author of Wake Up, You're Liberal!: How We Can Take America Back From The Right *(Soft Skull Press) and* Generalissimo El Busho: Essays and Cartoons on the Bush Years *(NBM Publishing).*

EDITOR'S NOTE

The day after the election, some of us here at Hylas were feeling very blue. We said, "The only way not to sink into a black depression is to *do* something." But we mostly just moped around. The next day we saw the sorryeverybody site. Someone doing something! Something positive, something affirming, something that expressed exactly how we felt—something that could make a difference. We wanted to be a part of it, and what better way than to do a *Sorry Everybody* book? Well, lucky for us, sorryeverybody was game.

But it wasn't that easy. We couldn't just take all the pictures that had been uploaded to the site and put them in a book. It's not okay to use someone's picture without their permission. So sorryeverybody posted a note on its site saying that if you wanted to be in the book, you needed to give your permission. Everyone in this book has consented to being in it.

We also had to establish some guidelines for the book. If your picture did not get in, it may have been because your submission wasn't at a high enough resolution, because we couldn't read your message, you scared us, or you gave us the finger! We wanted to further sorryeverybody's goal of providing a forum for those of us who felt desolate, defeated, hopeless—and yes, angry—after the election. We wanted the book to be uplifting—a message of hope and unity.

If your picture fit all of our criteria but still didn't make the cut, our apologies. We may simply have run out of room. We had thousands of submissions and used over 1,000 images, but we could not use them all. Thank you for trying.

We also had to take out Web sites and e-mail addresses, both to protect your privacy and so as not to make the book about self-promotion.

Thank you to James Zetlen and everyone else at sorryeverybody for letting us do this book. And thank you to everyone who contributed to the book and to the Web site. It makes us feel better about everything. We hope it makes a difference. We think it will.

"To announce that there must be no criticism of the president, or that we are to stand by the president right or wrong, is not only unpatriotic and servile, but is morally treasonable to the American public."

.....Theodore Roosevelt

I think the best definition of fascism/Nazism is the alliance of business, government and military/law enforcement. I don't think we are very far from that.

Benjamin Franklin said it best: "Those who exchange liberty for security deserve neither."
Joe, *Missouri*

Guilt, shame, sorrow. How could we have let this happen? So so sorry from Denver.

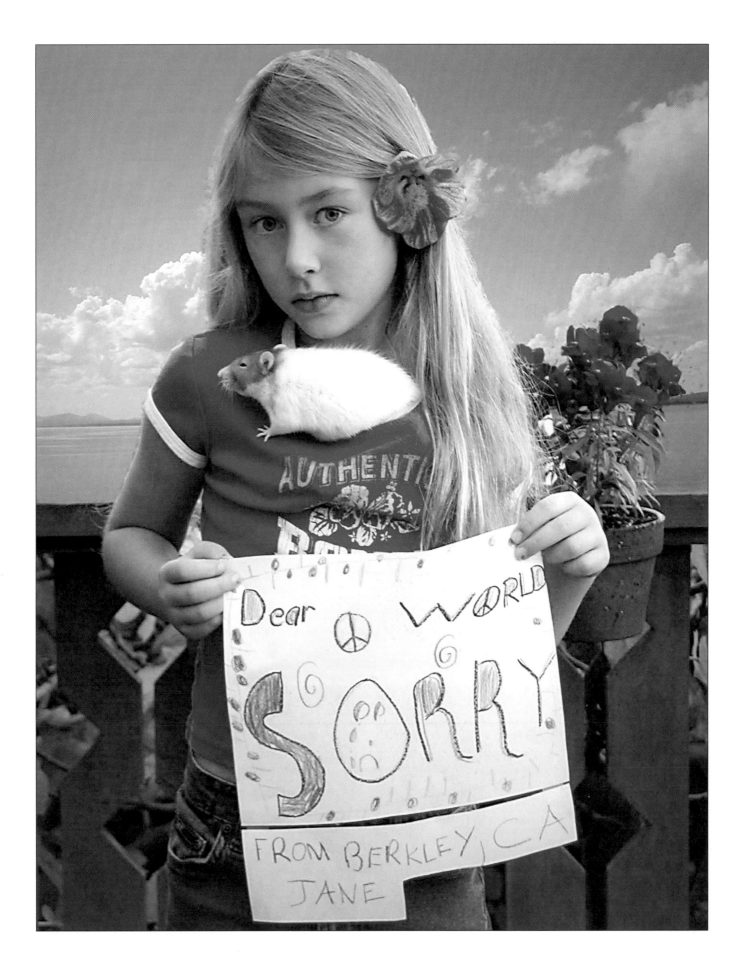

NOW WHAT??!

ummm...I guess we just have to press on, and let the world know that at least half of Americans are sane, rational, and caring people. Sorry everybody. We tried our best.

the snakeranch, gainesville, FL

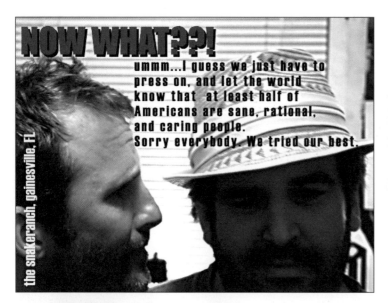

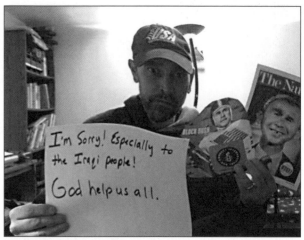

I'm Sorry! Especially to the Iraqi people! God help us all.

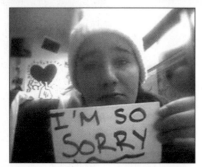

I'M SO SORRY

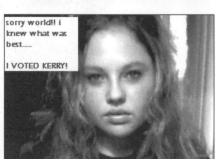

sorry world!! i knew what was best.....

I VOTED KERRY!

Dear World, We're Sorry. Please Forgive Us.

On behalf of Coconino, Apache, Pima, and Santa Cruz counties in Arizona, we're sorry. On behalf of the people in the other counties that voted against Bush, we're sorry. On behalf of anyone who didn't want him, we're sorry. And on behalf of those of us who freewayblogged in Tucson, we're very sorry. We'll keep on doing what we can. Not all of us want that ignorant fool in charge. Please don't think all Americans have been brainwashed by Bush & Co.

Signed,
Free-Thinking Americans

Freewayblogging in Tucson

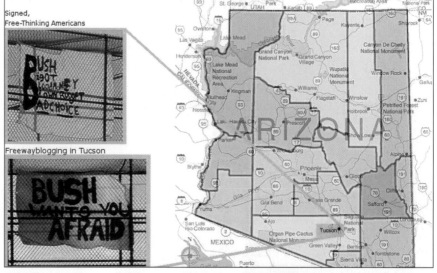

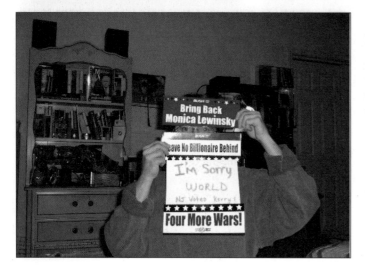

Bring Back Monica Lewinsky

Leave No Billionaire Behind

I'm Sorry WORLD
NJ Voted Kerry!

Four More Wars!

This election smells worse than my litter box!

14

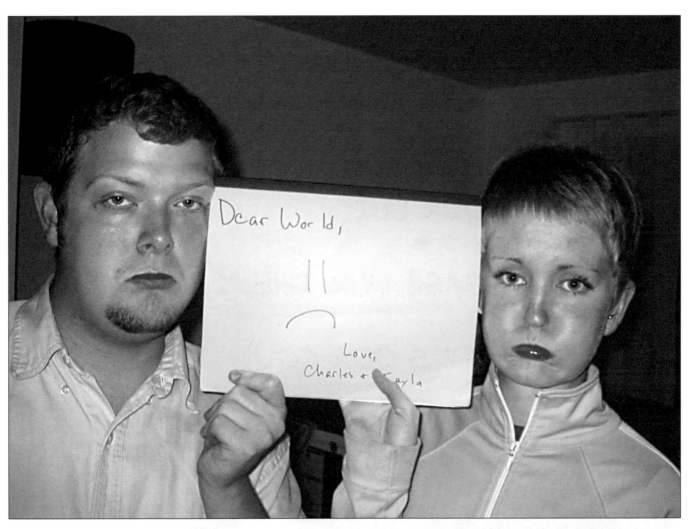

Sorry to all the inhabitants of Planet Earth.

Please forgive us.

Peace

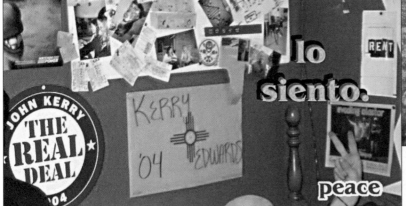

TOUT LE MONDE:
NOUS SOMMES DESOLES.

NOUS N'AVONS PAS
VOTE POUR LUI.

A MESSAGE FOR THE "51%" :

IT'S OUR COUNTRY TOO
& WE'RE FIGHTING
FOR IT!

GOT THAT?!

2 BLUE STATE DEMS
& PROUD OF IT!

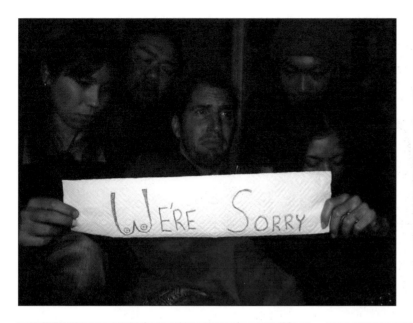

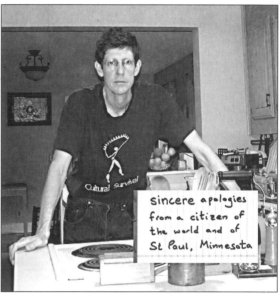

sincere apologies from a citizen of the world and of St Paul, Minnesota

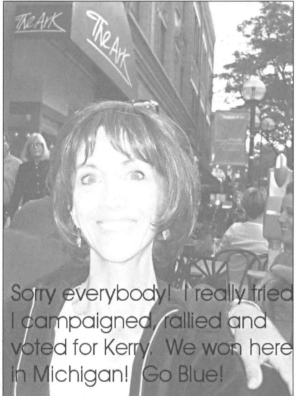

Sorry everybody! I really tried. I campaigned, rallied and voted for Kerry. We won here in Michigan! Go Blue!

Don't be fooled by the smile — it's a solemn time here in America. Many of us are ashamed, and afraid for the fate of our nation.

Thank you for your forgiveness, and for your prayers.

We need them, and will do our best to earn them.

Please remember that Americans and our government are not one and the same.

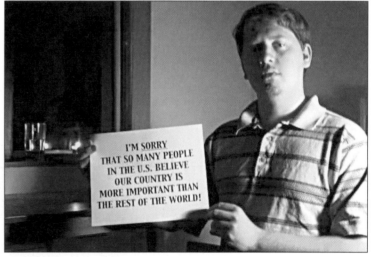

I'M SORRY THAT SO MANY PEOPLE IN THE U.S. BELIEVE OUR COUNTRY IS MORE IMPORTANT THAN THE REST OF THE WORLD!

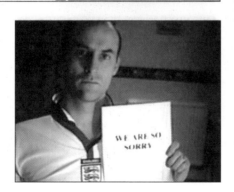

WE ARE SO SORRY

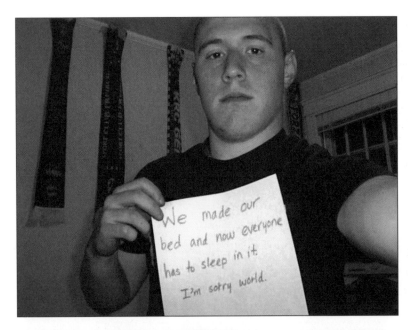

We made our bed and now everyone has to sleep in it. I'm sorry world.

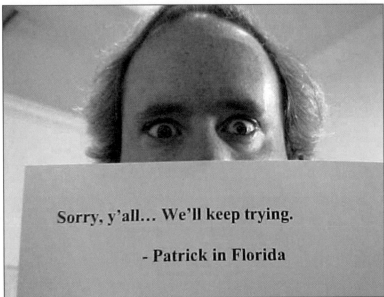

Sorry, y'all... We'll keep trying.

- Patrick in Florida

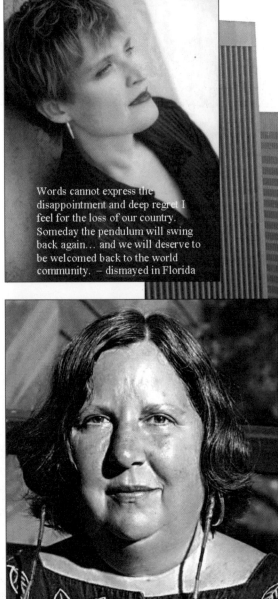

Words cannot express the disappointment and deep regret I feel for the loss of our country. Someday the pendulum will swing back again... and we will deserve to be welcomed back to the world community. – dismayed in Florida

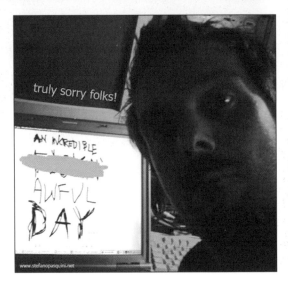

truly sorry folks!

AN INCREDIBLE
AWFUL DAY

www.stefanopasquini.net

I care, people of the world, and I'm sorry!

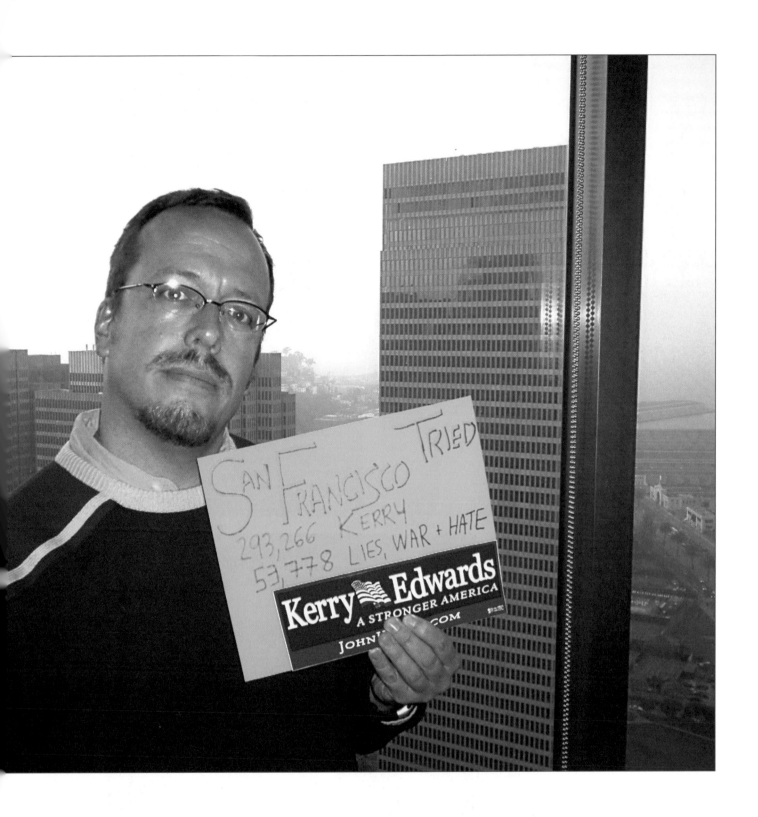

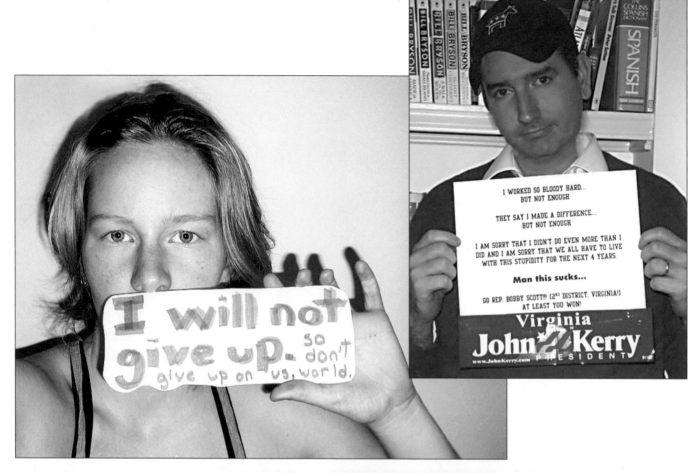

I will not give up. so don't give up on us, world.

I WORKED SO BLOODY HARD...
BUT NOT ENOUGH

THEY SAY I MADE A DIFFERENCE...
BUT NOT ENOUGH

I AM SORRY THAT I DIDN'T DO EVEN MORE THAN I
DID AND I AM SORRY THAT WE ALL HAVE TO LIVE
WITH THIS STUPIDITY FOR THE NEXT 4 YEARS.

Man this sucks...

GO REP. BOBBY SCOTT!!! (2nd DISTRICT, VIRGINIA!)
AT LEAST YOU WON!

Virginia
John 2 Kerry
PRESIDENT
www.JohnKerry.com

My family didn't vote for him!

BEWARE
THE RISING
TIDE OF
FASCISM

Mom and Dad are sad that
so many other Americans
support this war, this
president, the military
industrial complex,
and the rising tide of
intolerance and ignorance.

We want a good United States of America.

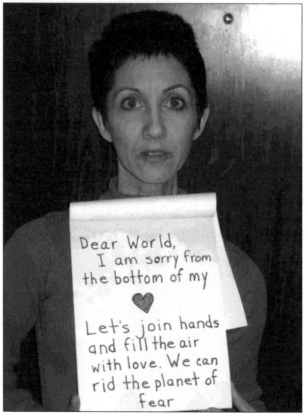

Dear World,
I am sorry from
the bottom of my
♥
Let's join hands
and fill the air
with love. We can
rid the planet of
fear

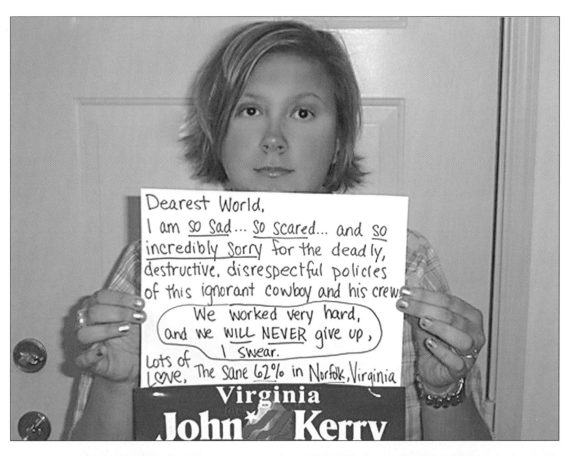

Dearest World,
I am <u>so sad</u>... <u>so scared</u>... and <u>so incredibly sorry</u> for the deadly, destructive, disrespectful policies of this ignorant cowboy and his crew. We worked very hard, and we <u>WILL NEVER</u> give up, I swear.
Lots of Love, The Sane 62% in Norfolk, Virginia

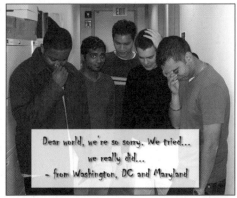

Dear world, we're so sorry. We tried... we really did...
~ from Washington, DC and Maryland

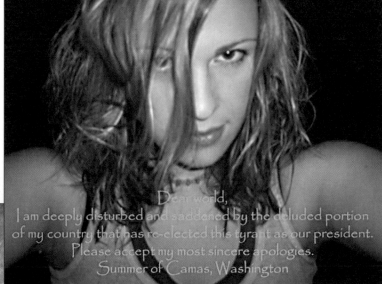

Dear world,
I am deeply disturbed and saddened by the deluded portion of my country that has re-elected this tyrant as our president. Please accept my most sincere apologies.
Summer of Camas, Washington

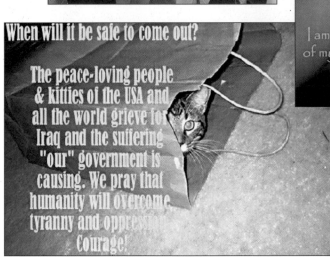

When will it be safe to come out?

The peace-loving people & kitties of the USA and all the world grieve for Iraq and the suffering "our" government is causing. We pray that humanity will overcome tyranny and oppression. Courage!

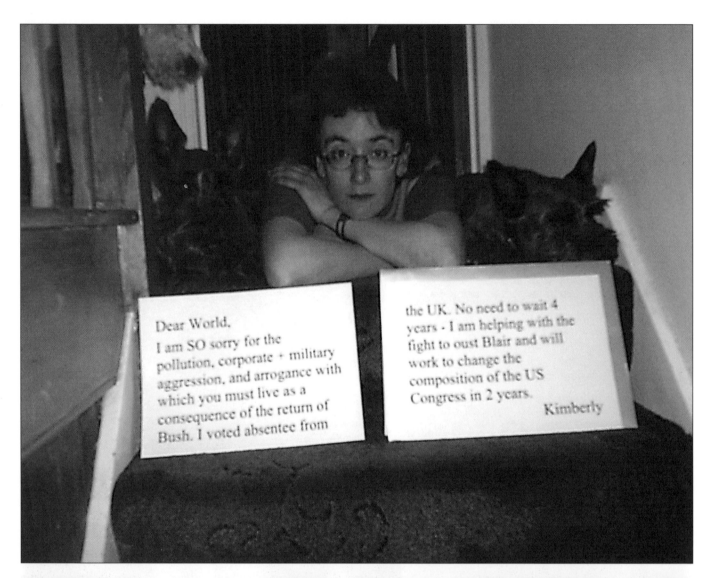

Dear World,

I am SO sorry for the pollution, corporate + military aggression, and arrogance with which you must live as a consequence of the return of Bush. I voted absentee from the UK. No need to wait 4 years - I am helping with the fight to oust Blair and will work to change the composition of the US Congress in 2 years.

Kimberly

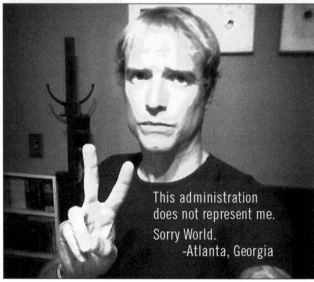

This administration does not represent me. Sorry World.
-Atlanta, Georgia

Sorry World - Smiling Through The Pain In Dallas Texas.

Still committed to changing hearts and minds one conversation at a time.

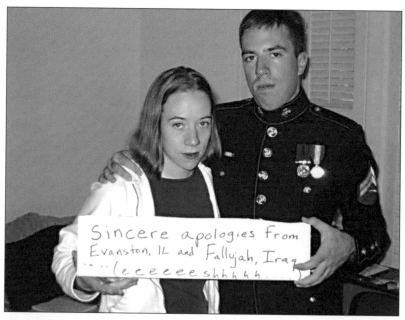

Sincere apologies from Evanston, IL and Fallujah, Iraq ...leeeeeeeshhhhh....

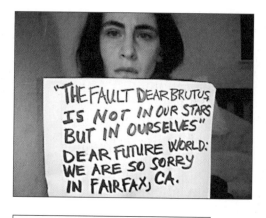

"THE FAULT DEAR BRUTUS IS NOT IN OUR STARS BUT IN OURSELVES" DEAR FUTURE WORLD: WE ARE SO SORRY IN FAIRFAX, CA.

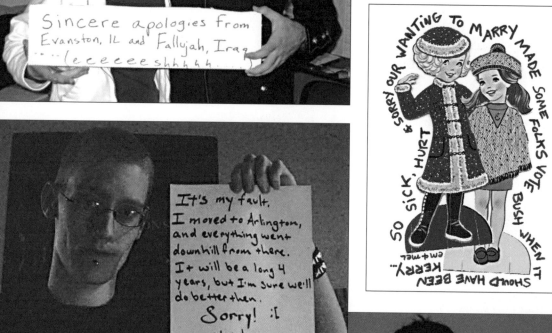

It's my fault. I moved to Arlington, and everything went downhill from there. It will be a long 4 years, but I'm sure we'll do better then.
Sorry! :|
-Keith
Texass

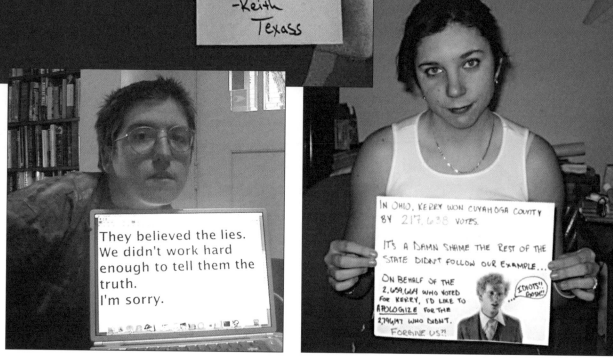

They believed the lies. We didn't work hard enough to tell them the truth. I'm sorry.

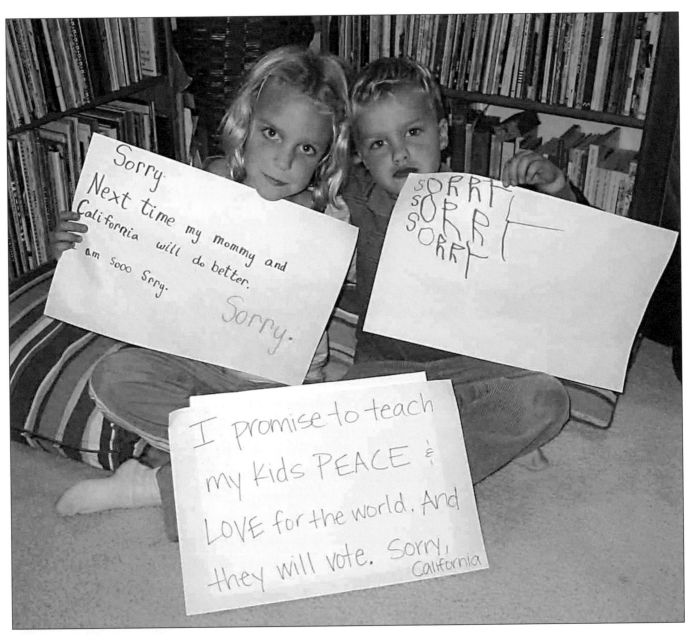

Sorry.
Next time my mommy and
California will do better.
am sooo Srry.
Sorry.

SORRY
SORRY
SORRY
SORRY

I promise to teach
my kids PEACE &
LOVE for the world. And
they will vote. Sorry,
California

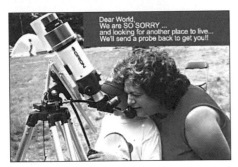

Dear World,
We are SO SORRY ...
and looking for another place to live...
We'll send a probe back to get you!!

Dear world -
On behalf of all the Oceanside
freshmen of New York i shall
apologice for not beeing
represented and unheard in
this vote. t(><t)
Only luzzers voted for bush <3
You would think out of the 51
states - We would have some
intellegence and NOT elect
bush again- I guess i was
wrong- Melyssa - NY - 14 and
unheard and not represented.

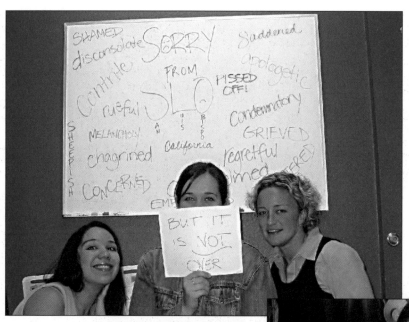

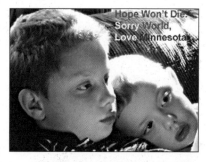

Hope Won't Die.
Sorry World,
Love Minnesota.

Dear World,

Even though there was no way for New York NOT to go blue, I still got my absentee ballot months ahead of time sent to my college at the other end of the state. I tried. So very very very very sorry. I'm just as upset as the rest of you. :(

Here's to four horrible years. I hope we can make the best of them.

I'm sorry World. I voted, I tried. And I'm grateful for my global family. I remain with you all in the struggle.

WE ARE SORRY!
—UT democrat
(endangered species)

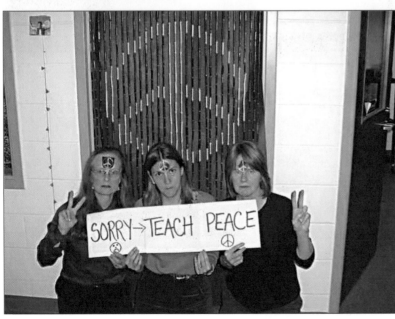

SORRY → TEACH PEACE

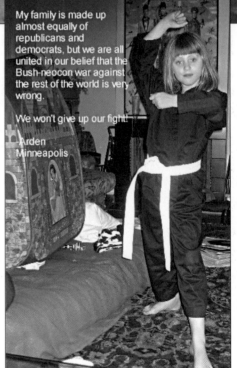

My family is made up almost equally of republicans and democrats, but we are all united in our belief that the Bush-neocon war against the rest of the world is very wrong.

We won't give up our fight!

—Arden
Minneapolis

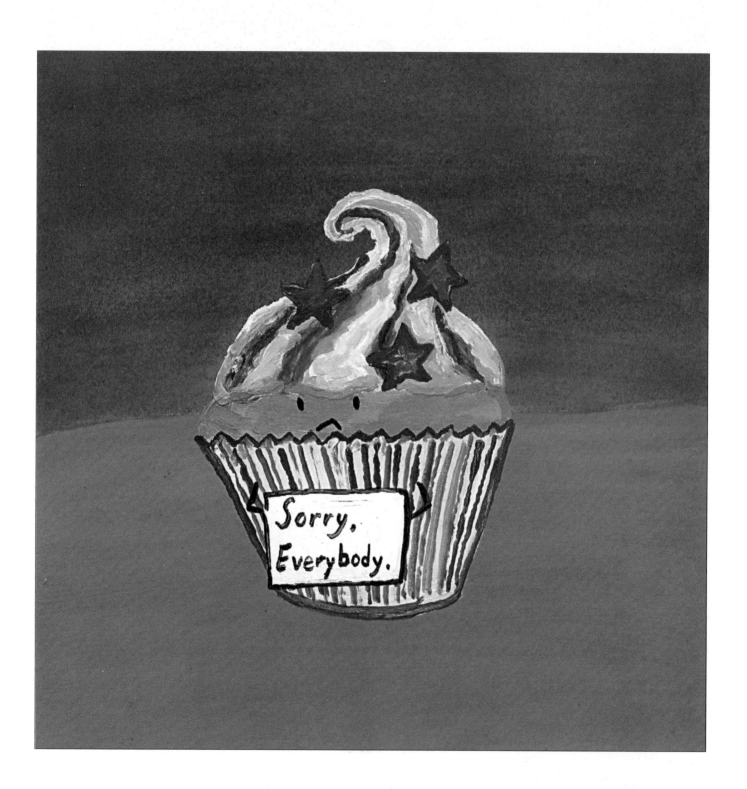

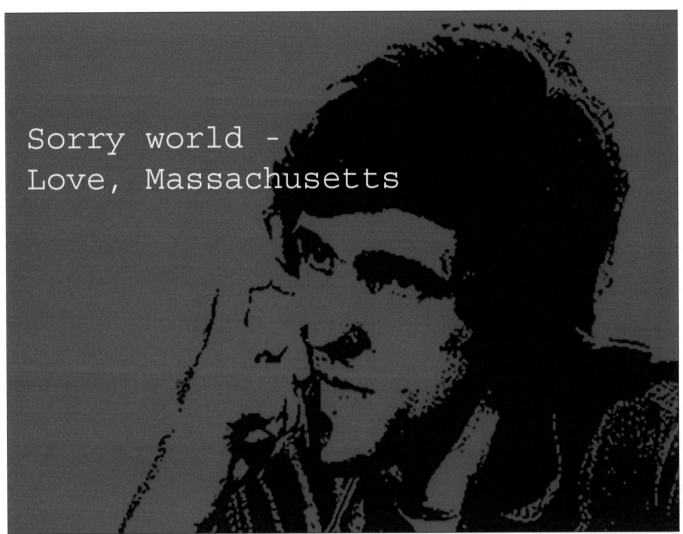

Sorry world -
Love, Massachusetts

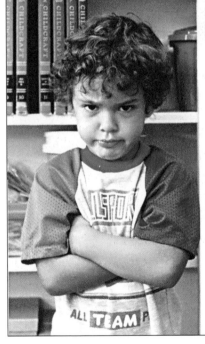

I'm not a happy
future voter.

But my Mom
& my Dad
(a disabled Viet Nam Veteran)

tried

Sorry Everybody

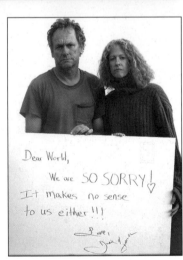

Dear World,
We are SO SORRY!
It makes no sense
to us either!!!

Love,

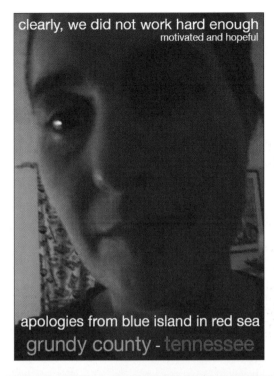

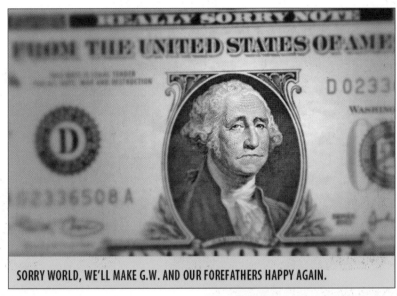

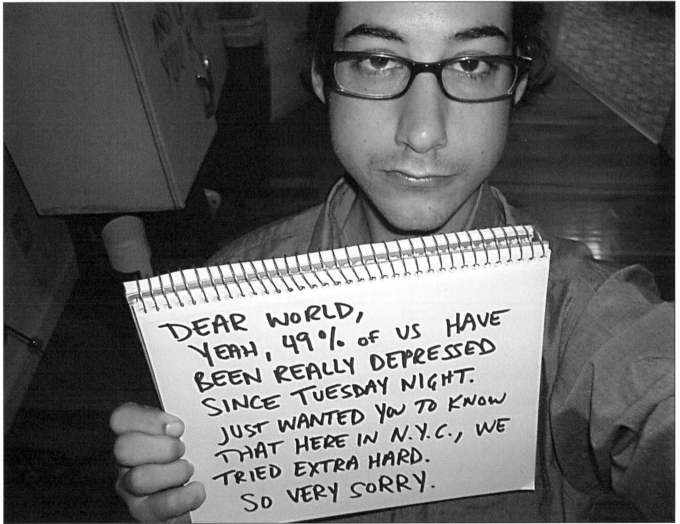

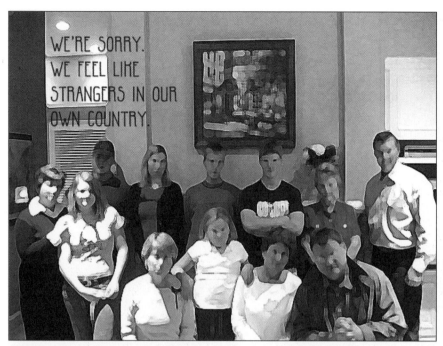

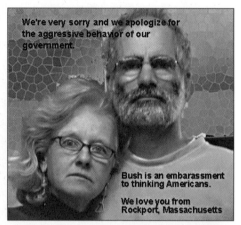

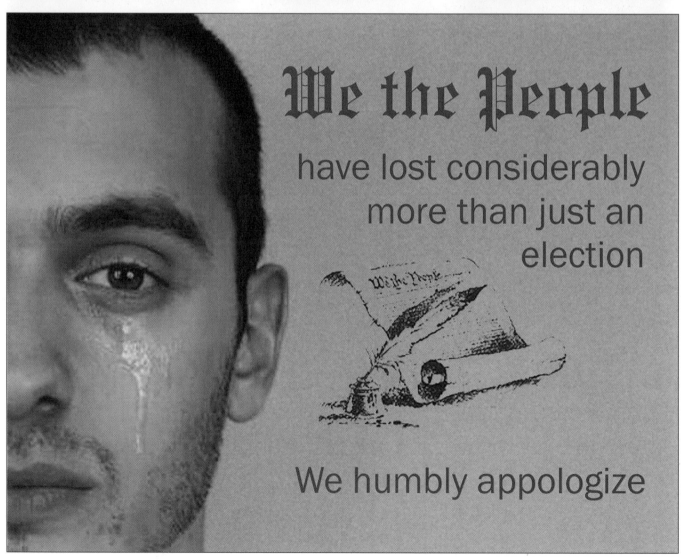

WE FEEL THE BLUES; WE SING THE BLUES; WE VOTE BLUE

CHICAGO IS SORRY, EVERYBODY

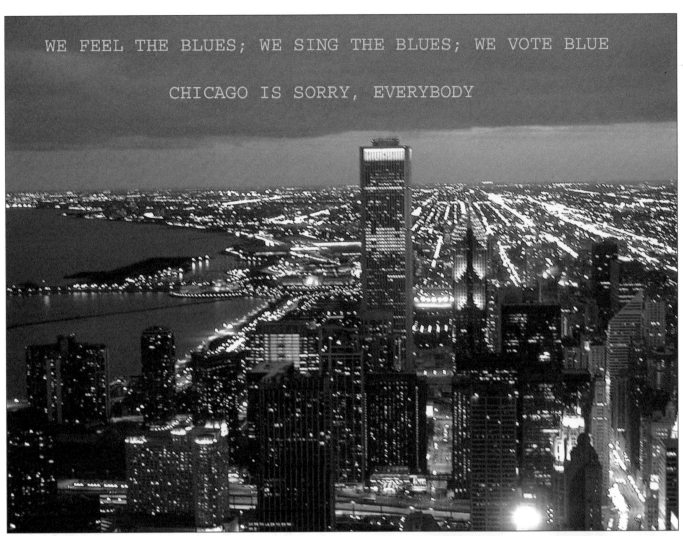

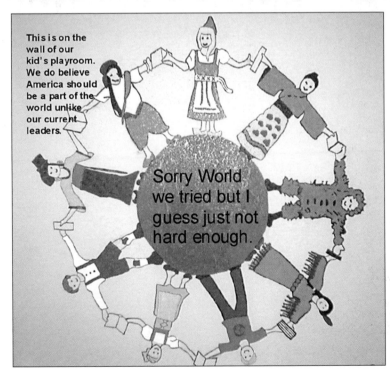

This is on the wall of our kid's playroom. We do believe America should be a part of the world unlike our current leaders.

Sorry World we tried but I guess just not hard enough.

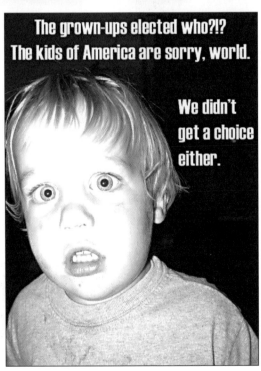

The grown-ups elected who?!?
The kids of America are sorry, world.

We didn't get a choice either.

My mommy & I are really sorry.

We protested the big meanies in the White House
&
We promise to keep our home, NEW YORK CITY, safe for all our international friends.

With love,
A tiny New Yorker

So sorry...

It Stinks! Sorry, World. Don't Blame the Flock. The Shepards are Charlatans.

I'm as sad as you are...

Please Clean up after your President

IT'S THE LAW
MAX. FINE $500

SORRY EVERYONE

JONAH 4:9 (NRSV)
WE'RE SORRY

We're VERY Sorry!!
(and we're just as disgusted as you are!)
- Bobby + Lisa

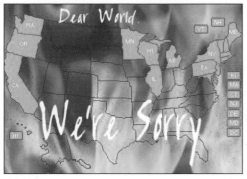

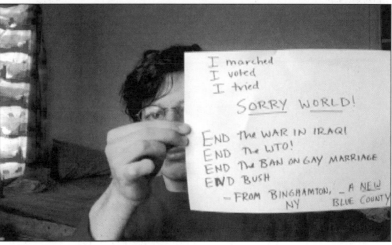

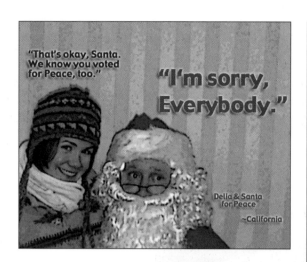

"That's okay, Santa. We know you voted for Peace, too."

"I'm sorry, Everybody."

Delia & Santa for Peace
~California

Sorry isn't good enough.
I promise to work smarter next time
Please forgive us.

California should secede.

America:
It was fun while it lasted!!!

Sorry, world. Apparently 51% of our country is completely clueless as to what's going on. I'm glad I voted and that we all tried so hard to save this nation, but apparently a few more people didn't see it our way.

Oh well, I better enjoy my computer while I still have it. You never know when I'll have to sell it for food money...

Please forgive us!!! It wasn't our fault!!!

Hey, Canada, can I crash with you for a while?

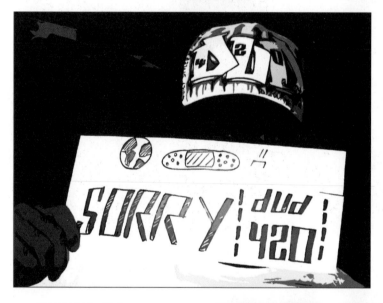

SORRY! dud 420

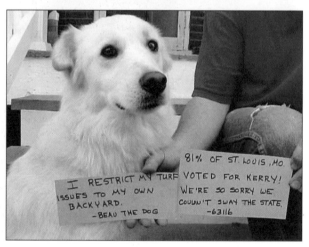

I RESTRICT MY TURF ISSUES TO MY OWN BACKYARD.
-BEAU THE DOG

81% OF ST. LOUIS, MO. VOTED FOR KERRY! WE'RE SO SORRY WE COULDN'T SWAY THE STATE.
-63116

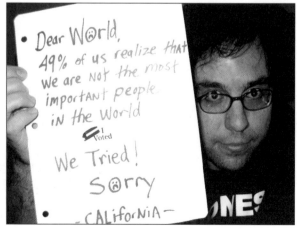

• Dear World,
49% of us realize that we are not the most important people in the World
I Voted
We Tried!
S@rry
-CALIFORNIA-

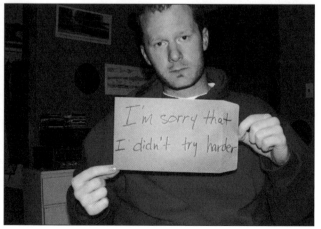

I'm sorry that I didn't try harder

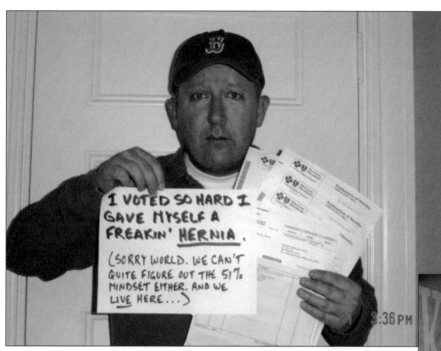

I VOTED SO HARD I GAVE MYSELF A FREAKIN' HERNIA.

(SORRY WORLD. WE CAN'T QUITE FIGURE OUT THE 51% MINDSET EITHER. AND WE LIVE HERE...)

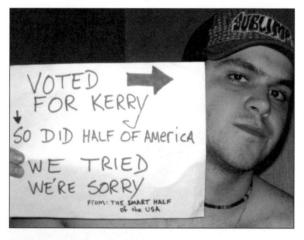

VOTED FOR KERRY →
↓ SO DID HALF OF AMERICA
WE TRIED WE'RE SORRY
FROM: THE SMART HALF of the USA

IM SORRY

My country has been overthrown by religious fundamentalists headed by a brutal moron. Please don't launch a preemptive strike against me!

I am so very sorry.

To the people of Iraq, I am sorry we forcefully replaced your despot with ours; 49% of us are so ashamed. Please be safe and please forgive us.

sorry from california

11/20/2004

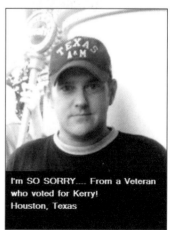

I'm SO SORRY.... From a Veteran who voted for Kerry!
Houston, Texas

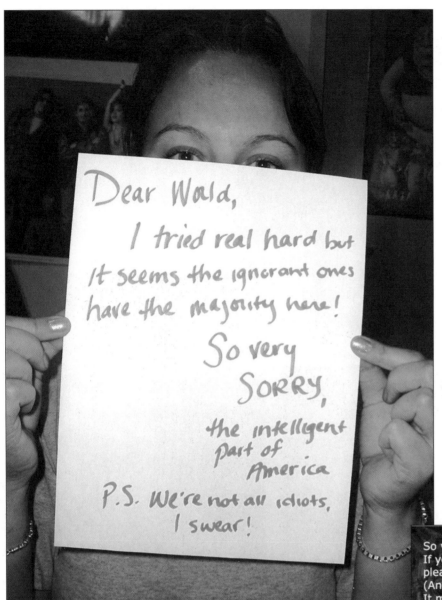

Dear World,
 I tried real hard but it seems the ignorant ones have the majority here!
 So very SORRY,
 the intelligent part of America

P.S. We're not all idiots, I swear!

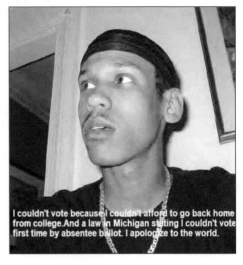

I couldn't vote because I couldn't afford to go back home from college. And a law in Michigan stating I couldn't vote first time by absentee ballot. I apologize to the world.

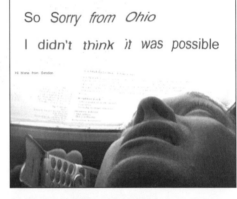

So Sorry from Ohio
I didn't think it was possible

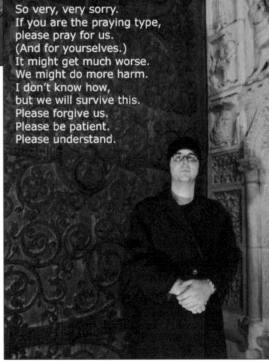

So very, very sorry.
If you are the praying type,
please pray for us.
(And for yourselves.)
It might get much worse.
We might do more harm.
I don't know how,
but we will survive this.
Please forgive us.
Please be patient.
Please understand.

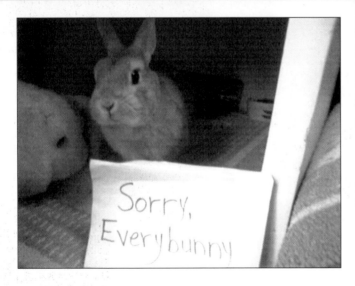

Sorry, Everybunny

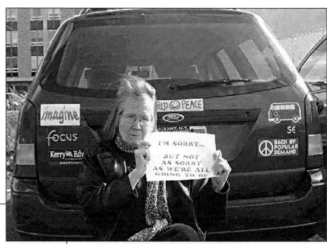

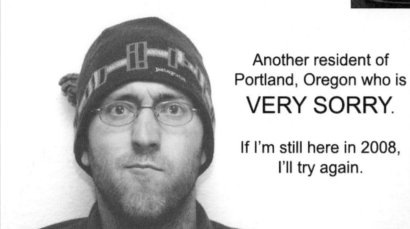

Another resident of
Portland, Oregon who is
VERY SORRY.

If I'm still here in 2008,
I'll try again.

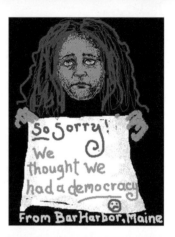

So Sorry!
We
thought We
had a democracy

From Bar Harbor, Maine

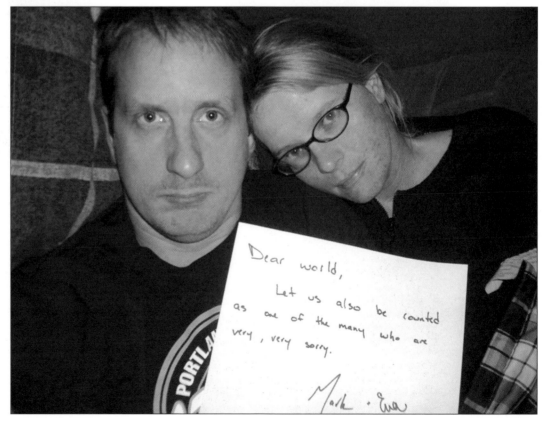

Dear world,
Let us also be counted
as one of the many who are
very, very sorry.

Mark + Eva

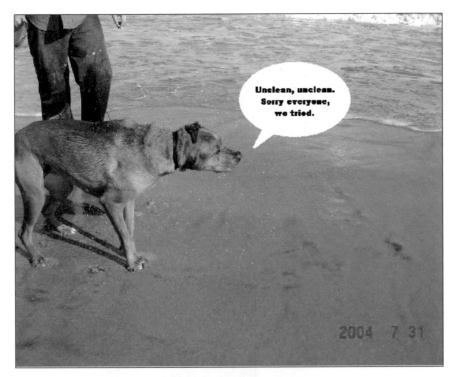

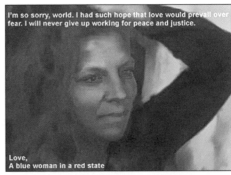

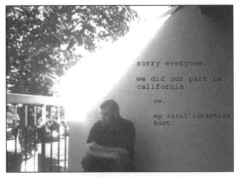

38

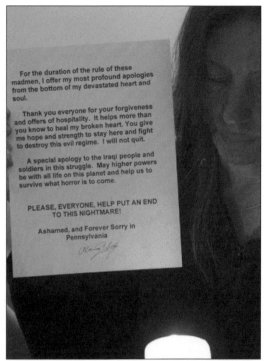

For the duration of the rule of these madmen, I offer my most profound apologies from the bottom of my devastated heart and soul.

Thank you everyone for your forgiveness and offers of hospitality. It helps more than you know to heal my broken heart. You give me hope and strength to stay here and fight to destroy this evil regime. I will not quit.

A special apology to the Iraqi people and soldiers in this struggle. May higher powers be with all life on this planet and help us to survive what horror is to come.

PLEASE, EVERYONE, HELP PUT AN END TO THIS NIGHTMARE!

Ashamed, and Forever Sorry in Pennsylvania

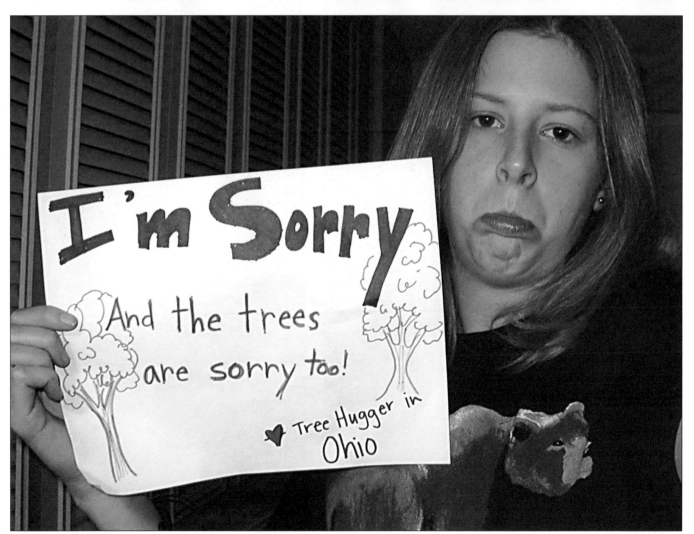

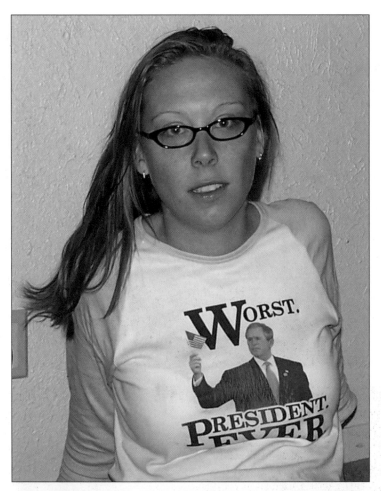

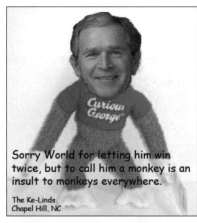

Sorry World for letting him win twice, but to call him a monkey is an insult to monkeys everywhere.

The Ke-Linds
Chapel Hill, NC

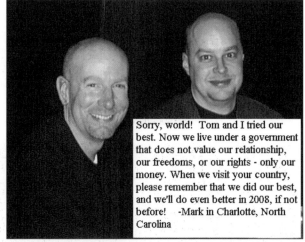

Sorry, world! Tom and I tried our best. Now we live under a government that does not value our relationship, our freedoms, or our rights - only our money. When we visit your country, please remember that we did our best, and we'll do even better in 2008, if not before! -Mark in Charlotte, North Carolina

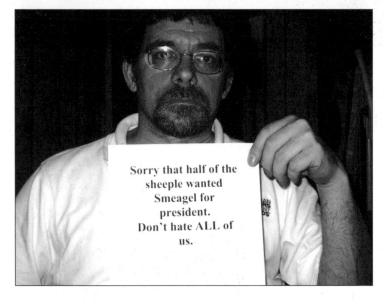

Sorry that half of the sheeple wanted Smeagel for president. Don't hate ALL of us.

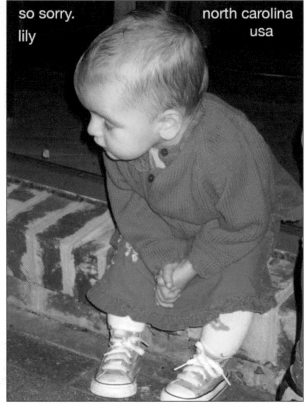

so sorry.
lily

north carolina
usa

40

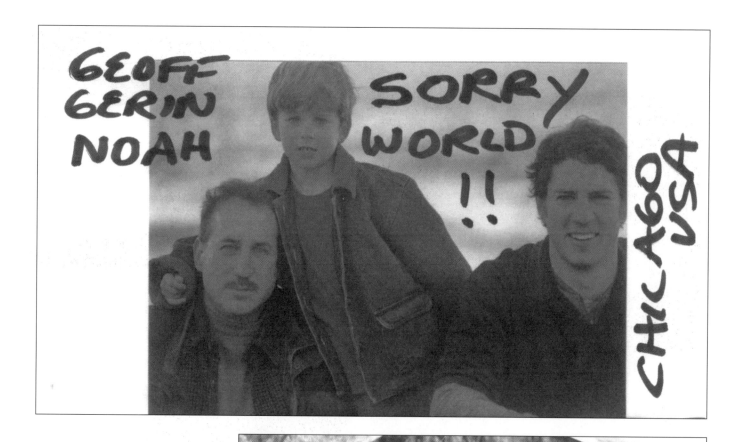

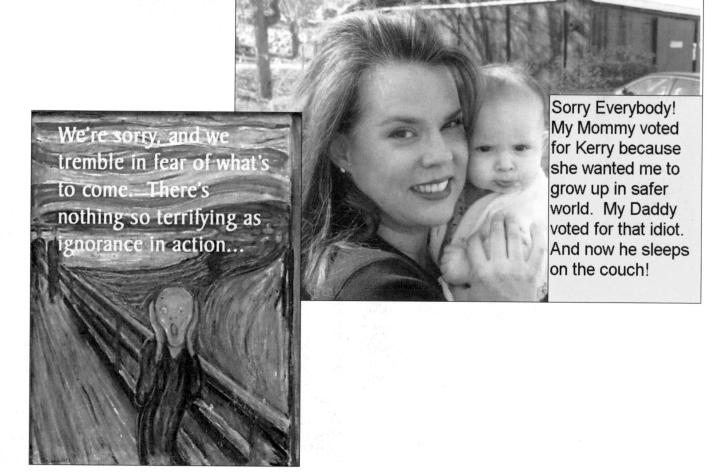

41

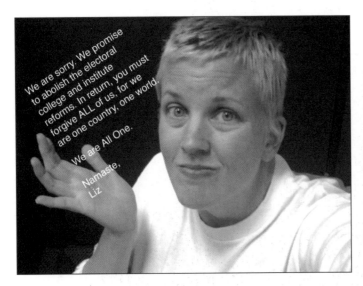

We are sorry. We promise to abolish the electoral college and institute reforms. In return, you must forgive ALL of us, for we are one country, one world.

We are All One.

Namaste,
Liz

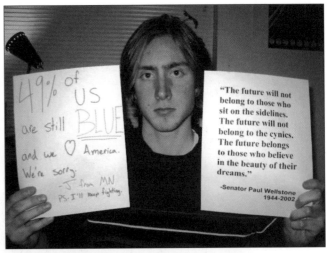

49% of US are still BLUE and we ♡ America. We're sorry.
-J from MN
PS-I'll keep fighting.

"The future will not belong to those who sit on the sidelines. The future will not belong to the cynics. The future belongs to those who believe in the beauty of their dreams."

-Senator Paul Wellstone
1944-2002

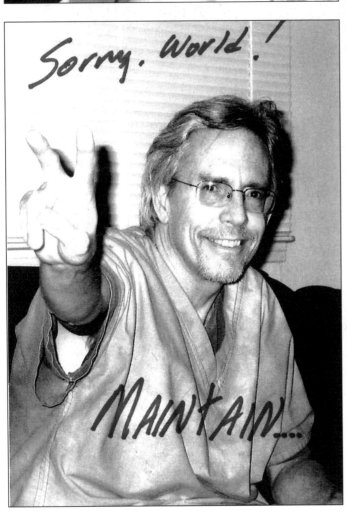

Sorry. World.!

MAINTAIN....

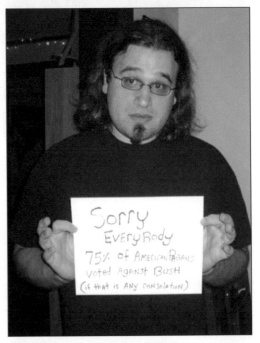

Sorry EveryBody
75% of American Pagans voted Against Bush
(if that is any consolation)

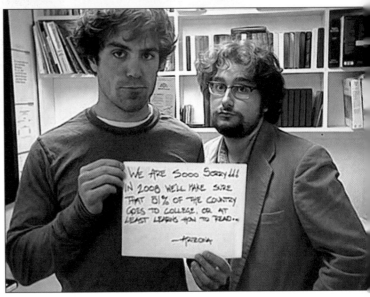

We are Sooo Sorry!!!
In 2008 We'll make sure that 81% of the country goes to college, or at least learns how to read...
-ARIZONA

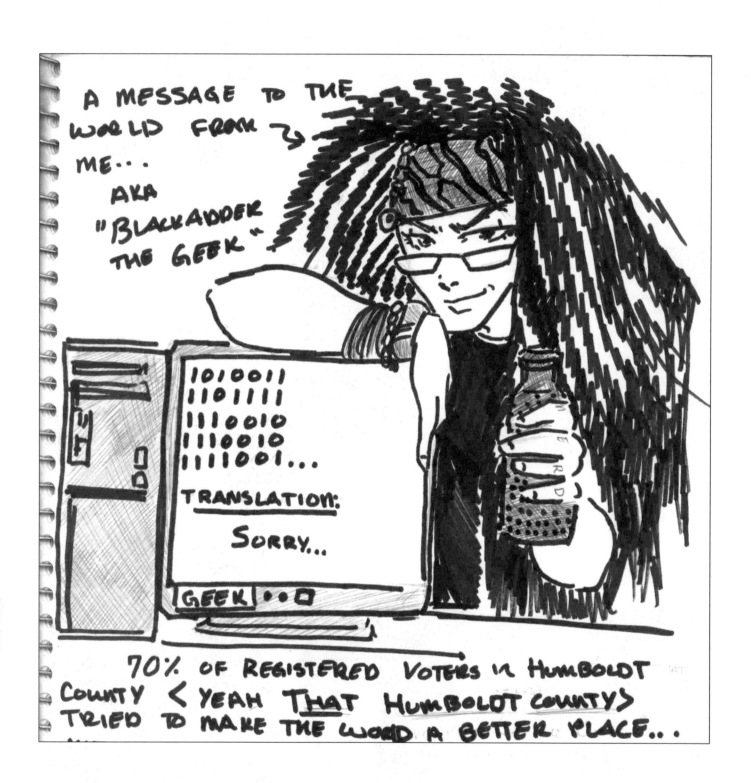

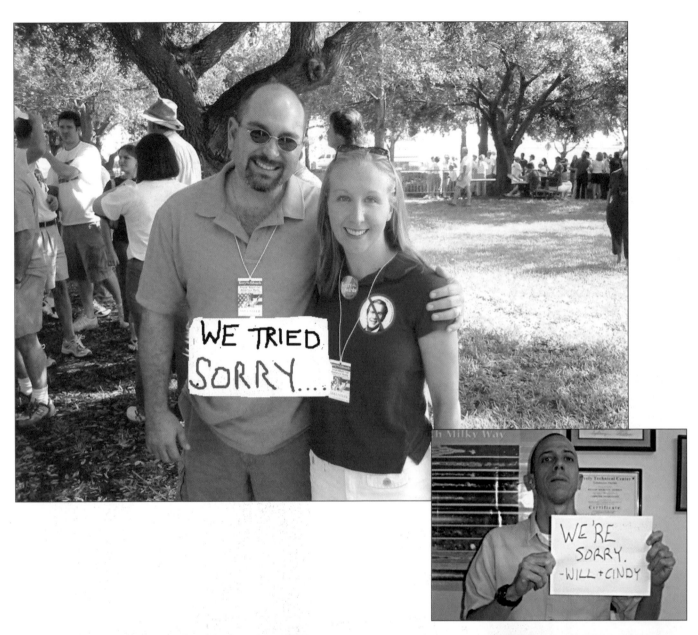

WE TRIED SORRY....

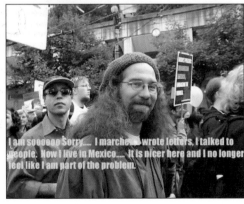

WE'RE SORRY. —WILL+CINDY

I am sooooop Sorry..... I marched, I wrote letters, I talked to people. Now I live in Mexico...... It is nicer here and I no longer feel like I am part of the problem.

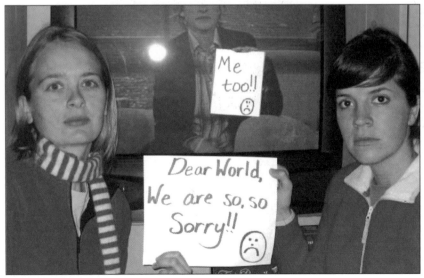

Me too!!

Dear World, We are so, so Sorry!!

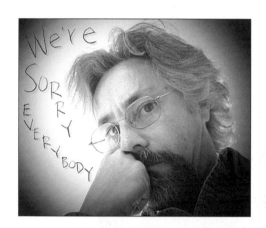

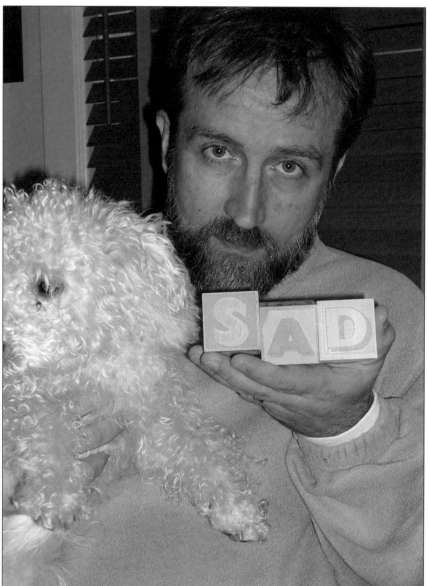

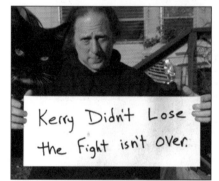

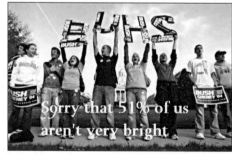

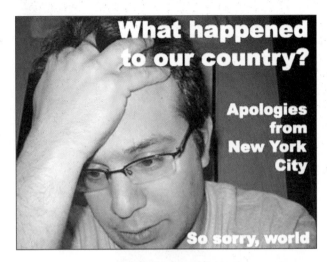

What happened to our country?

Apologies from New York City

So sorry, world

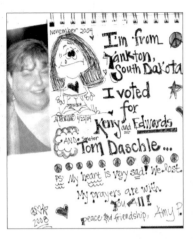

November 2004

I'm from Yankton, South Dakota I voted for Kerry and Edwards AND Senator Tom Daschle...

PS: My heart is very sad! We lost. My prayers are with you ALL!

peace and friendship, Amy P.

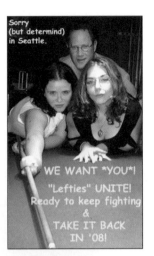

Sorry (but determind) in Seattle.

WE WANT *YOU*!

"Lefties" UNITE! Ready to keep fighting & TAKE IT BACK IN '08!

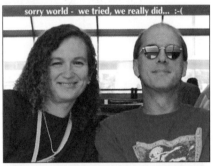

sorry world - we tried, we really did... :-(

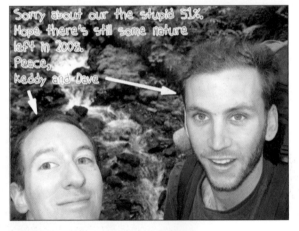

Sorry about our the stupid 51%. Hope there's still some nature left in 2008. Peace, Keddy and Dave

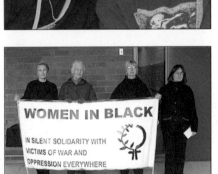

WOMEN IN BLACK

IN SILENT SOLIDARITY WITH VICTIMS OF WAR AND OPPRESSION EVERYWHERE

We are sorry. Albany, OR

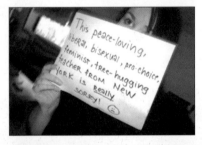

This peace-loving, liberal, bisexual, pro-choice, feminist, tree-hugging teacher from New York is really SORRY!

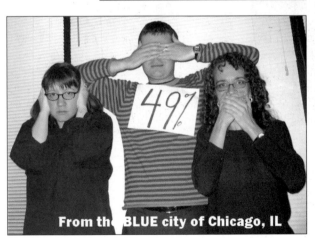

49%

From the BLUE city of Chicago, IL

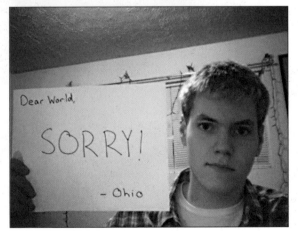

Dear World,

SORRY!

- Ohio

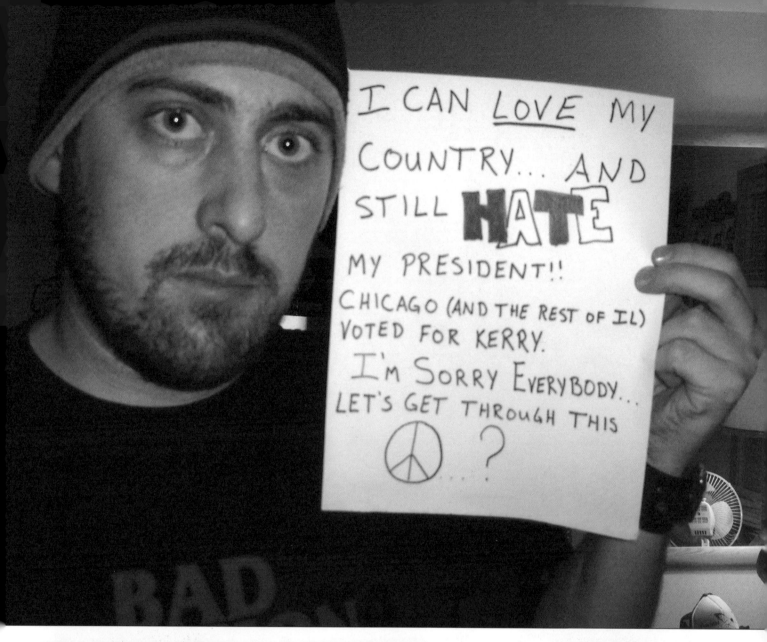

I CAN LOVE MY COUNTRY... AND STILL HATE MY PRESIDENT!!

CHICAGO (AND THE REST OF IL) VOTED FOR KERRY.

I'M SORRY EVERYBODY... LET'S GET THROUGH THIS ☮...?

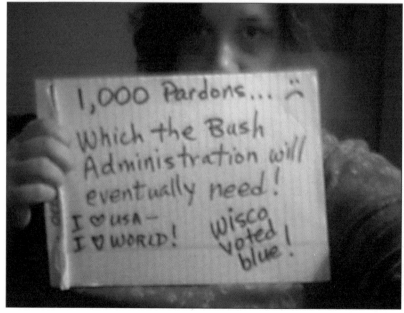

1,000 Pardons... ☺
Which the Bush Administration will eventually need!
I ♡ USA —
I ♡ WORLD! Wisco voted blue!

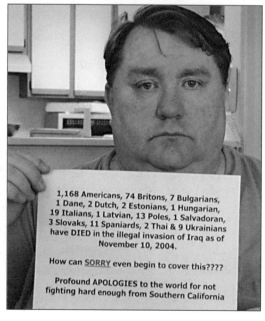

1,168 Americans, 74 Britons, 7 Bulgarians, 1 Dane, 2 Dutch, 2 Estonians, 1 Hungarian, 19 Italians, 1 Latvian, 13 Poles, 1 Salvadoran, 3 Slovaks, 11 Spaniards, 2 Thai & 9 Ukrainians have DIED in the illegal invasion of Iraq as of November 10, 2004.

How can SORRY even begin to cover this????

Profound APOLOGIES to the world for not fighting hard enough from Southern California

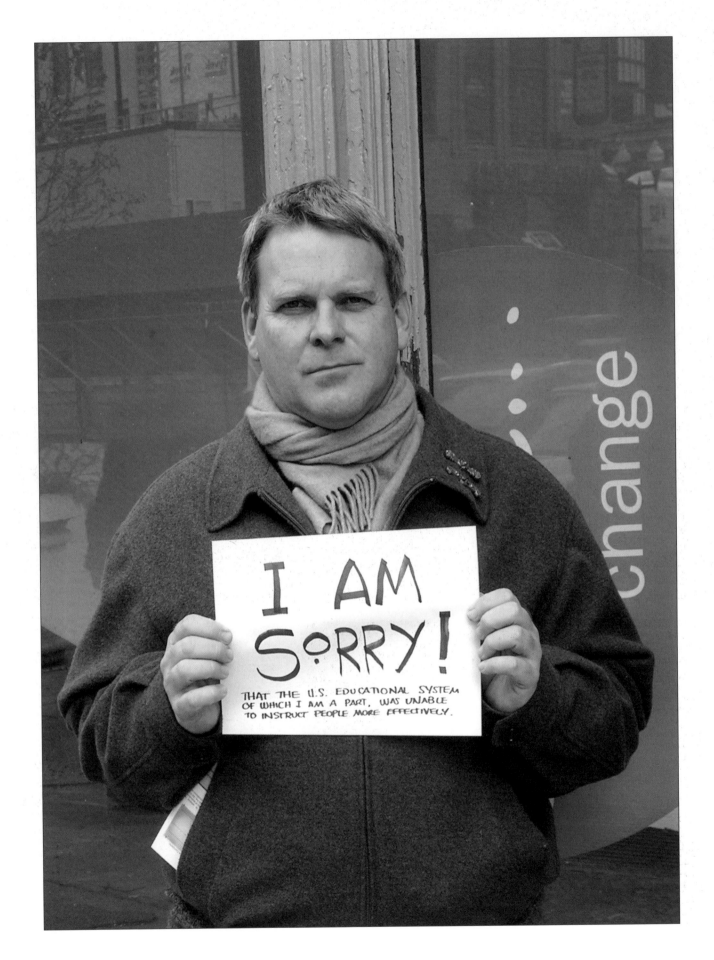

Couldn't get the vote up,
couldn't get enough votes.
Sorry, everyone.

Allie
Columbus, Ohio

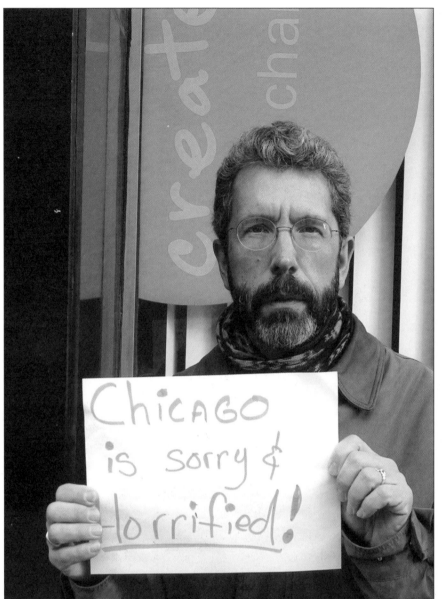

Chicago is sorry & torrified!

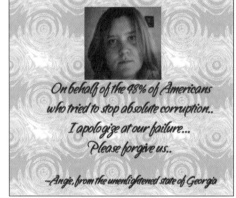

Dear World,
i'm sorry. i'm sorry i
wasn't old enough to vote.
i'm sorry that only half
of us are sane. Please forgive
us. -♥-Britnie
P.S. i'm voting in 2008!

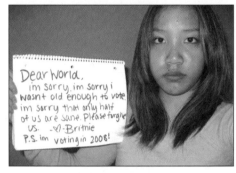

On behalf of the 48% of Americans
who tried to stop absolute corruption..
I apologize at our failure...
Please forgive us..

—Angie, from the unenlightened state of Georgia

WE'RE SORRY.
OUR BAD.

(Could you, like, check on us now
and then to make sure, we're
still breathing? Thanks.)
— America

Sorry!
(couldn't vote this time)
bainbridge Island
Washington

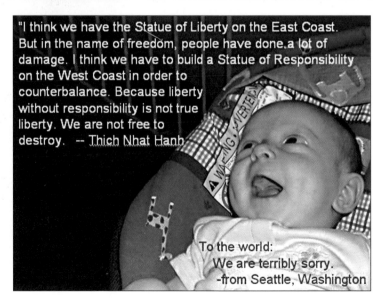

"I think we have the Statue of Liberty on the East Coast.
But in the name of freedom, people have done a lot of
damage. I think we have to build a Statue of Responsibility
on the West Coast in order to
counterbalance. Because liberty
without responsibility is not true
liberty. We are not free to
destroy. -- Thich Nhat Hanh

To the world:
 We are terribly sorry.
 -from Seattle, Washington

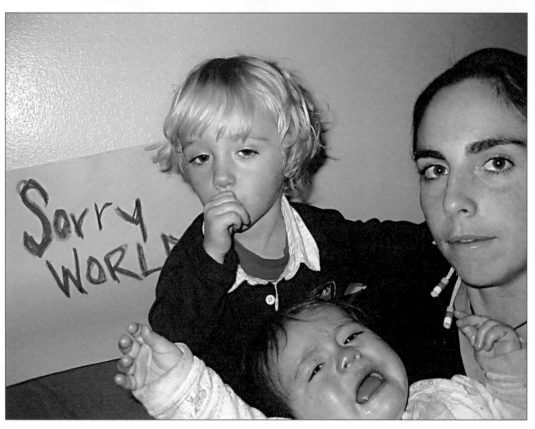

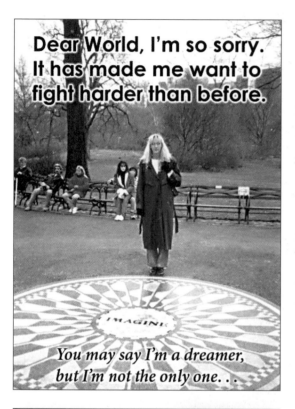

Dear World, I'm so sorry. It has made me want to fight harder than before.

You may say I'm a dreamer, but I'm not the only one. . .

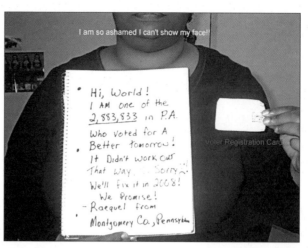

I am so ashamed I can't show my face!!

Hi, World!
I AM one of the
2,883,833 in P.A.
Who voted for A
Better tomorrow!
It Didn't work out
That way. Sorry.
We'll fix it in 2008!
We Promise!
- Raequel from
Montgomery Co., Pennsylvania

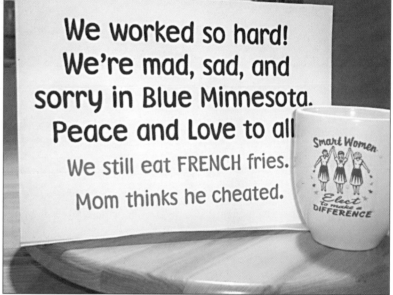

We worked so hard! We're mad, sad, and sorry in Blue Minnesota. Peace and Love to all

We still eat FRENCH fries.

Mom thinks he cheated.

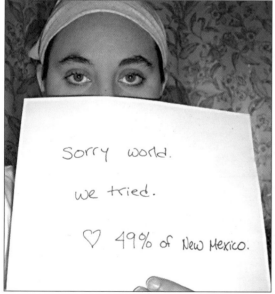

Sorry world.

We tried.

♡ 49% of New Mexico.

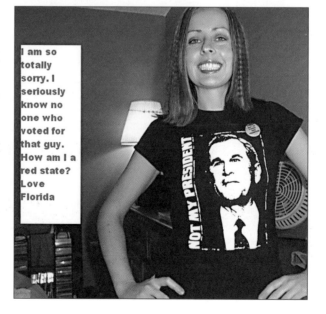

I am so totally sorry. I seriously know no one who voted for that guy. How am I a red state? Love Florida

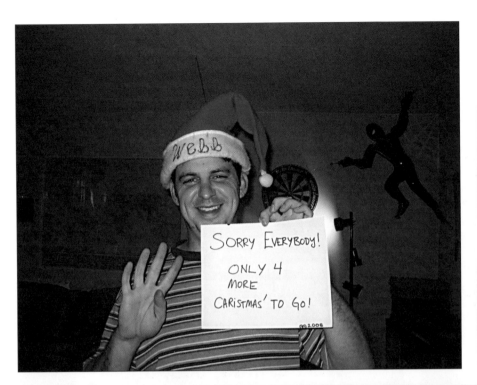

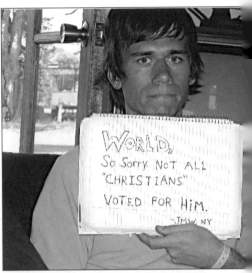

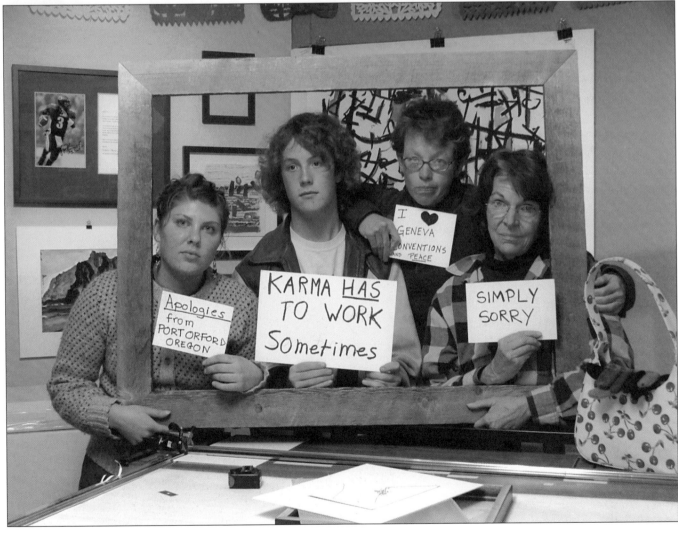

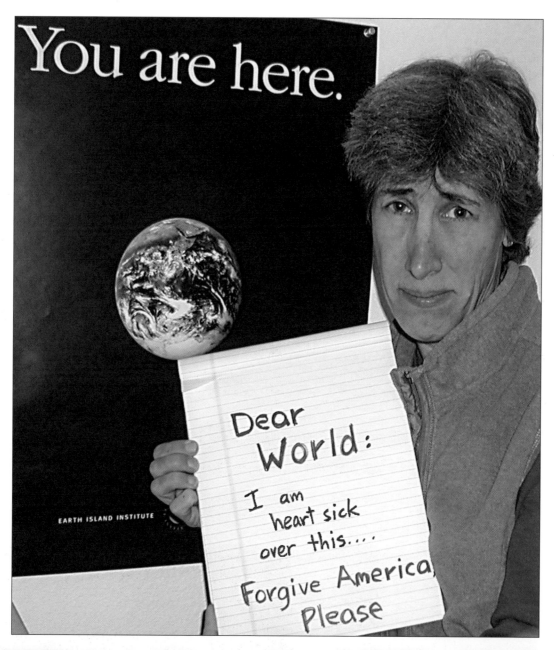

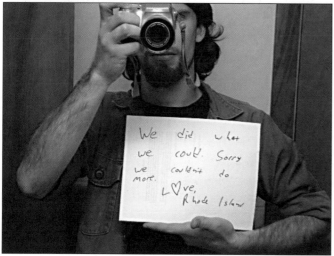

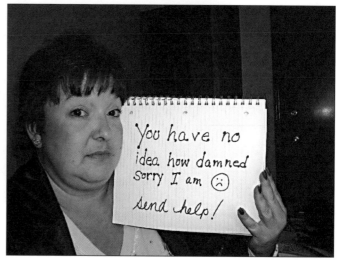

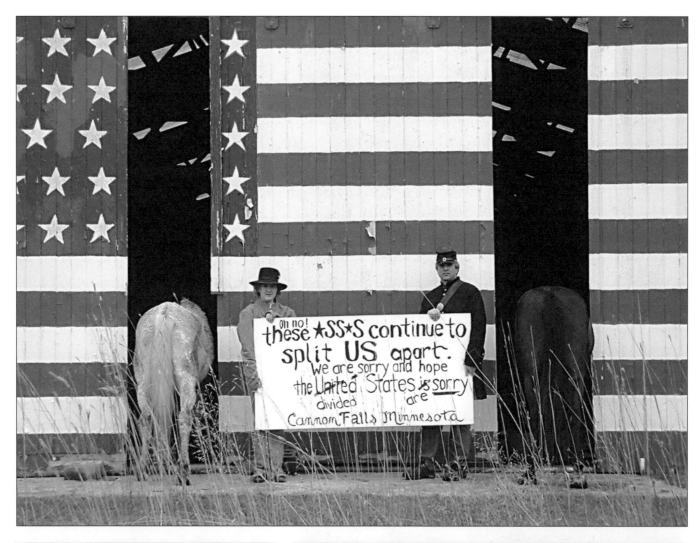

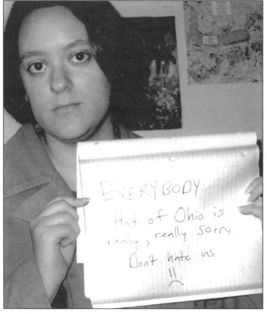

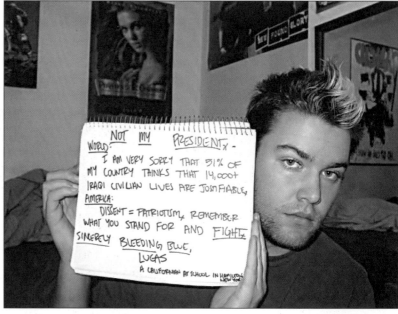

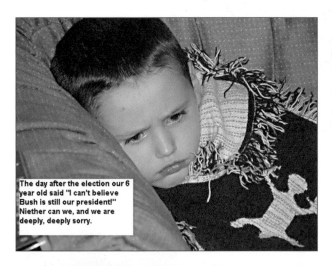

The day after the election our 6 year old said "I can't believe Bush is still our president!" Niether can we, and we are deeply, deeply sorry.

THE APEMAN COMETH .. SORRY - ALICE

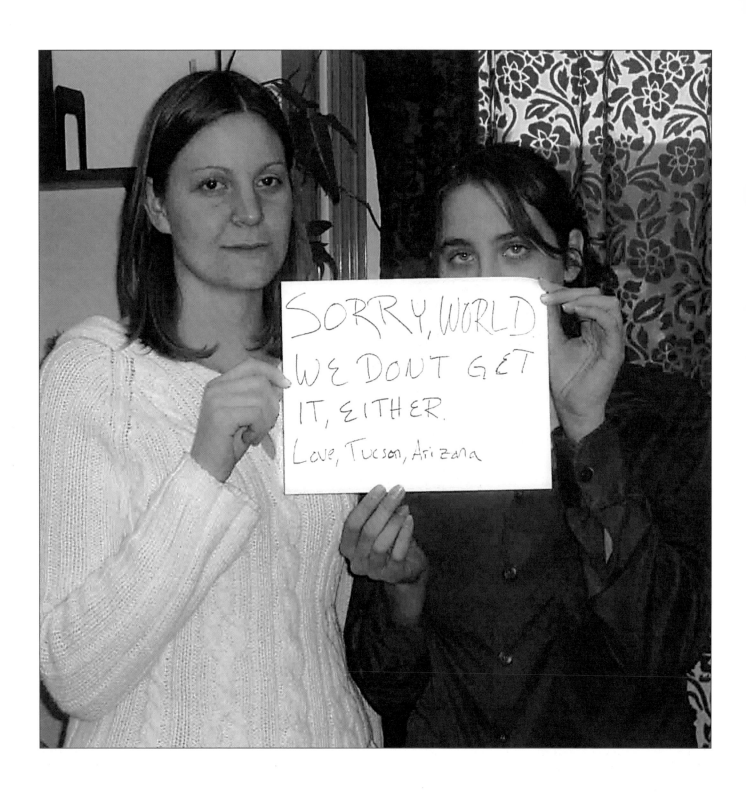

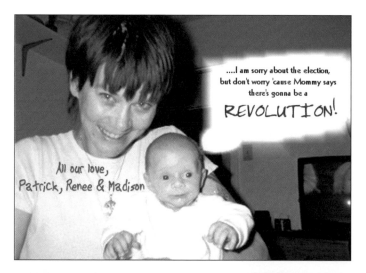

….I am sorry about the election, but don't worry 'cause Mommy says there's gonna be a

REVOLUTION!

All our love,
Patrick, Renee & Madison

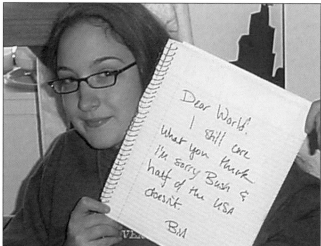

It's not enough to say we're sorry. We must continue to fight to take back our country from the Cheney's and Bush's of the world. They do not represent what is best about us!

from a sad latina in North Carolina....

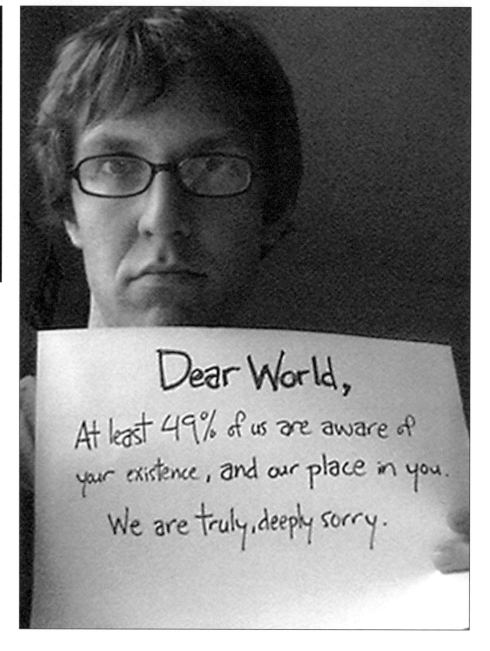

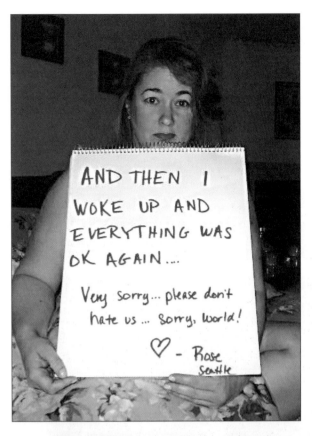

AND THEN I WOKE UP AND EVERYTHING WAS OK AGAIN....

Very sorry... please don't hate us ... Sorry, World!

♡ - Rose
Seattle

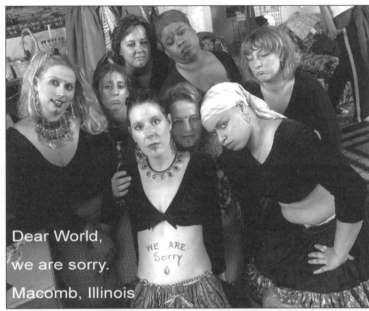

Dear World,
we are sorry.
Macomb, Illinois

So sorry. never give up hope, despite the sadness in our hearts.

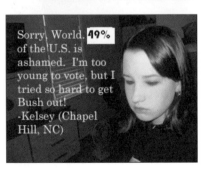

Sorry, World. 49% of the U.S. is ashamed. I'm too young to vote, but I tried so hard to get Bush out!
-Kelsey (Chapel Hill, NC)

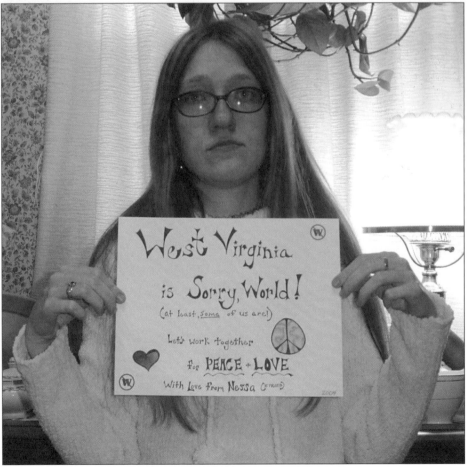

West Virginia is Sorry, World! (at least, some of us are!)
Let's work together for PEACE + LOVE
With love from Nessa (I tried)

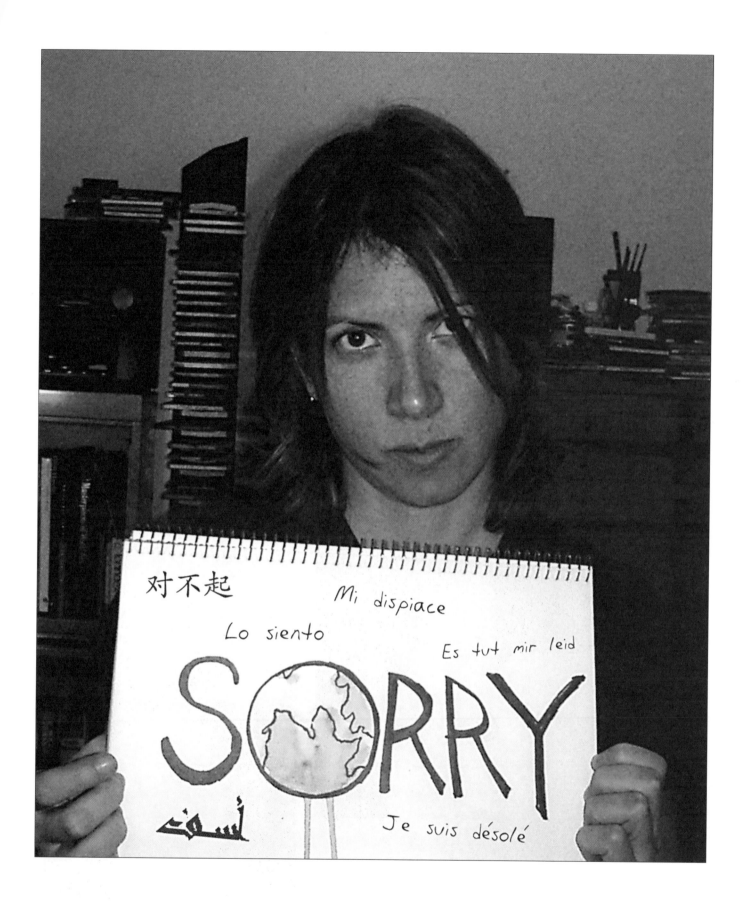

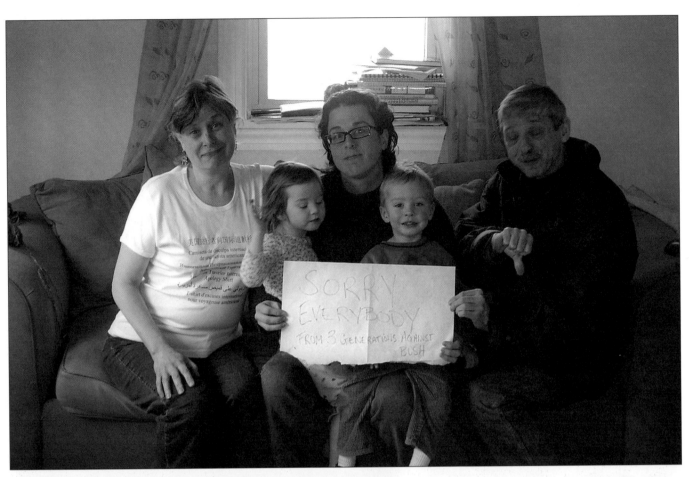

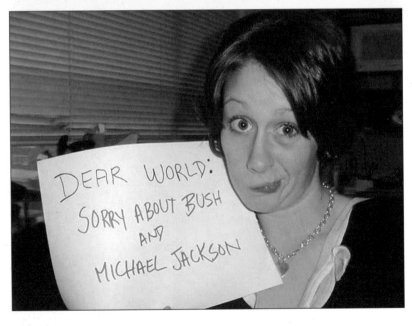

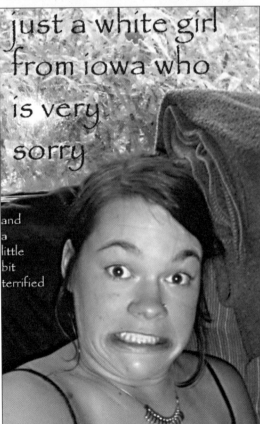

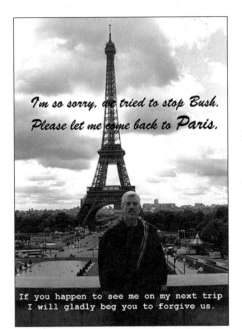

I'm so sorry, we tried to stop Bush.
Please let me come back to Paris.

If you happen to see me on my next trip
I will gladly beg you to forgive us.

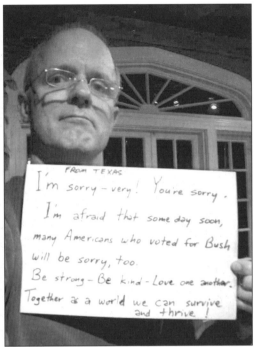

FROM TEXAS

I'm sorry – very! You're sorry.
I'm afraid that some day soon,
many Americans who voted for Bush
will be sorry, too.
Be strong – Be kind – Love one another.
Together as a world we can survive
and thrive!

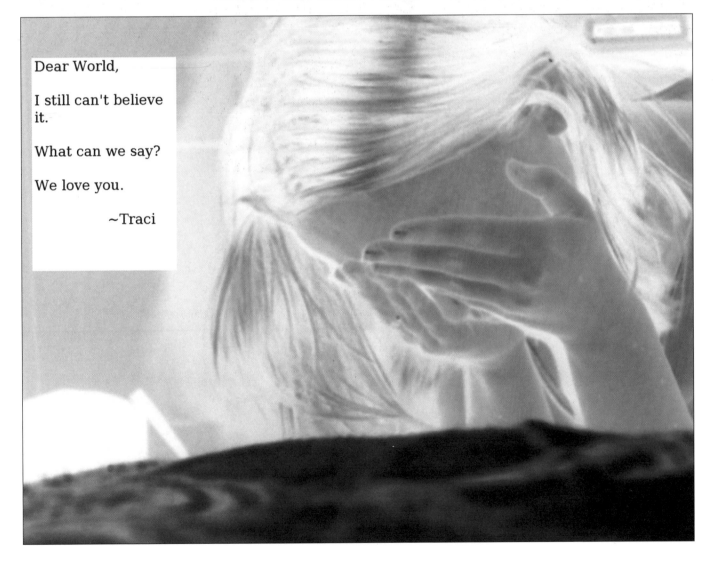

Dear World,

I still can't believe it.

What can we say?

We love you.

~Traci

Just because Iowa is wearing red, it doesn't mean this is Bush country. Even my pro-life Republican friend voted Kerry! My in-laws are Lebanese-American, Canadian, and Japanese; my state representative was born in India. The Mother Mosque is here—did you know?—and a Zen center and a Jewish temple. A lot of us love you and know we're part of you, World! I'm so sorry, those who are suffering. I pray for you every day.

(p.s. Please don't attack D.C.: the world needs the wisdom of the Native American museum!)

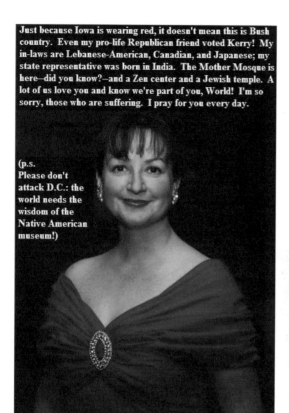

48.5% of Ohioans voted for a better world
For us
For our children
For you and your children.
We tried our best.
We're so very sorry.

--Missy
Toledo, Ohio

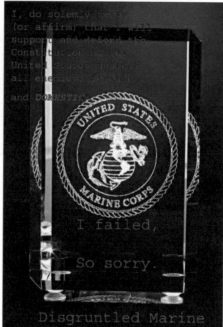

I, do solemnly swear (or affirm) that I will support and defend the Constitution of the United States against all enemies, foreign and DOMESTIC...

I failed,

So sorry.

Disgruntled Marine

Dear World,

Wish I could have done more to stop the creeping Republican menace.

Be right back. There are some guys in dark suits at the door...

≋ *Sorry, Everybody.* ≋

I voted by absentee ballot in **South Carolina**.

Even there, in the buckle of the Bible Belt, 44% of us voted to fire Dubya.

We haven't given up! We will try harder in 2008—MUCH harder!

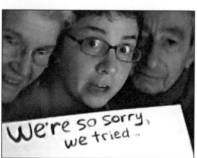

We're so sorry, we tried...

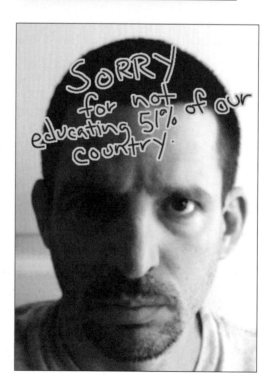

SORRY for not educating 51% of our country.

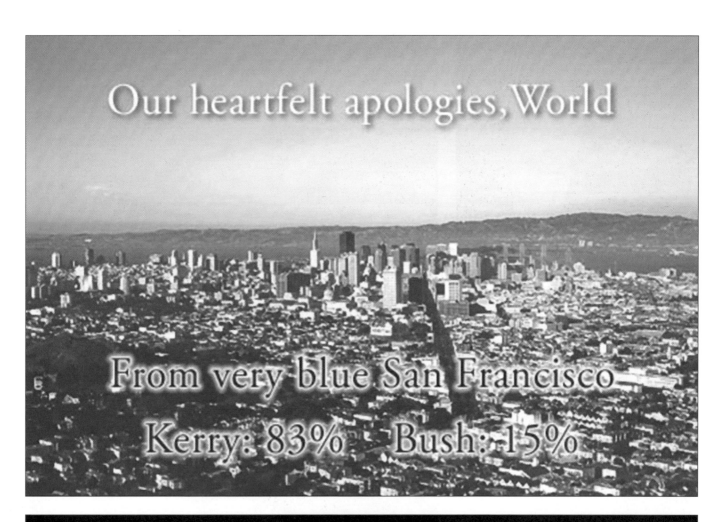

Our heartfelt apologies, World

From very blue San Francisco

Kerry: 83% Bush: 15%

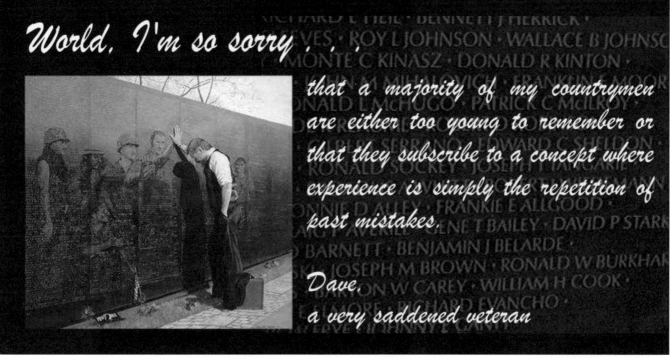

World, I'm so sorry,

that a majority of my countrymen are either too young to remember or that they subscribe to a concept where experience is simply the repetition of past mistakes.

Dave,
a very saddened veteran

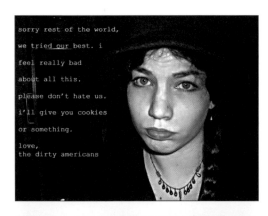

sorry rest of the world,
we tried our best. i
feel really bad
about all this.
please don't hate us.
i'll give you cookies
or something.
love,
the dirty americans

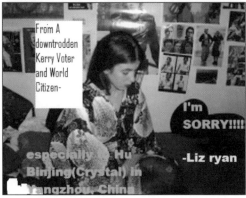

From A
downtrodden
Kerry Voter
and World
Citizen-

I'm
SORRY!!!!

especially to Hu
Binjing(Crystal) in
Yangzhou, China

-Liz ryan

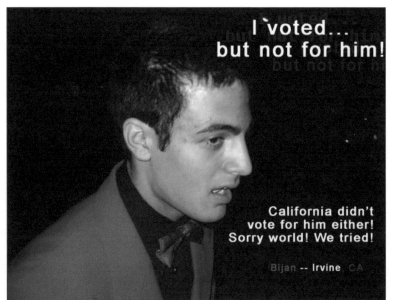

I `voted...
but not for him!

California didn't
vote for him either!
Sorry world! We tried!

Bijan -- Irvine, CA

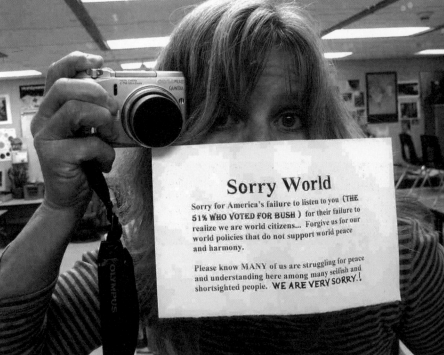

Sorry World

Sorry for America's failure to listen to you (THE
51% WHO VOTED FOR BUSH) for their failure to
realize we are world citizens... Forgive us for our
world policies that do not support world peace
and harmony.

Please know MANY of us are struggling for peace
and understanding here among many selfish and
shortsighted people. WE ARE VERY SORRY.!

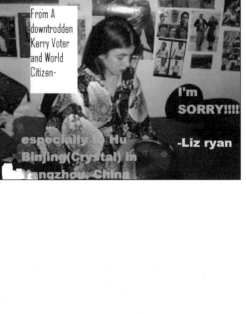

Bee and I are sorry -
we're aliens
And couldn't vote
in Iowa.

Sorry World

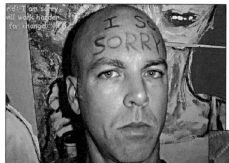

I S[] SORRY

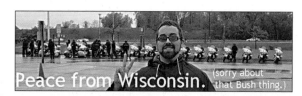

Peace from Wisconsin. (sorry about that Bush thing.)

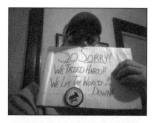

SO SORRY! WE TRIED HARD!! WE LET THE WORLD DOWN

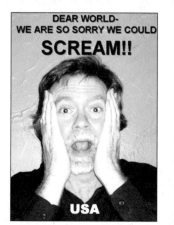

DEAR WORLD-
WE ARE SO SORRY WE COULD
SCREAM!!
USA

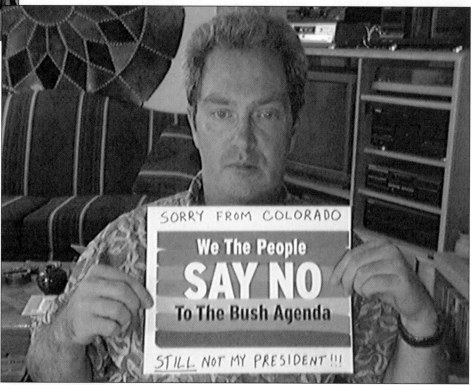

SORRY FROM COLORADO

We The People
SAY NO
To The Bush Agenda

STILL NOT MY PRESIDENT !!!

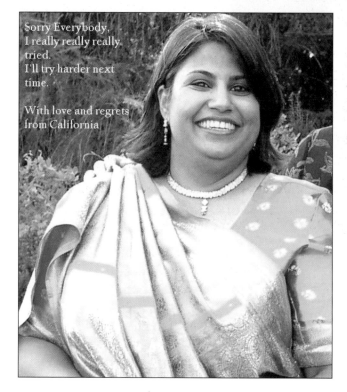

Sorry Everybody,
I really really really
tried.
I'll try harder next
time.

With love and regrets
from California

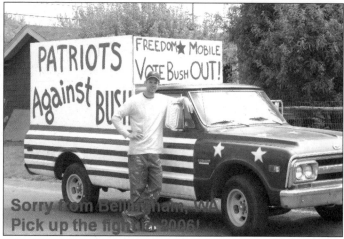

PATRIOTS Against BUSH

FREEDOM ★ MOBILE
VOTE BUSH OUT!

Sorry from Bellingham, WA
Pick up the fight in 2006!

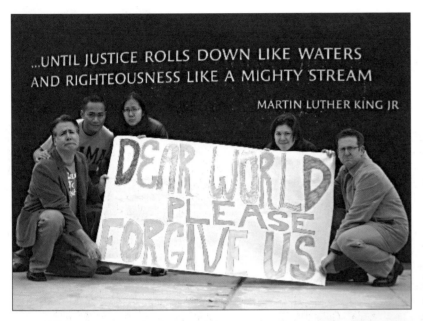

...UNTIL JUSTICE ROLLS DOWN LIKE WATERS
AND RIGHTEOUSNESS LIKE A MIGHTY STREAM

MARTIN LUTHER KING JR

DEAR WORLD PLEASE FORGIVE US

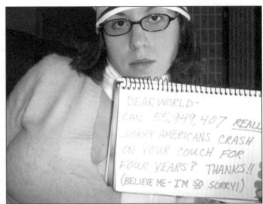

DEAR WORLD-
CAN 55,949,407 REALLY
SORRY AMERICANS CRASH
ON YOUR COUCH FOR
FOUR YEARS? THANKS!!
(BELIEVE ME - I'M SO SORRY!)

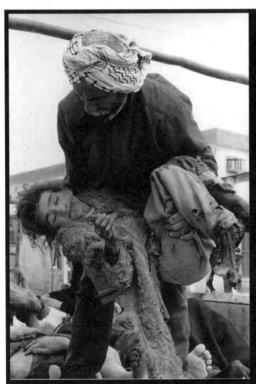

I'm sure she would accept all the apologies...
if she were still alive.

I'm sure she's a hell of a lot more sorry than any of us will ever be. Within the next 4 years she'll most likely be joined by all of her family, friends and neighbors. All because half the country somehow got it into their heads that it's more patriotic to support the president... no matter what he does. —Seren, CA—

SO SORRY EVERYBODY

There were serious voting irregularities and actual voting FRAUD happened on November 2, 2004.

SORRY
VERITAS VINCIT TOTOS TYRANNOS
TRUTH CONQUERS ALL TYRANTS

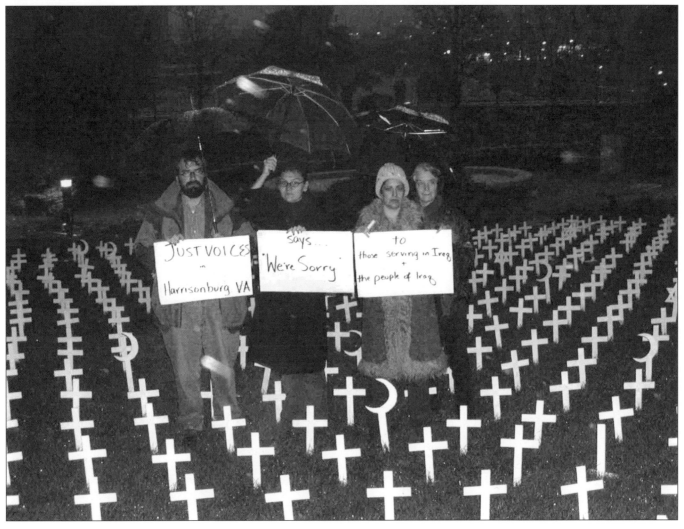

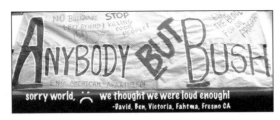

ANYBODY BUT BUSH

NO BILLIONAIRE STOP LEFT BEHIND! KILLING POOR PEOPLE! END AMERICAN APARTHEID! BUSH THE BLOOD FOR OIL PROGRAM!

sorry world, we thought we were loud enough!
-David, Ben, Victoria, Fahtma, Fresno CA

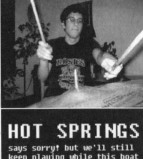

HOT SPRINGS
says sorry! but we'll still keep playing while this boat sinks. all's not lost yet.
GOOD LUCK BLUE AMERICA!

sorry world

many of us do not stand behind our president and many of us do care what the rest of the world thinks

though we do not have control of the presidency, *we the people* still have the *power* to *stand up* for what we believe in

i am confident because we have 49% of america and we have the support of the rest of the world:

thank you very much!

together, we will survive bush and return *stronger in 2008!*

- justin reusch - michigan

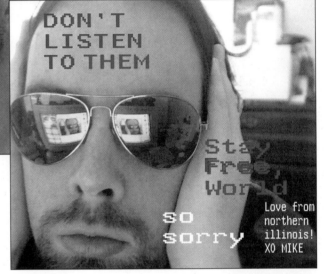

DON'T LISTEN TO THEM

Stay Free, World

so sorry

Love from northern illinois! XO MIKE

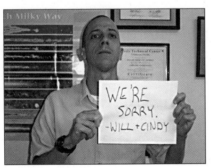

WE'RE SORRY.
-WILL + CINDY

SORRY FROM AUSTIN TEXAS WE AREN'T ALL MORONS!

Here is how America really voted. There are a lot of true blue people in all those red states. I am from Missoula, Montana and we are the little blue corner of Montana. We are very, very, very sorry for what the rest of our state has done. Please forgive us.

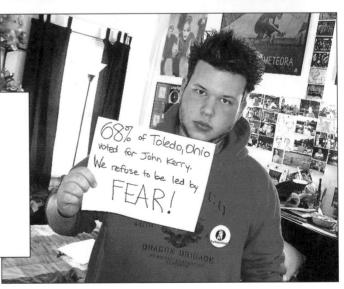

68% of Toledo, Ohio voted for John Kerry. We refuse to be led by FEAR!

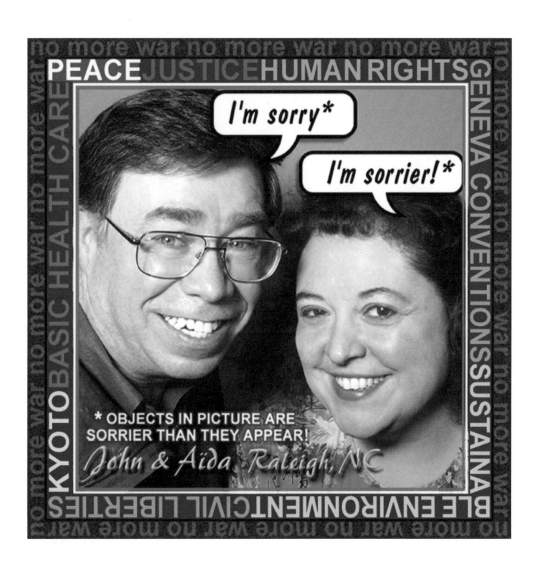

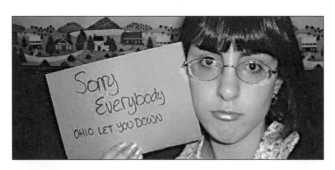

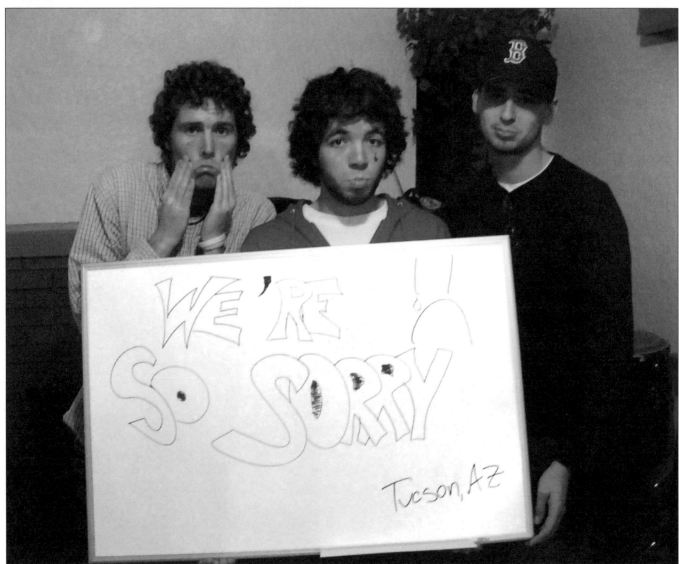

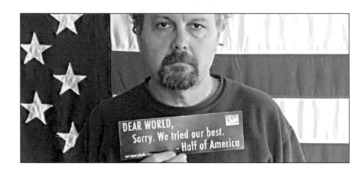

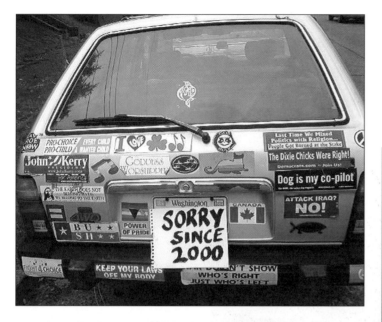

is all pooped out, but not beaten!

Sorry World. Gordon, Alabama

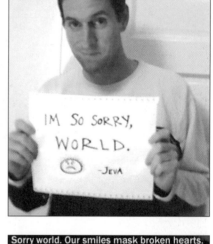

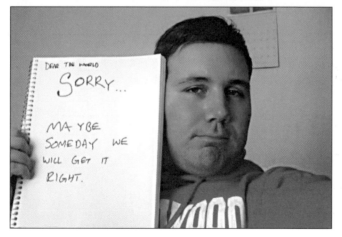

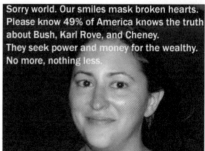

Sorry world. Our smiles mask broken hearts. Please know 49% of America knows the truth about Bush, Karl Rove, and Cheney. They seek power and money for the wealthy. No more, nothing less.

Sorry World. Please don't foresake us,
Most of America knows not what they
do. We still love you!

WE'RE SORRY

We're afraid this lying,
xenophobic tyrant will start
World War III. Please help
us stop him!

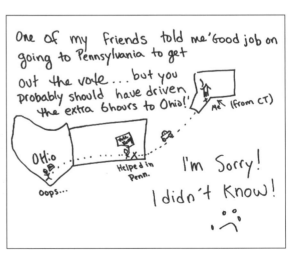

One of my friends told me 'Good job on
going to Pennsylvania to get
out the vote... but you
probably should have driven
the extra 6 hours to Ohio!'

Me (from CT)

Ohio

Helped in
Penn.

oops...

I'm Sorry!
I didn't Know!

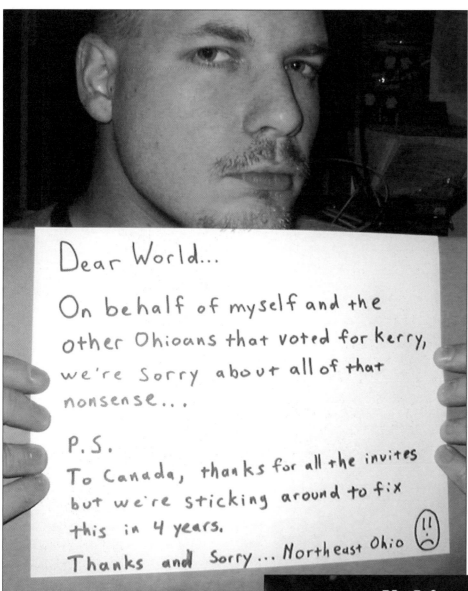

Dear World...

On behalf of myself and the other Ohioans that voted for kerry, we're sorry about all of that nonsense...

P.S.
To Canada, thanks for all the invites but we're sticking around to fix this in 4 years.
Thanks and Sorry... Northeast Ohio

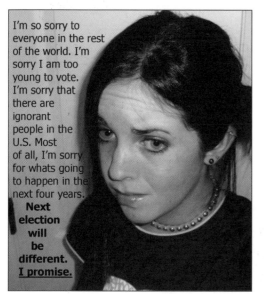

I'm so sorry to everyone in the rest of the world. I'm sorry I am too young to vote. I'm sorry that there are ignorant people in the U.S. Most of all, I'm sorry for whats going to happen in the next four years. **Next election will be different. I promise.**

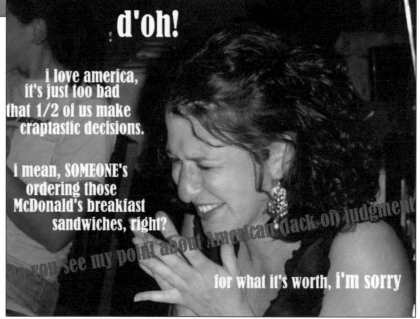

d'oh!

i love america, it's just too bad that 1/2 of us make craptastic decisions.

i mean, SOMEONE's ordering those McDonald's breakfast sandwiches, right?

you see my point about American gack on judgment

for what it's worth, i'm sorry

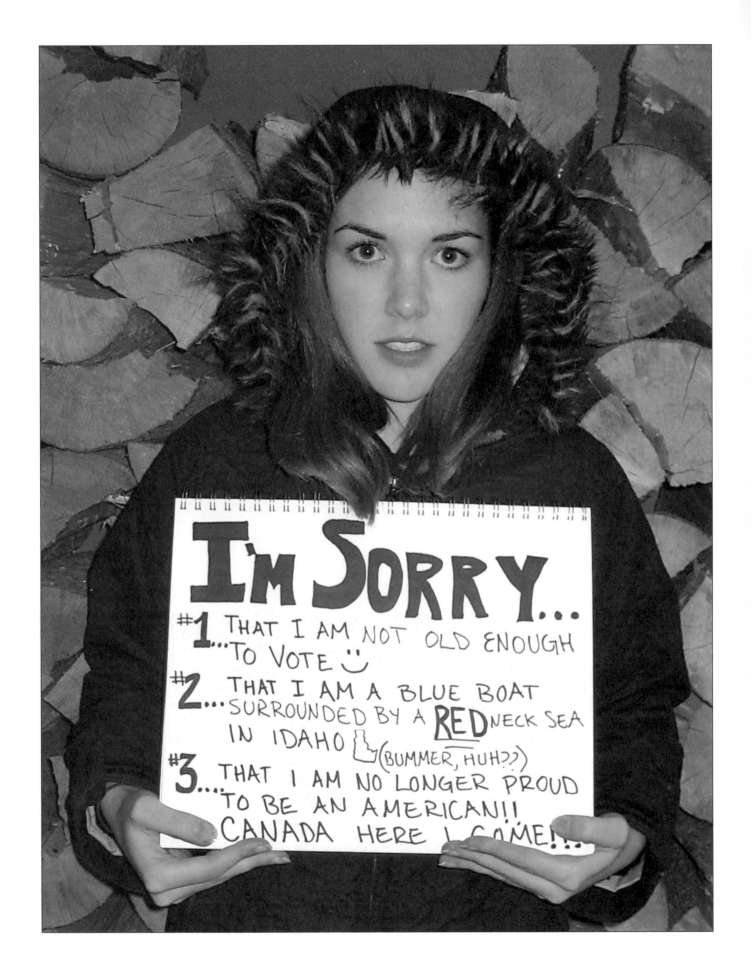

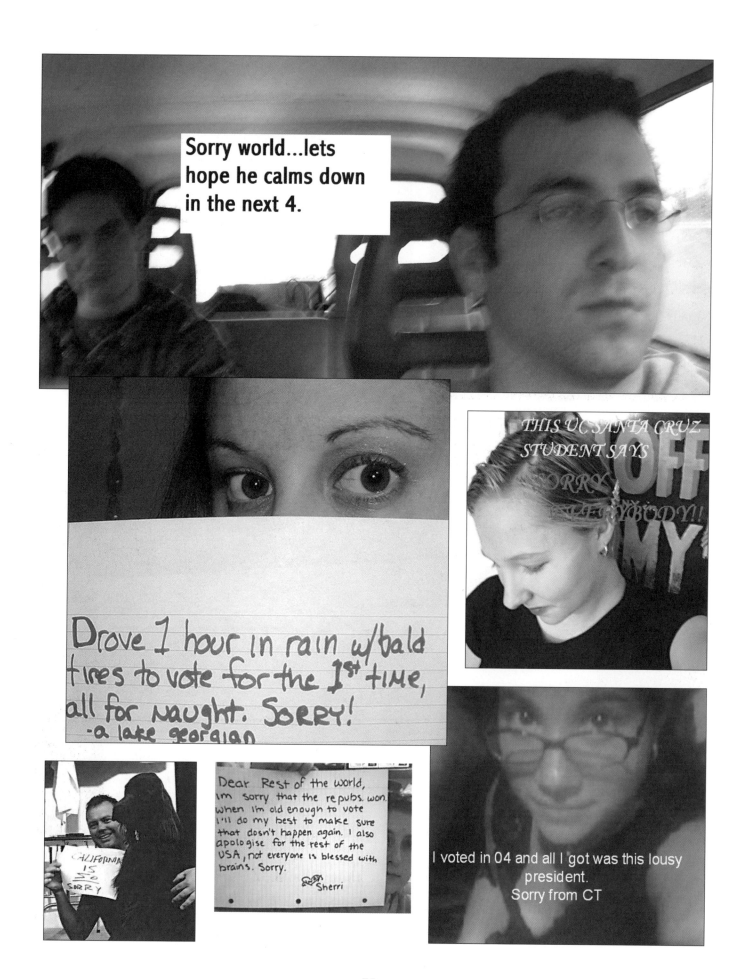

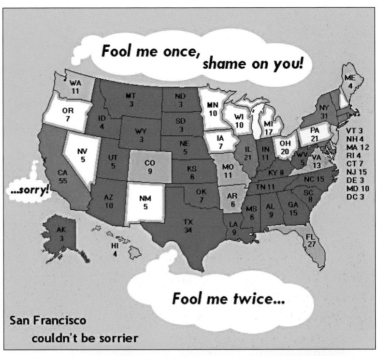

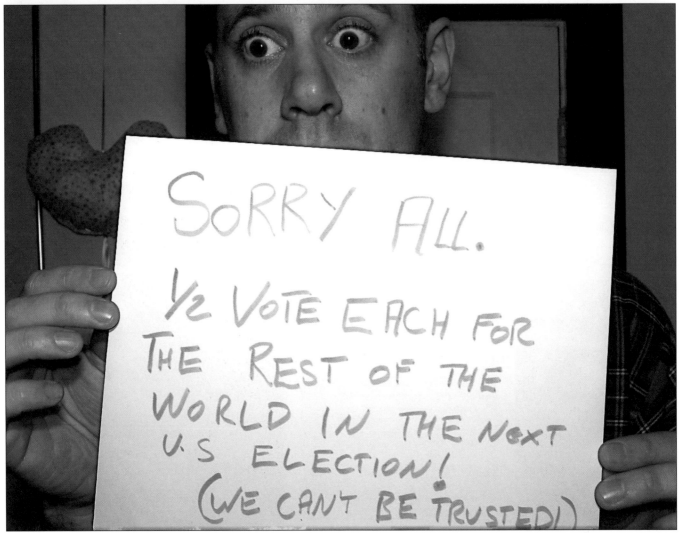

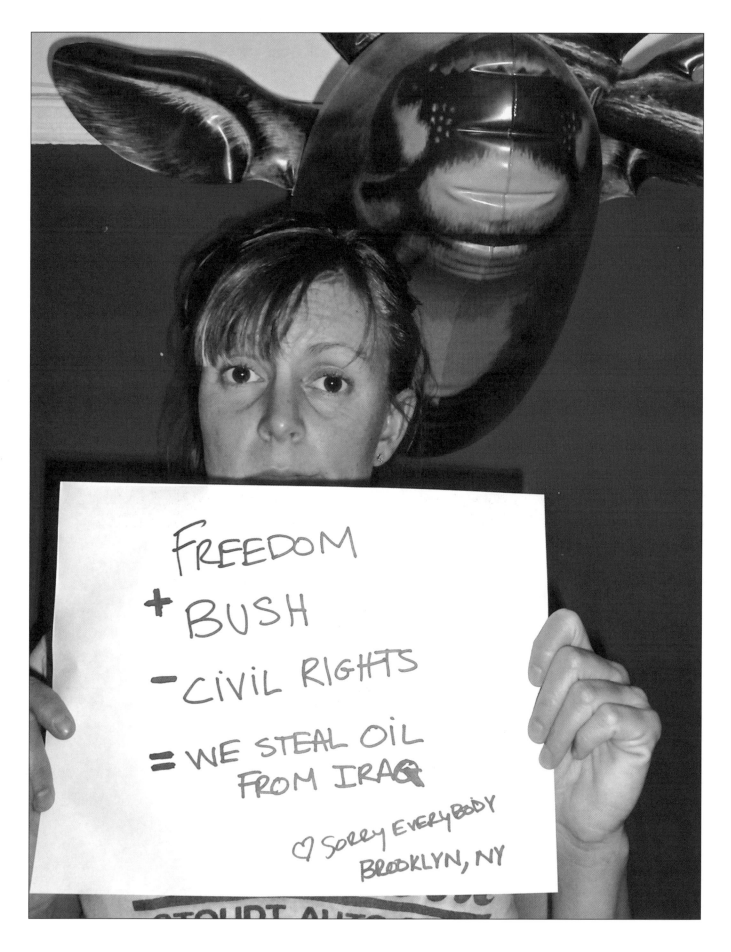

I AM SO SORRY WORLD!!! I TRIED!

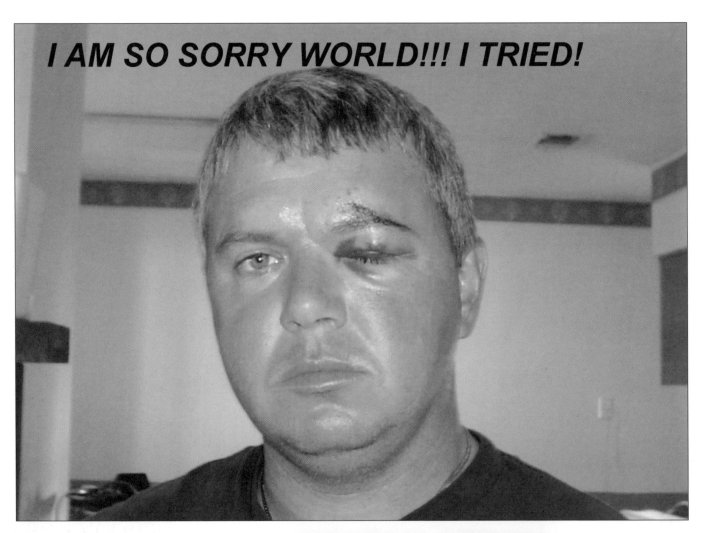

Oh, America, why do we have to suck so bad?

I tried to make a fake I.D. and dude, but I got caught. Next time...

sorry sorry sorry.

♡ Sarah
(Massachusetts)

SOOOOOO SORRY!! - karen... from a blue state, WASHINGTON!!!!!

Sorry !
Oh so devistatingly sorry.
Wish we were bigger.

RHODE ISLAND

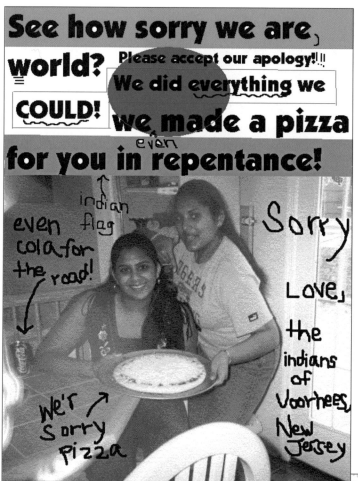

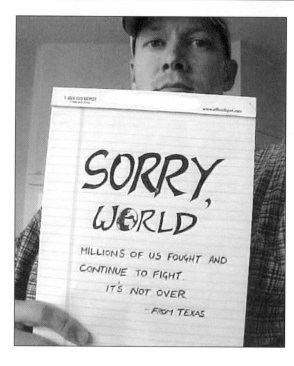

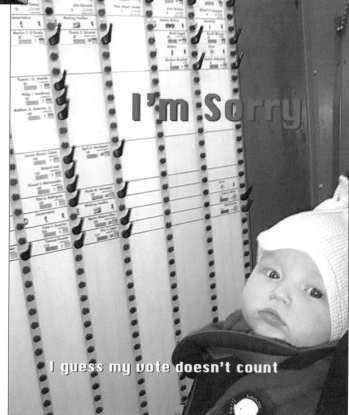

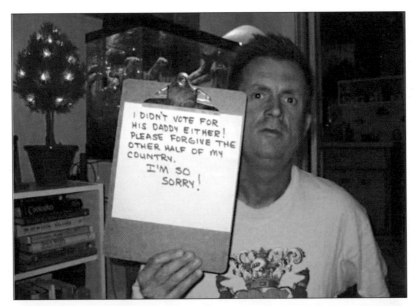

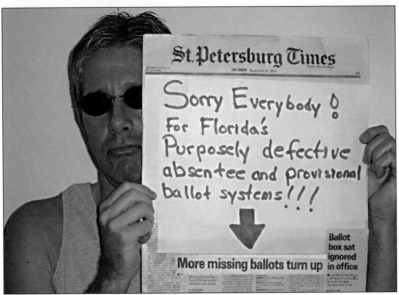

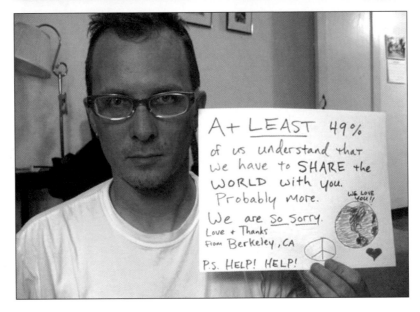

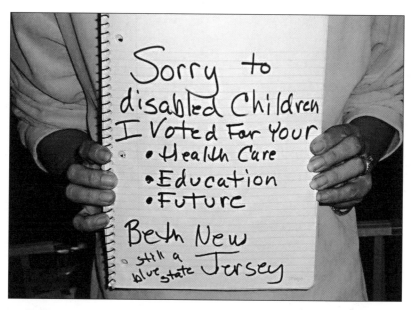

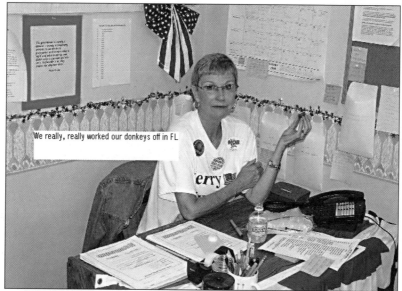

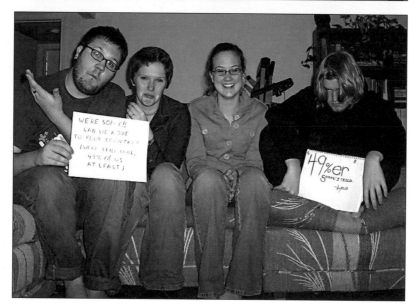

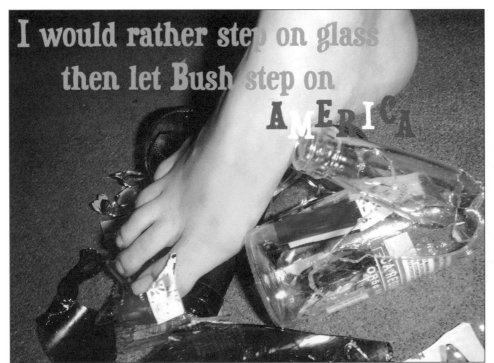

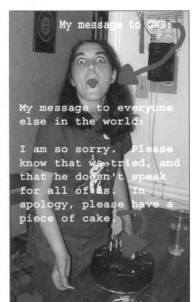

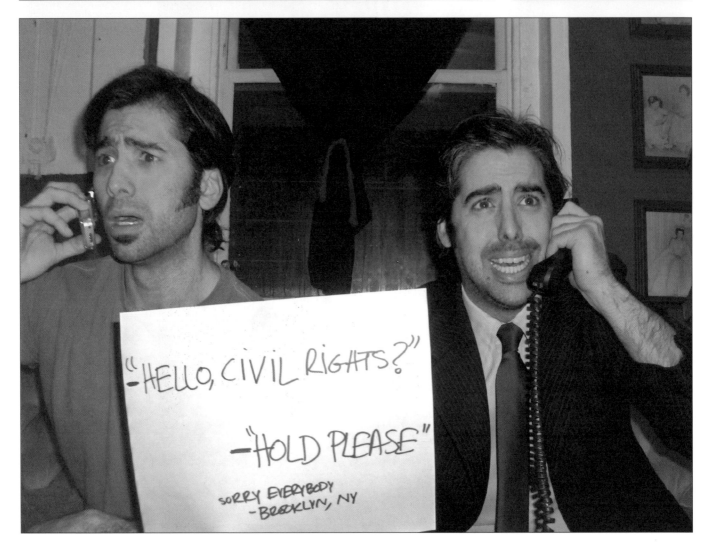

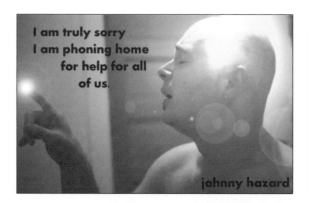

I am truly sorry
I am phoning home
for help for all
of us.

johnny hazard

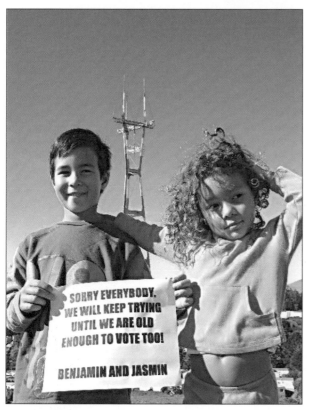

SORRY EVERYBODY.
WE WILL KEEP TRYING
UNTIL WE ARE OLD
ENOUGH TO VOTE TOO!

BENJAMIN AND JASMIN

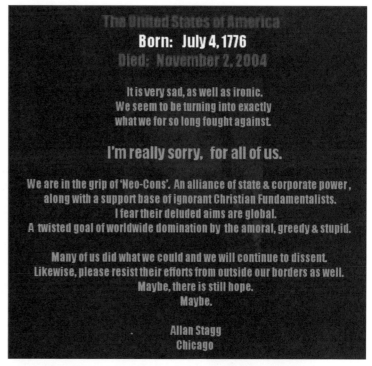

The United States of America

Born: July 4, 1776
Died: November 2, 2004

It is very sad, as well as ironic.
We seem to be turning into exactly
what we for so long fought against.

I'm really sorry, for all of us.

We are in the grip of 'Neo-Cons'. An alliance of state & corporate power,
along with a support base of ignorant Christian Fundamentalists.
I fear their deluded aims are global.
A twisted goal of worldwide domination by the amoral, greedy & stupid.

Many of us did what we could and we will continue to dissent.
Likewise, please resist their efforts from outside our borders as well.
Maybe, there is still hope.
Maybe.

Allan Stagg
Chicago

I AM
SORRY.

WE MUST
ACCEPT FINITE
DISAPPOINTMENT, BUT
WE MUST NEVER
LOOSE INFINITE
HOPE!

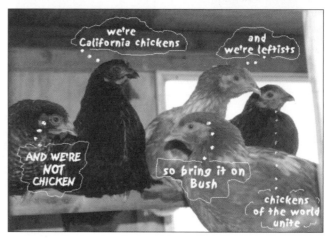

we're
California chickens

and
we're leftists

AND WE'RE
NOT
CHICKEN

so bring it on
Bush

chickens
of the world
unite

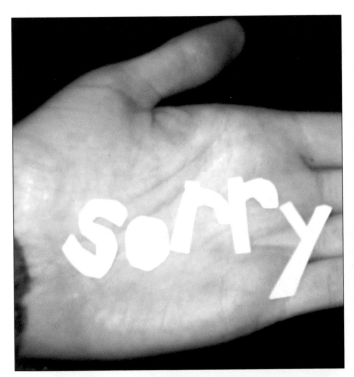

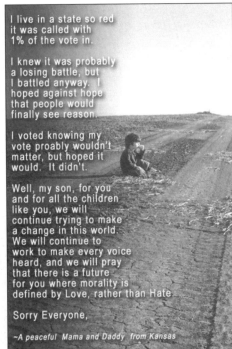

I live in a state so red it was called with 1% of the vote in.

I knew it was probably a losing battle, but I battled anyway. I hoped against hope that people would finally see reason.

I voted knowing my vote proably wouldn't matter, but hoped it would. It didn't.

Well, my son, for you and for all the children like you, we will continue trying to make a change in this world. We will continue to work to make every voice heard, and we will pray that there is a future for you where morality is defined by Love, rather than Hate.

Sorry Everyone,

~A peaceful Mama and Daddy from Kansas

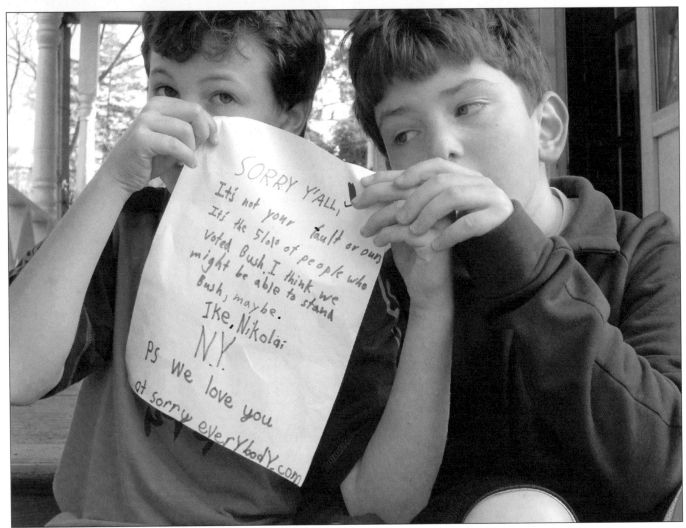

SORRY Y'ALL, It's not your fault or oun It's the 5lol of people who voted Bush. I think we might be able to stand Bush, maybe.
Ike, Nikolai
N.Y.
PS We love you
at sorryeveryBodY.com

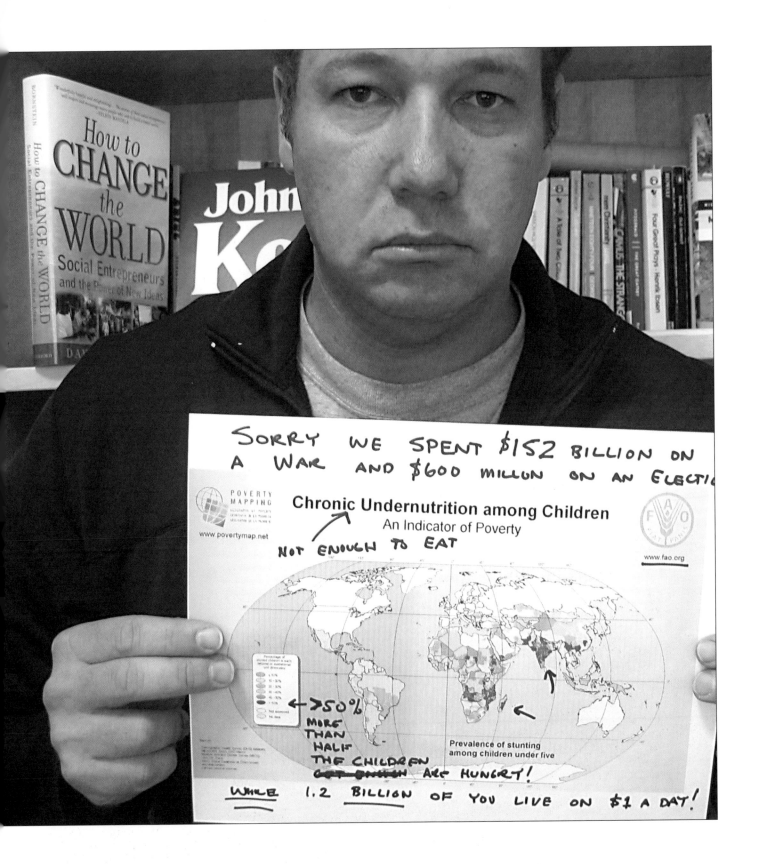

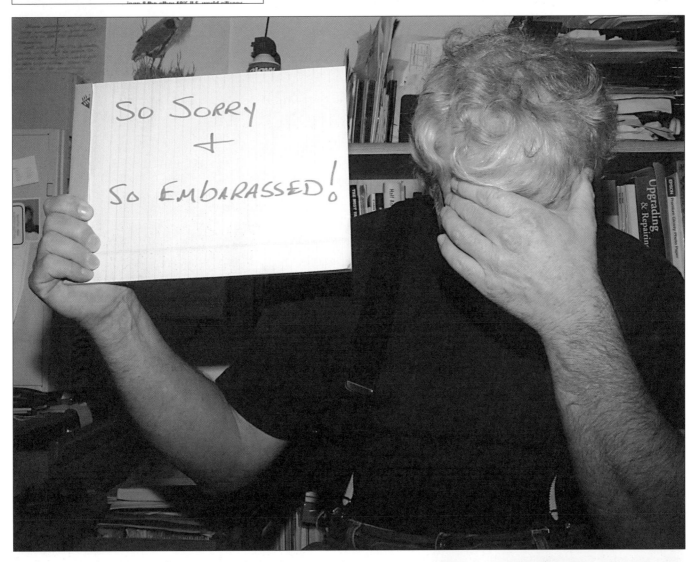

SO SORRY
+
SO EMBARASSED!

"So, so sorry in Missouri"

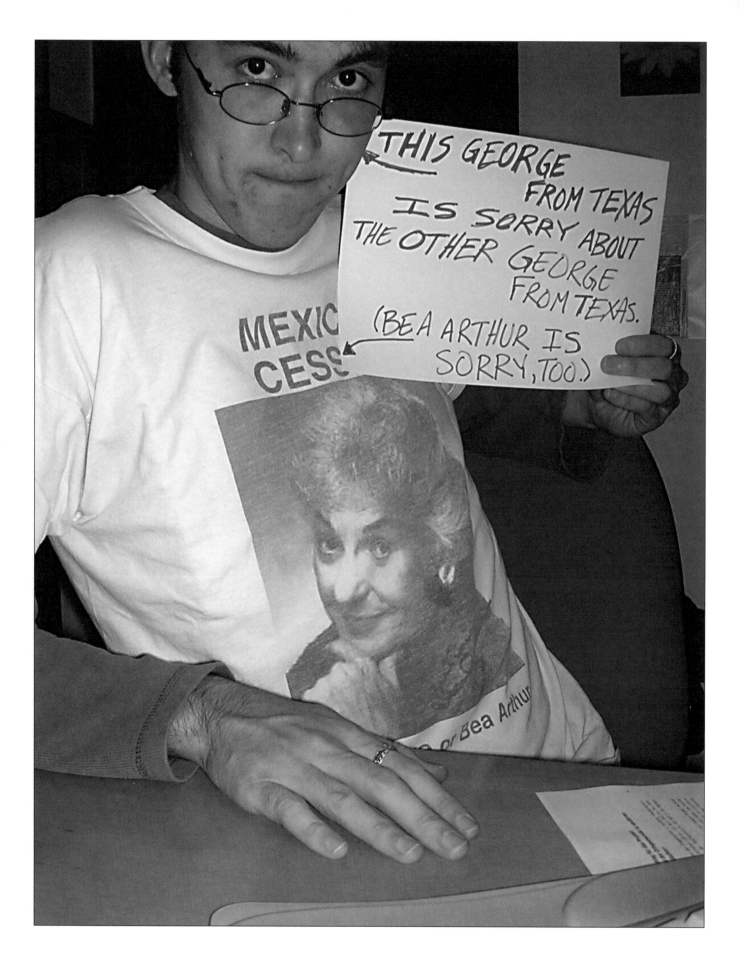

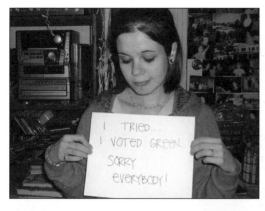

Dear World: We are so sorry that too many of our human citizens voted for that old hairball. My humans worked very hard to send this bunch of crooks packing, but they stole the election anyway. We are all very sad right now,

Cats for Kerry Cats for Kerry
Cats for Kerry Cats for Kerry

but we promise to continue the fight. Love & Peace, Cats for Kerry and their humans in very blue Lane County, Oregon.

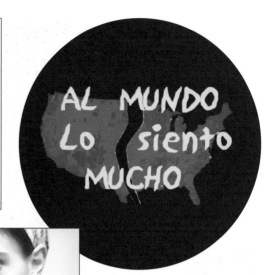

AL MUNDO
Lo siento
MUCHO

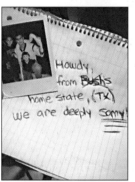

Howdy, from Bush's home state, (TX) we are deeply sorry!

BOTH of my states voted for the scary little monkey-man.

Tennessee & Georgia

I'm not surprised...

but I'm definitely sorry.

I'll keep trying!

TERRIBLY SORRY!
>.<

...SORRY WORLD,

81% OF US IN CHICAGO TRIED VERY HARD.

Hugs and Kisses form Chicago......

P.S OBAMA IN 2008 !

89

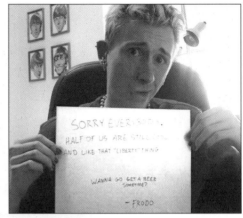

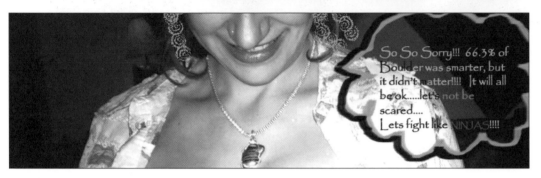

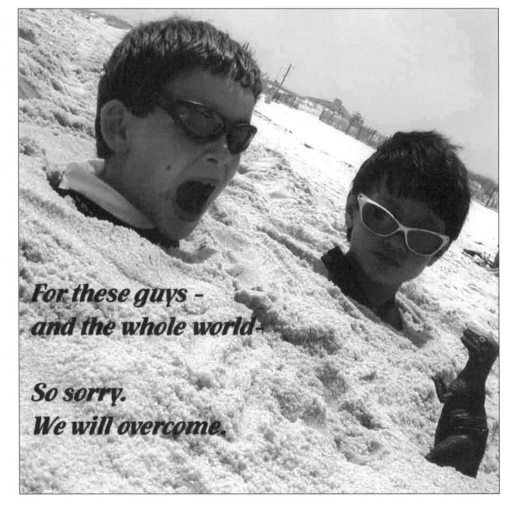

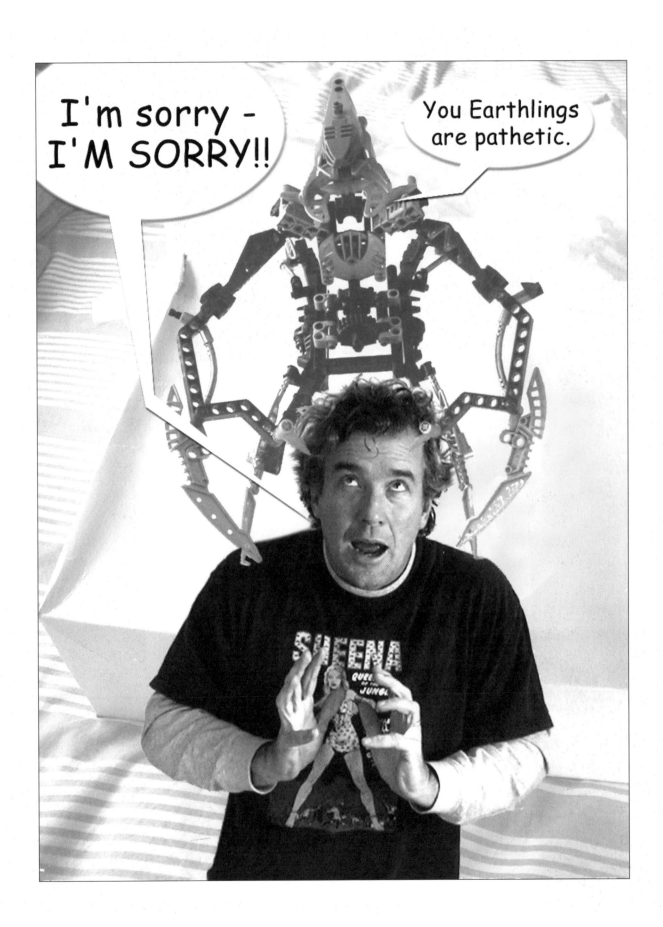

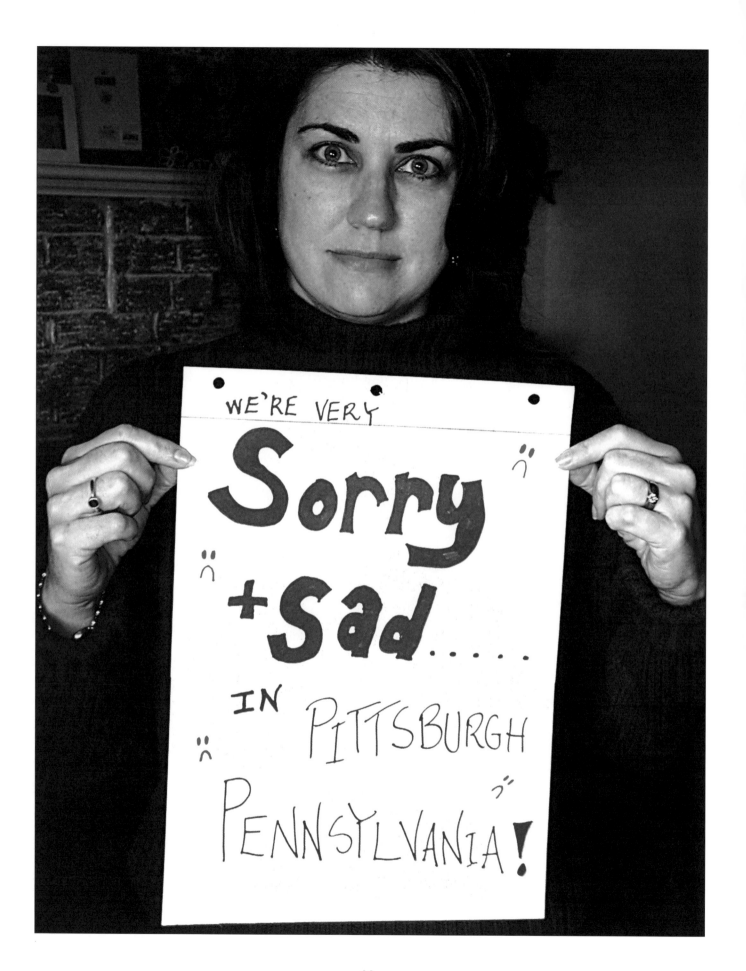

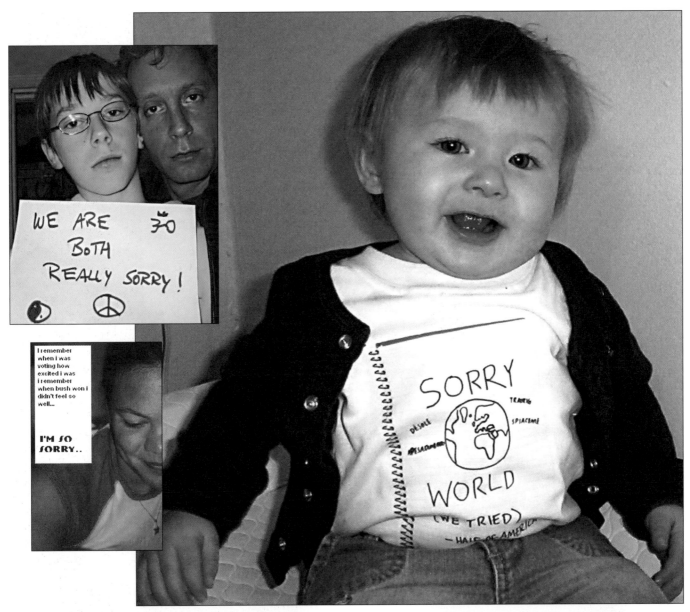

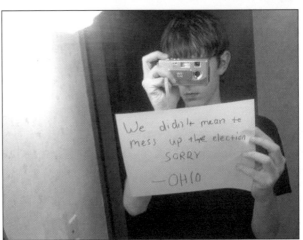

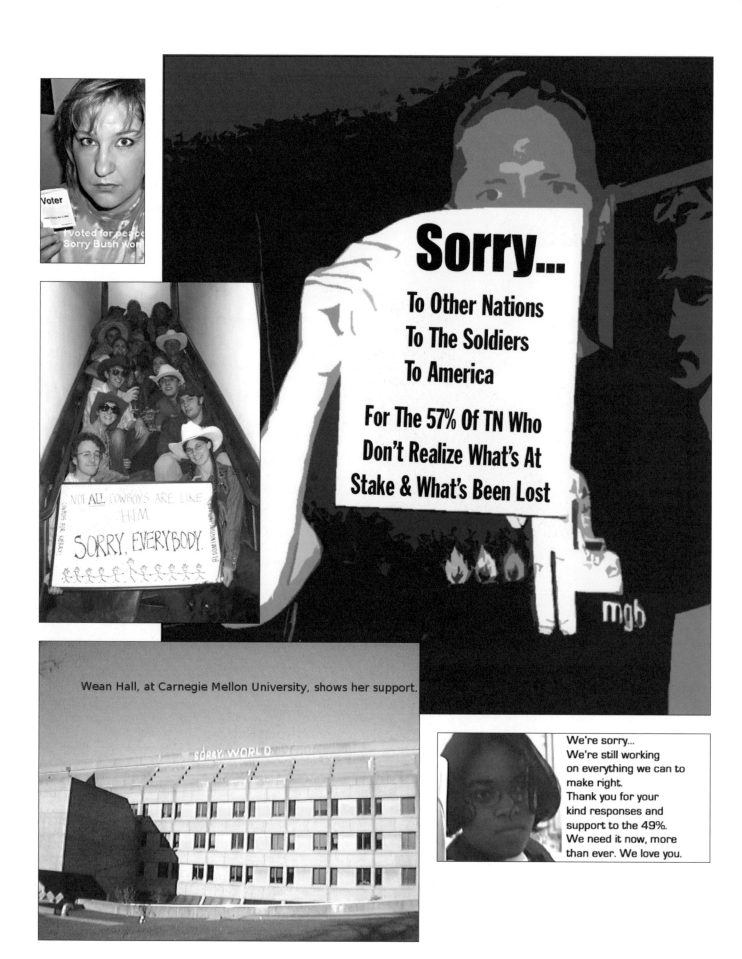

Voter

I voted for peace
Sorry Bush won

NOT ALL COWBOYS ARE LIKE HIM

SORRY, EVERYBODY.

Sorry...

To Other Nations
To The Soldiers
To America

For The 57% Of TN Who Don't Realize What's At Stake & What's Been Lost

mgb

Wean Hall, at Carnegie Mellon University, shows her support.

SORAY WORLD

We're sorry...
We're still working
on everything we can to
make right.
Thank you for your
kind responses and
support to the 49%.
We need it now, more
than ever. We love you.

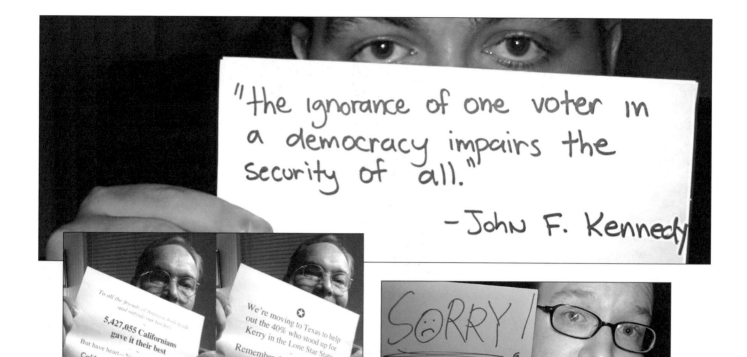

"the ignorance of one voter in a democracy impairs the security of all."

—John F. Kennedy

I am a voter
I am a teacher
I am an optimist
I am an activist
I am a liberal
I am a Democrat
I am a blue-state New Englander
I am a patriot
I am a citizen of the world.
I was born on Lincoln's birthday,
I embrace his hope:
 "to do all which may achieve
 and cherish a just and
 lasting peace
 among ourselves
 and with
 all nations".

I am not sorry,
I am determined.
I will not leave,
I will fight.

"Never doubt that a small, group of thoughtful, committed citizens can change the world. Indeed, it is the only thing that ever has."
—Margaret Mead

THANK YOU WORLD
THANK YOU 49%

YOU HAVE
RESTORED MY HOPE
FOR OUR FUTURE.

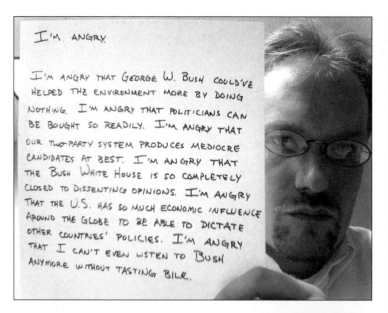

I'M ANGRY

I'M ANGRY THAT GEORGE W. BUSH COULD'VE HELPED THE ENVIRONMENT MORE BY DOING NOTHING. I'M ANGRY THAT POLITICIANS CAN BE BOUGHT SO READILY. I'M ANGRY THAT OUR TWO-PARTY SYSTEM PRODUCES MEDIOCRE CANDIDATES AT BEST. I'M ANGRY THAT THE BUSH WHITE HOUSE IS SO COMPLETELY CLOSED TO DISSENTING OPINIONS. I'M ANGRY THAT THE U.S. HAS SO MUCH ECONOMIC INFLUENCE AROUND THE GLOBE TO BE ABLE TO DICTATE OTHER COUNTRIES' POLICIES. I'M ANGRY THAT I CAN'T EVEN LISTEN TO BUSH ANYMORE WITHOUT TASTING BILE.

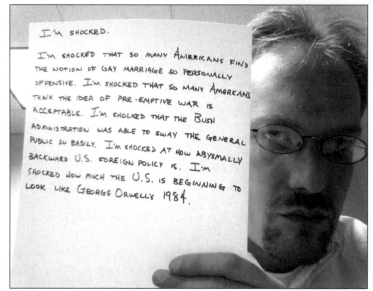

I'M SHOCKED.

I'M SHOCKED THAT SO MANY AMERICANS FIND THE NOTION OF GAY MARRIAGE SO PERSONALLY OFFENSIVE. I'M SHOCKED THAT SO MANY AMERICANS THINK THE IDEA OF PRE-EMPTIVE WAR IS ACCEPTABLE. I'M SHOCKED THAT THE BUSH ADMINISTRATION WAS ABLE TO SWAY THE GENERAL PUBLIC SO EASILY. I'M SHOCKED AT HOW ABYSMALLY BACKWARD U.S. FOREIGN POLICY IS. I'M SHOCKED HOW MUCH THE U.S. IS BEGINNING TO LOOK LIKE GEORGE ORWELL'S 1984.

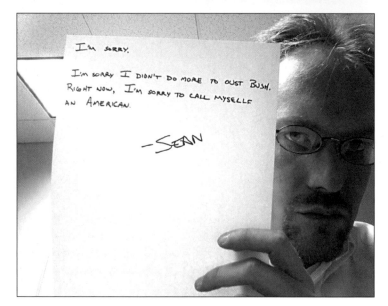

I'M SORRY.

I'M SORRY I DIDN'T DO MORE TO OUST BUSH. RIGHT NOW, I'M SORRY TO CALL MYSELF AN AMERICAN.

—SEAN

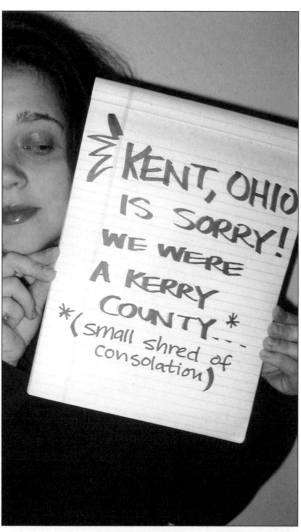

KENT, OHIO IS SORRY! WE WERE A KERRY COUNTY... *(small shred of consolation)

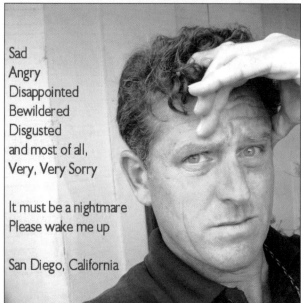

Sad
Angry
Disappointed
Bewildered
Disgusted
and most of all,
Very, Very Sorry

It must be a nightmare
Please wake me up

San Diego, California

On Nov. 2, 2004, not only did John Kerry get voted down but

★ Integrity got voted down

★ Intelligence got voted down

★ Reason got voted down

and George Bush II won on a platform of

★ Discrimination

★ Hate

★ Greed

★ Arrogance

★ Irresponsibility

I'm sorry to the rest of the world and the 49% of America that thinks like me.

I tried my hardest. I am heartbroken, ashamed, and baffled by the outcome of this election.

– Boston, MA

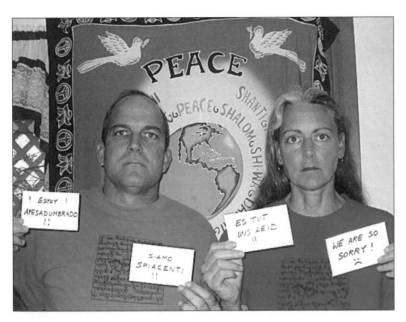

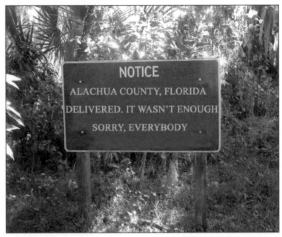

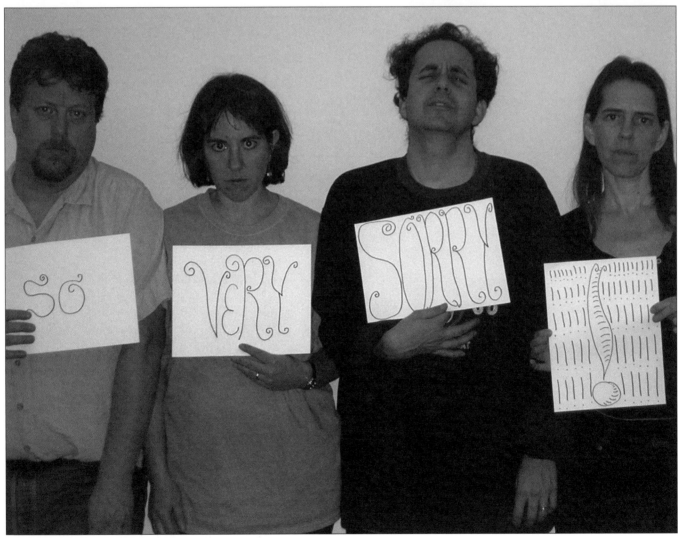

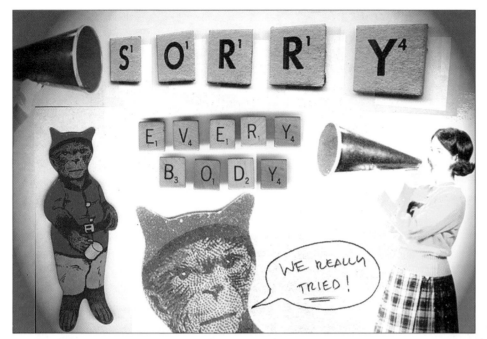

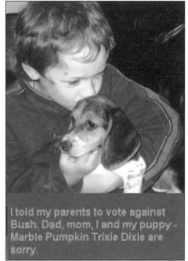

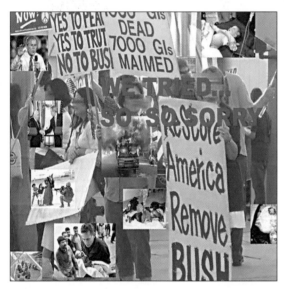

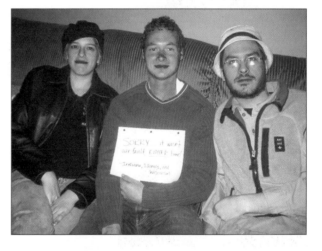

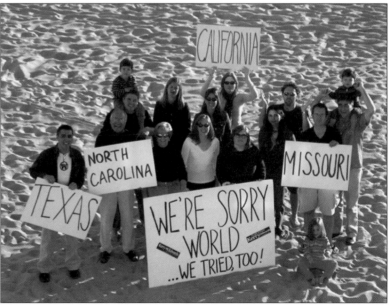

99

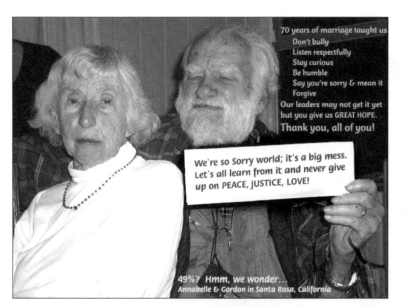

70 years of marriage taught us
Don't bully
Listen respectfully
Stay curious
Be humble
Say you're sorry & mean it
Forgive
Our leaders may not get it yet
but you give us GREAT HOPE.
Thank you, all of you!

We're so Sorry world; it's a big mess. Let's all learn from it and never give up on PEACE, JUSTICE, LOVE!

49%? Hmm, we wonder...
Annabelle & Gordon in Santa Rosa, California

sorry sorry sorry sorry

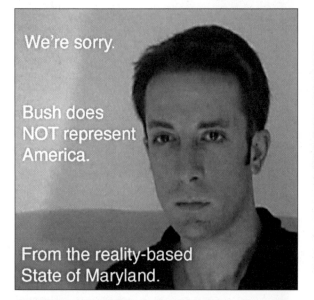

We're sorry.

Bush does NOT represent America.

From the reality-based State of Maryland.

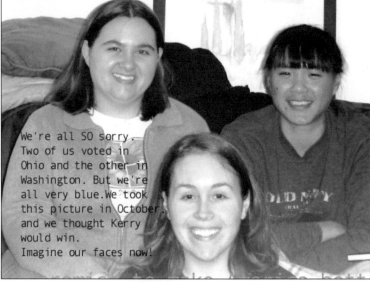

We're all SO sorry. Two of us voted in Ohio and the other in Washington. But we're all very blue. We took this picture in October, and we thought Kerry would win. Imagine our faces now!

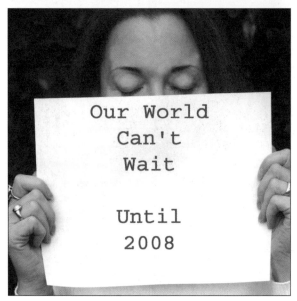

Our World Can't Wait

Until 2008

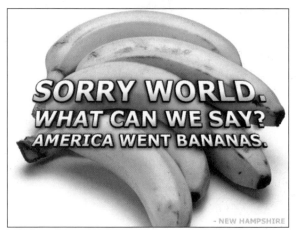

SORRY WORLD. WHAT CAN WE SAY? AMERICA WENT BANANAS.

- NEW HAMPSHIRE

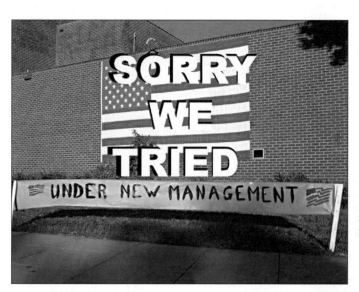

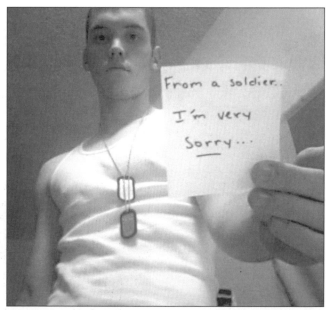

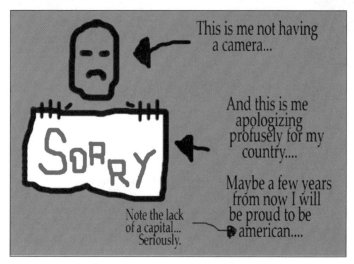

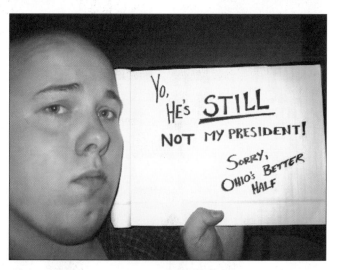

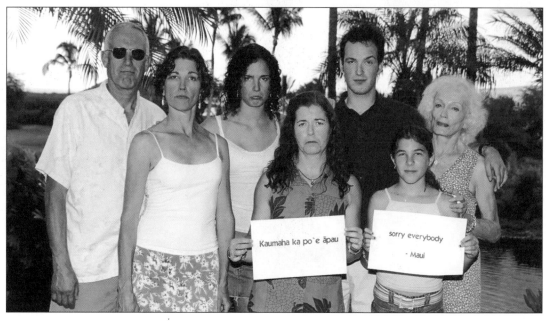

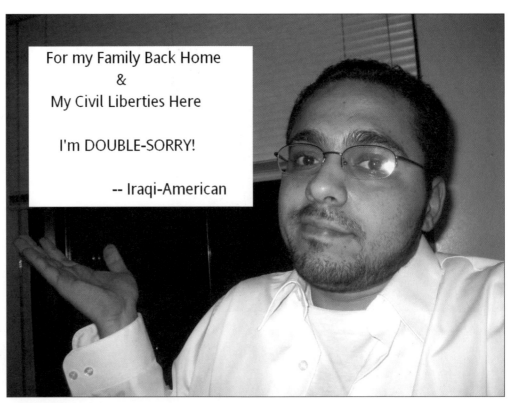

For my Family Back Home
&
My Civil Liberties Here

I'm DOUBLE-SORRY!

-- Iraqi-American

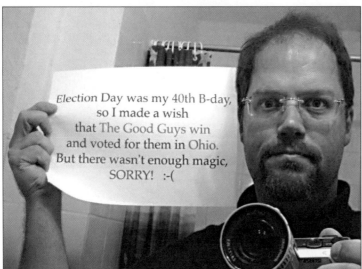

Election Day was my 40th B-day, so I made a wish that The Good Guys win and voted for them in Ohio. But there wasn't enough magic, SORRY! :-(

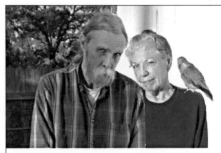

We're Sorry.
Our bird's cousins voted Bush,
But after all, they are a bunch of parrots.

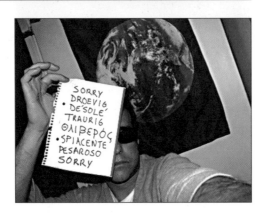

SORRY
DROEVIG
• DE'SOLE'
TRAURIG
ΘΛΙΒΕΡΌΣ
• SPIACENTE
PESAROSO
SORRY

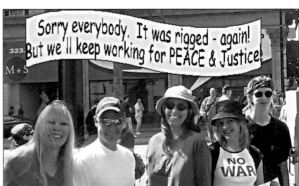

Sorry everybody. It was rigged - again! But we'll keep working for PEACE & Justice!

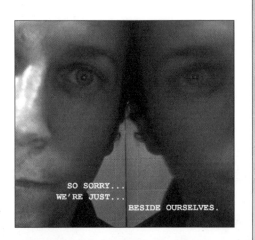

SO SORRY...
WE'RE JUST...
BESIDE OURSELVES.

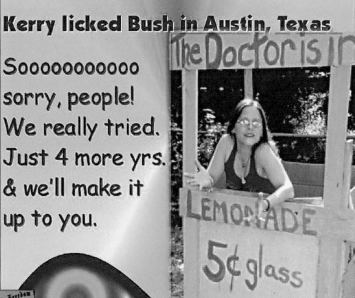

Kerry licked Bush in Austin, Texas

Sooooooooooo
sorry, people!
We really tried.
Just 4 more yrs.
& we'll make it
up to you.

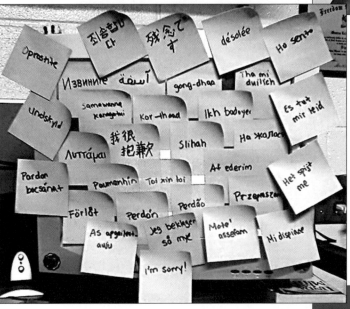

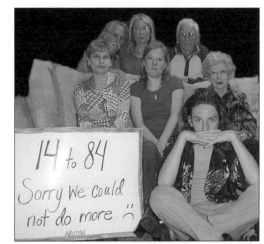

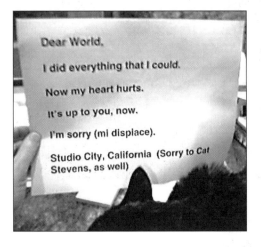

Dear World,

I did everything that I could.

Now my heart hurts.

It's up to you, now.

I'm sorry (mi displace).

Studio City, California (Sorry to Cat
Stevens, as well)

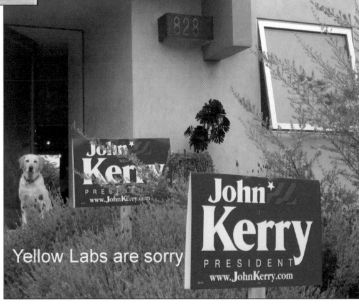

Yellow Labs are sorry

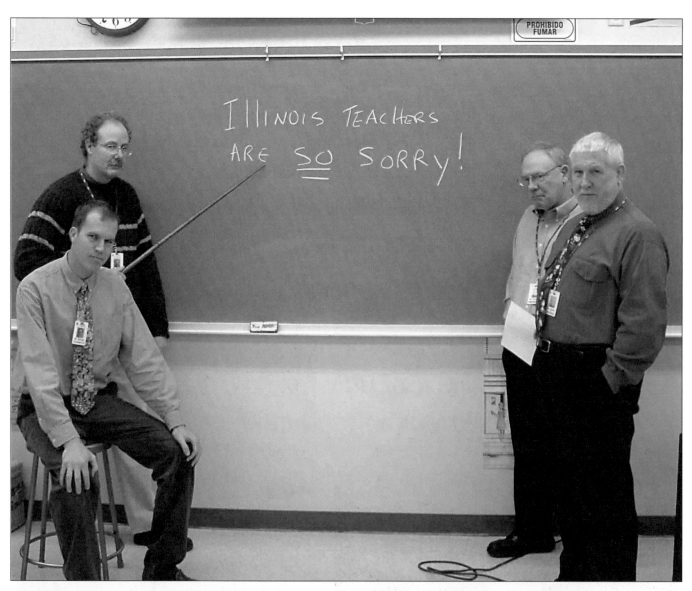

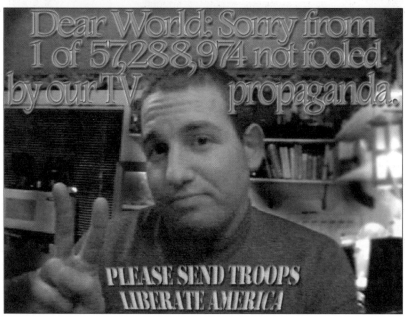

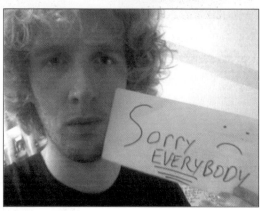

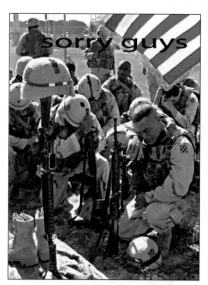

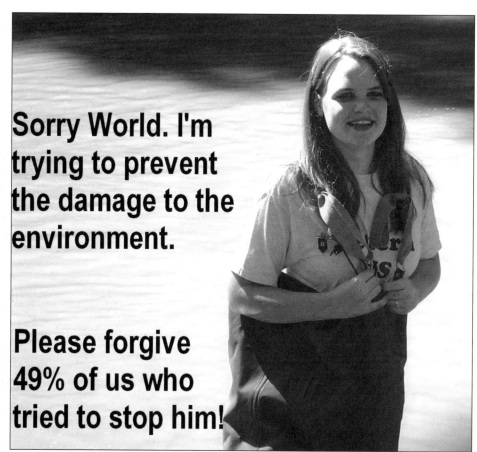

Sorry World. I'm trying to prevent the damage to the environment.

Please forgive 49% of us who tried to stop him!

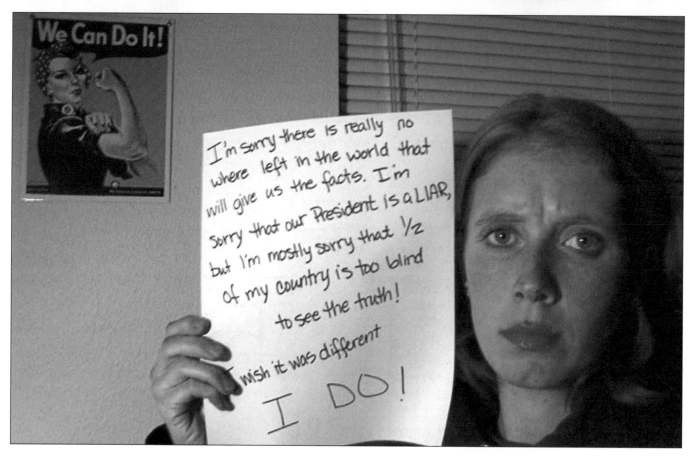

This Sucks.
Sorry.

Al
Seattle

Sorry World,
When you are 16
Theres nothing you can
do but hope that everything
goes ok, apparently 51%
of us didnt want things to be ok.
Sorry again world,
I would have voted for Kerry.

Things aren't looking up...

sorry guys
-from Atlanta

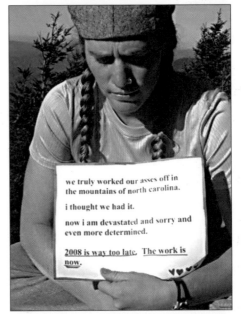

we truly worked our asses off in
the mountains of north carolina.

i thought we had it.

now i am devastated and sorry and
even more determined.

2008 is way too late. The work is
now.

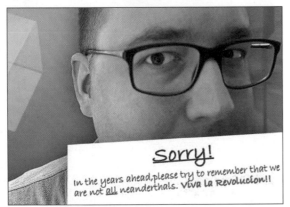

Sorry!

In the years ahead, please try to remember that we
are not all neanderthals. Viva la Revolucion!!

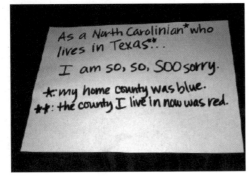

As a North Carolinian* who
lives in Texas**...

I am so, so, soo sorry.

*: my home county was blue.
**: the county I live in now was red.

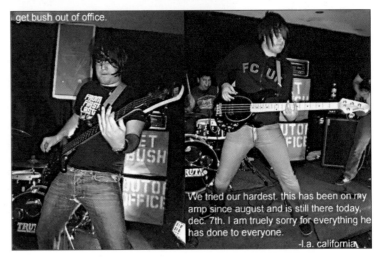

get bush out of office.

We tried our hardest. this has been on my
amp since august and is still there today,
dec. 7th. I am truely sorry for everything he
has done to everyone.

-l.a. california

106

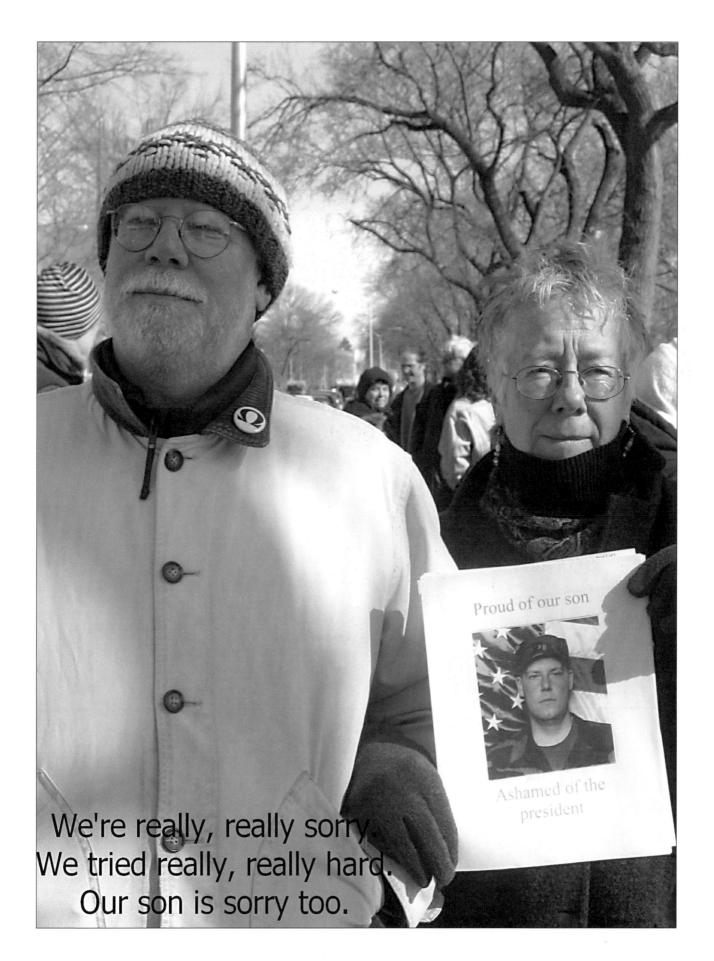

We're really, really sorry.
We tried really, really hard.
Our son is sorry too.

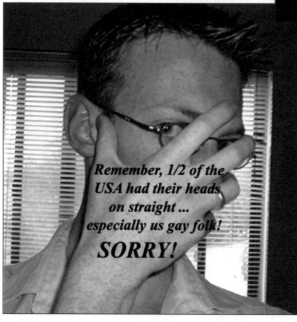

Dear World
I am Religious
and voted for
Kerry
I am sorry.
We tried.

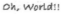

Oh, World!!
I'm at a loss for words. I'm just a **blue** girl, living in a red state, I feel very helpless!

I'm really sorry about all the hypocrisy that has been emanating from this country.
I'm really sorry 51% of the people in this country have forgotten what this country was originally founded for.
They have forgotten the Constitution, seperation of church and state, freedom of any religion (not just Christianity) tolerance, and independence.

I'm now looking to move, for serious! Anyone in New Zealand looking for a geologist?!?!? Please! Pretty Please!!

Love, Poteet

Remember, 1/2 of the USA had their heads on straight ... especially us gay folk!
SORRY!

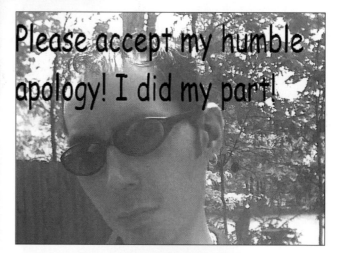

Please accept my humble apology! I did my part!

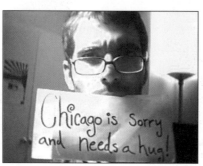

Chicago is Sorry and needs a hug!

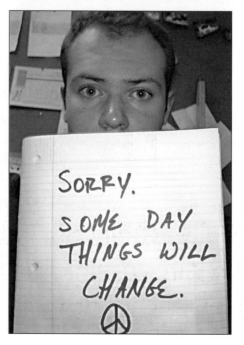

SORRY.
SOME DAY
THINGS WILL
CHANGE.

Sorry World, I can't beleive that 51% voted for Bush. I feel like
we've let the world down. I feel like I've been stripped of
everything that is worthy of enlightenment for the planet.
I promise to run free of oppression and do what I can to enhance
the planet.
I send love and I pray that the 51% will wake up in 4 years.

Kent, Washington

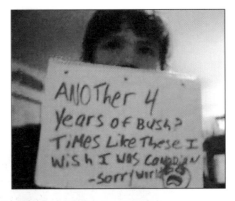

apologies from California

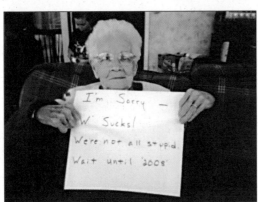

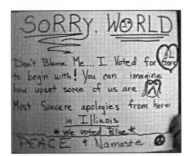

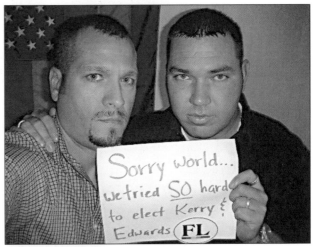

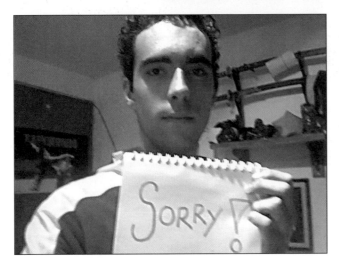

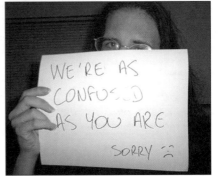

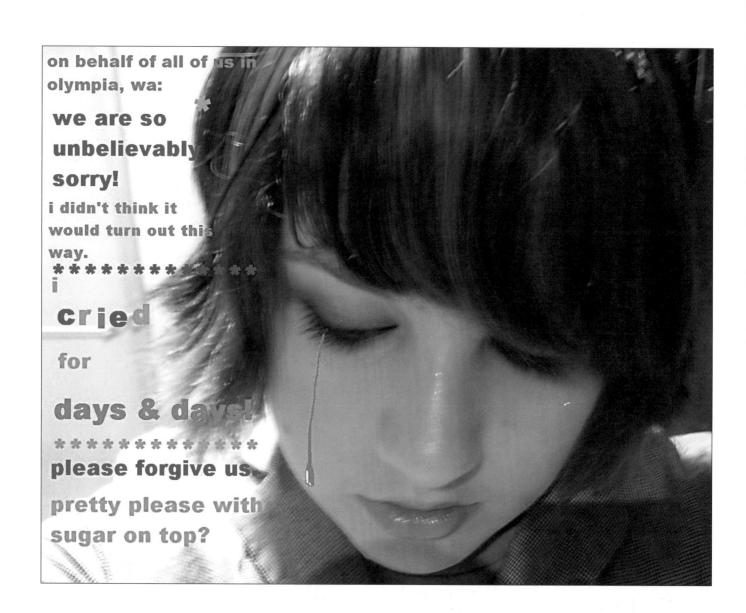

on behalf of all of us in olympia, wa:

we are so unbelievably sorry!

i didn't think it would turn out this way.

i cried for days & days!

please forgive us. pretty please with sugar on top?

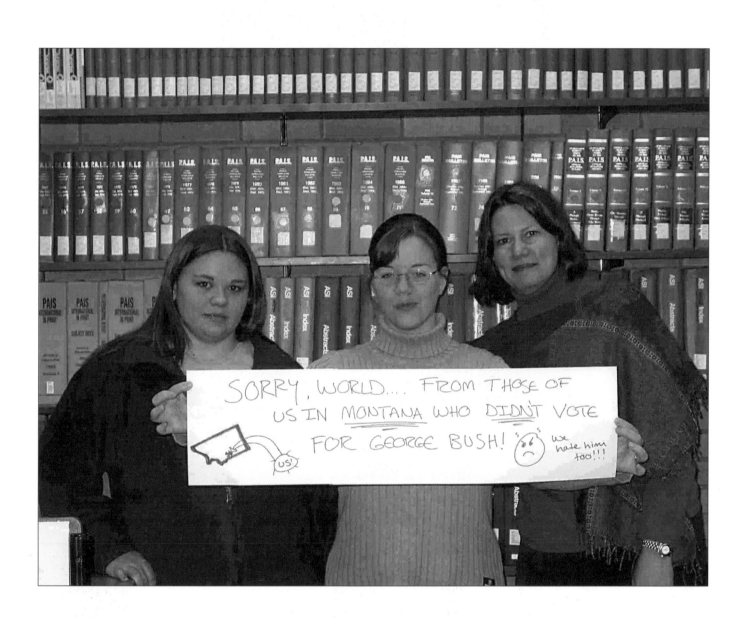

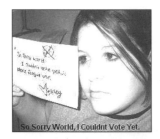

So Sorry World, I Couldnt Vote Yet.

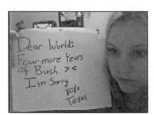

Dear World: Four more Years of Bush. >< I'm Sorry yoyo Texas

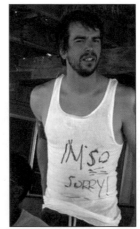

I'M SO SORRY!

I'm sorry Bless Our Planet

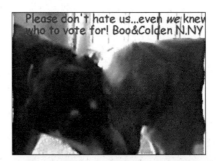

Please don't hate us...even *we* knew who to vote for! Boo&Colden N.NY

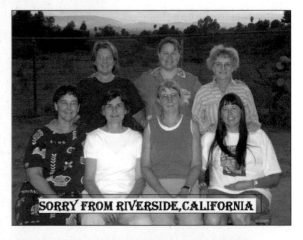

SORRY FROM RIVERSIDE, CALIFORNIA

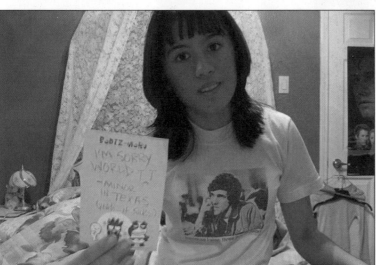

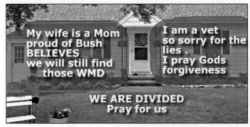

My wife is a Mom proud of Bush BELIEVES we will still find those WMD

I am a vet so sorry for the lies . I pray Gods forgiveness

WE ARE DIVIDED Pray for us

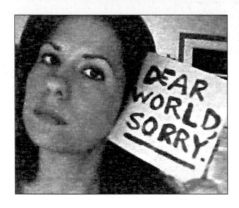

DEAR WORLD SORRY.

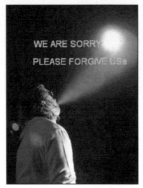

WE ARE SORRY PLEASE FORGIVE US

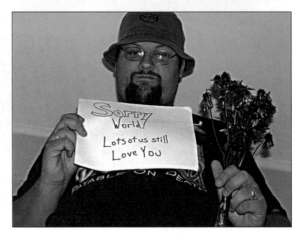

Sorry World! Lots of us still Love You

Dear World,

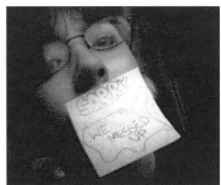

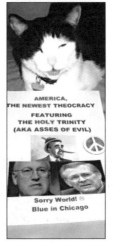

AMERICA,
THE NEWEST THEOCRACY

FEATURING
THE HOLY TRINITY
(AKA ASSES OF EVIL)

Sorry World! ☺
Blue in Chicago

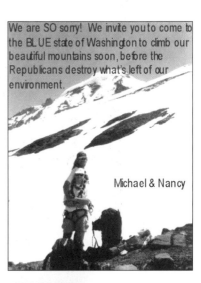

We are SO sorry! We invite you to come to
the BLUE state of Washington to climb our
beautiful mountains soon, before the
Republicans destroy what's left of our
environment.

Michael & Nancy

We're sorry.
We'll work to keep the
damage to a minimum

Doug and Collette,
in California.

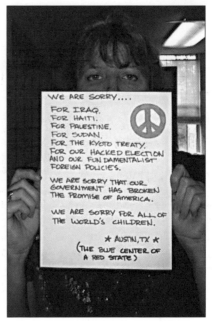

WE ARE SORRY....

FOR IRAQ,
FOR HAITI.
FOR PALESTINE.
FOR SUDAN.
FOR THE KYOTO TREATY,
FOR OUR HACKED ELECTION
AND OUR FUNDAMENTALIST
FOREIGN POLICIES.

WE ARE SORRY THAT OUR
GOVERNMENT HAS BROKEN
THE PROMISE OF AMERICA.

WE ARE SORRY FOR ALL OF
THE WORLD'S CHILDREN.

★ AUSTIN, TX ★
(THE BLUE CENTER OF
A RED STATE)

113

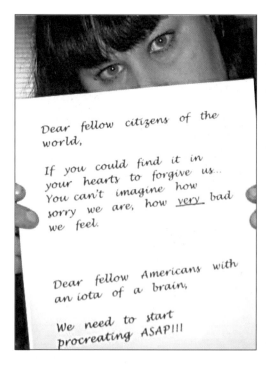

Dear fellow citizens of the world,

If you could find it in your hearts to forgive us... You can't imagine how sorry we are, how _very_ bad we feel.

Dear fellow Americans with an iota of a brain,

We need to start procreating ASAP!!!

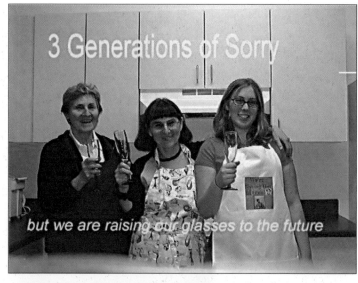

3 Generations of Sorry

but we are raising our glasses to the future

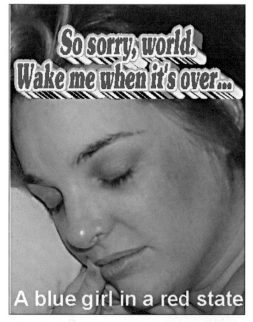

So sorry, world. Wake me when it's over...

A blue girl in a red state

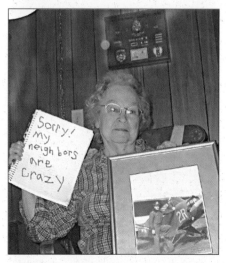

Sorry! My neighbors are crazy

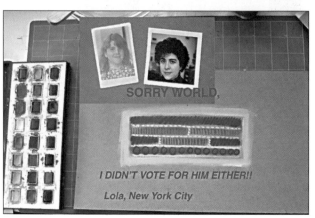

SORRY WORLD,

I DIDN'T VOTE FOR HIM EITHER!!

Lola, New York City

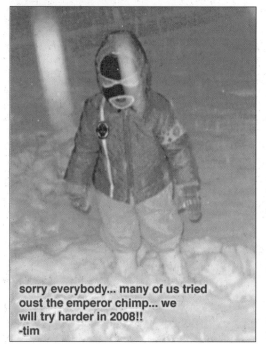

sorry everybody... many of us tried oust the emperor chimp... we will try harder in 2008!!
-tim

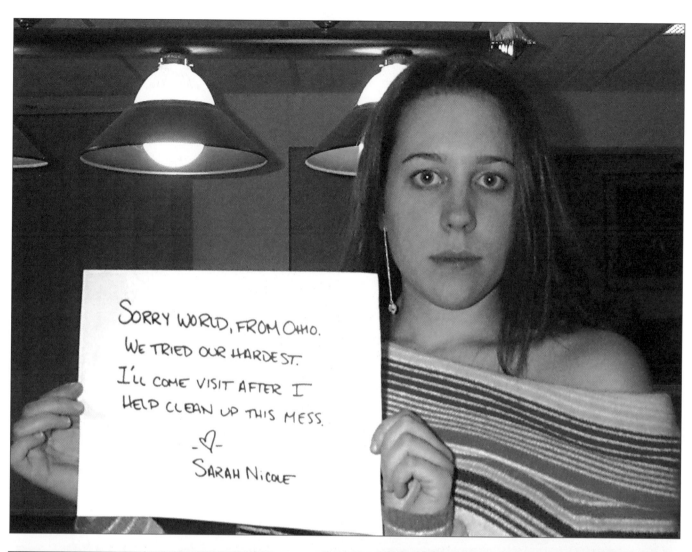

SORRY WORLD, FROM OHIO.
WE TRIED OUR HARDEST.
I'LL COME VISIT AFTER I
HELP CLEAN UP THIS MESS.
-♡-
SARAH NICOLE

Our persons are very, very sorry, and so are we! Hedgehogs can't vote!

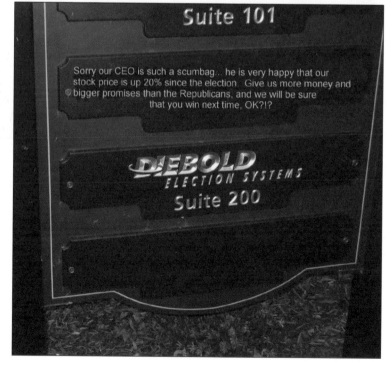

Suite 101

Sorry our CEO is such a scumbag... he is very happy that our stock price is up 20% since the election. Give us more money and bigger promises than the Republicans, and we will be sure that you win next time, OK?!?

DIEBOLD
ELECTION SYSTEMS
Suite 200

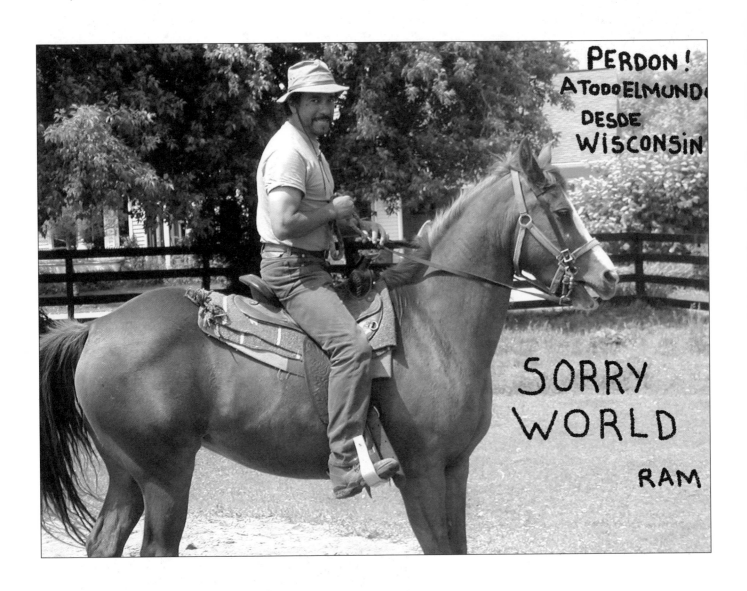

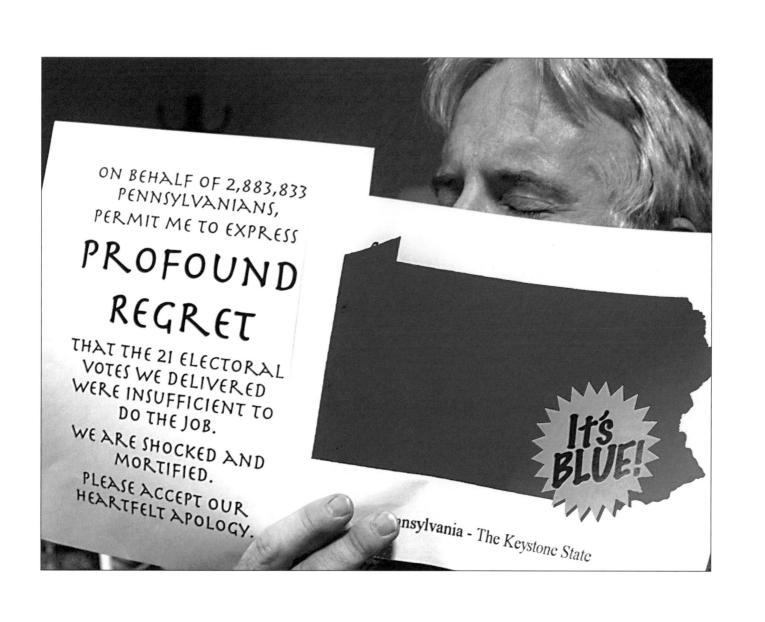

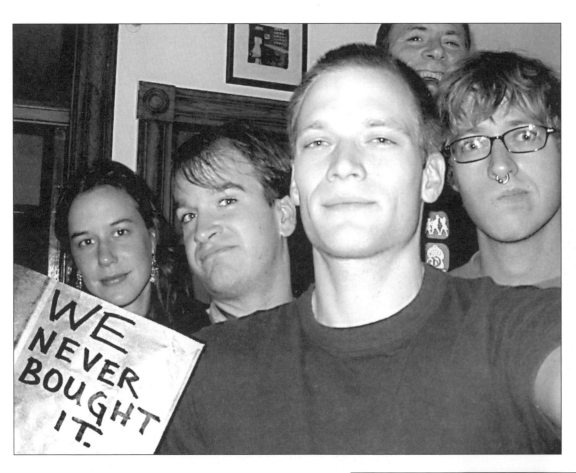

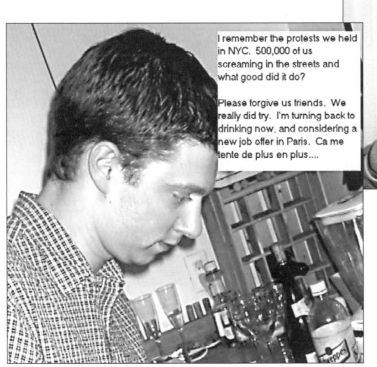

I remember the protests we held in NYC. 500,000 of us screaming in the streets and what good did it do?

Please forgive us friends. We really did try. I'm turning back to drinking now, and considering a new job offer in Paris. Ca me tente de plus en plus....

FROM A BLUE GIRL IN A RED STATE— I'M SORRY! I DON'T UNDERSTAND IT EITHER! CANADA LOOKS PRETTY GOOD, EH?

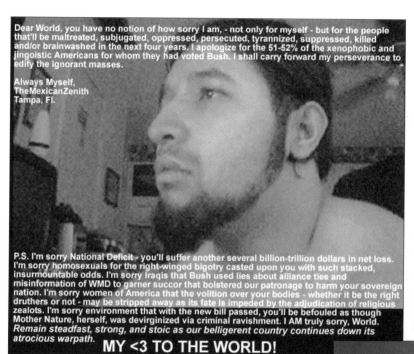

Dear World, you have no notion of how sorry I am, - not only for myself - but for the people that'll be maltreated, subjugated, oppressed, persecuted, tyrannized, suppressed, killed and/or brainwashed in the next four years. I apologize for the 51-52% of the xenophobic and jingoistic Americans for whom they had voted Bush. I shall carry forward my perseverance to edify the ignorant masses.

Always Myself,
TheMexicanZenith
Tampa, Fl.

P.S. I'm sorry National Deficit - you'll suffer another several billion-trillion dollars in net loss. I'm sorry homosexuals for the right-winged bigotry casted upon you with such stacked, insurmountable odds. I'm sorry Iraqis that Bush used lies about alliance ties and misinformation of WMD to garner succor that bolstered our patronage to harm your sovereign nation. I'm sorry women of America that the volition over your bodies - whether it be the right druthers or not - may be stripped away as its fate is impeded by the adjudication of religious zealots. I'm sorry environment that with the new bill passed, you'll be befouled as though Mother Nature, herself, was devirginized via criminal ravishment. I AM truly sorry, World. Remain steadfast, strong, and stoic as our belligerent country continues down its atrocious warpath.

MY <3 TO THE WORLD!

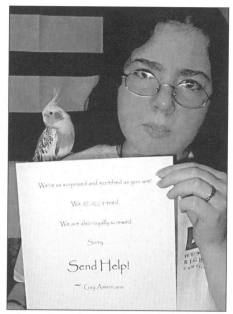

We're as surprised and mortified as you are!

We REALLY tried.

We are also royally screwed.

Sorry.

Send Help!

~ Gay Americans

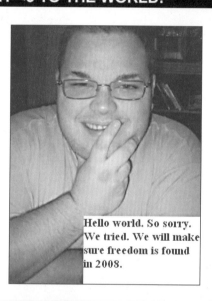

Hello world. So sorry. We tried. We will make sure freedom is found in 2008.

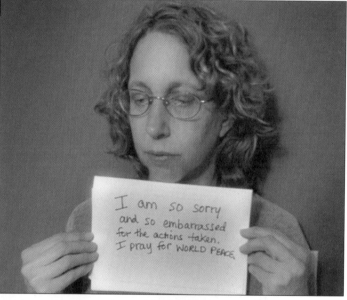

I am so sorry and so embarrassed for the actions taken. I pray for WORLD PEACE.

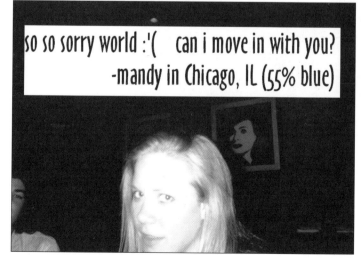

so so sorry world :'(can i move in with you?
-mandy in Chicago, IL (55% blue)

SORRY from Ohio

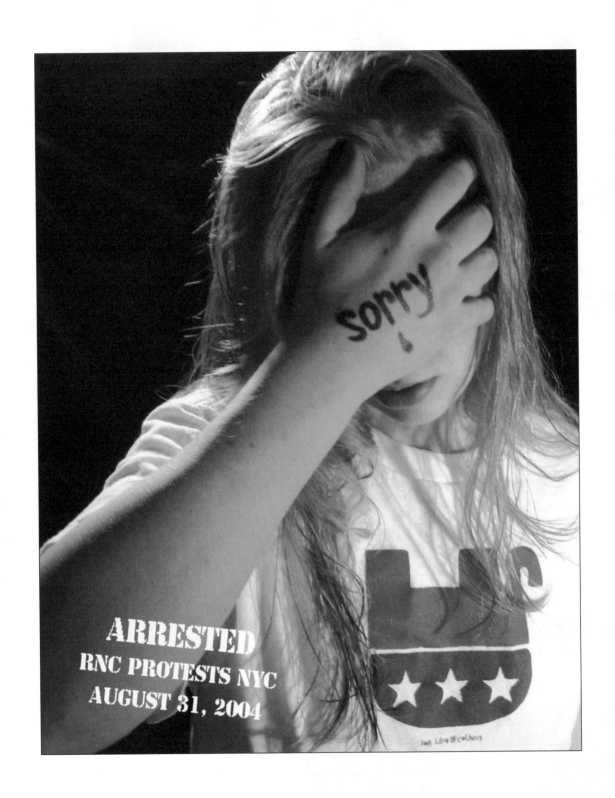

ARRESTED
RNC PROTESTS NYC
AUGUST 31, 2004

120

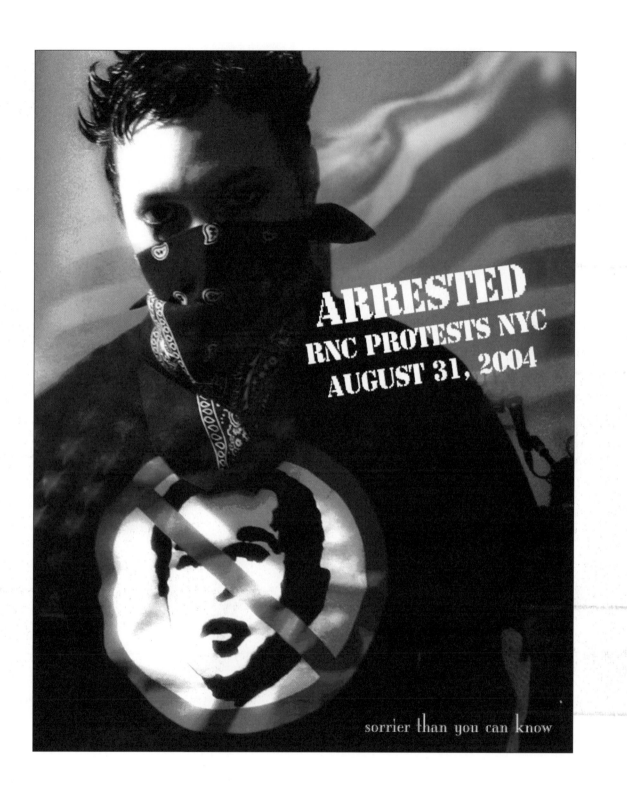

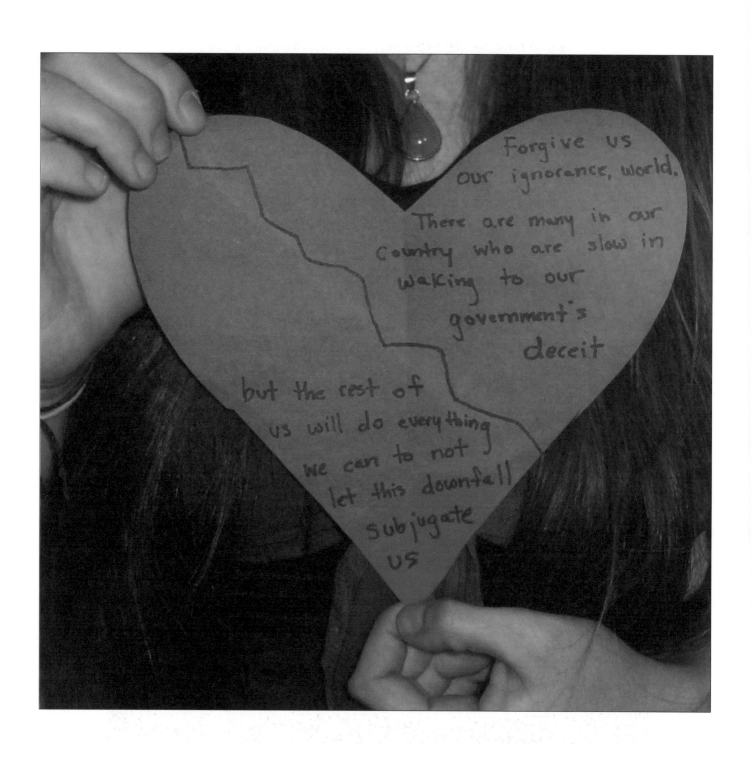

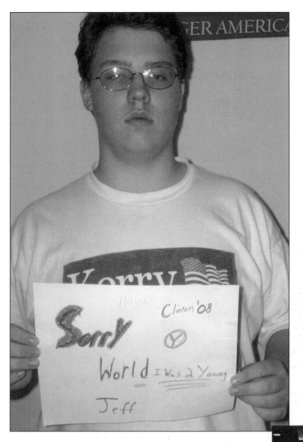

Sorry World
Hillary Clinton '08
I Was 2 Young
Jeff

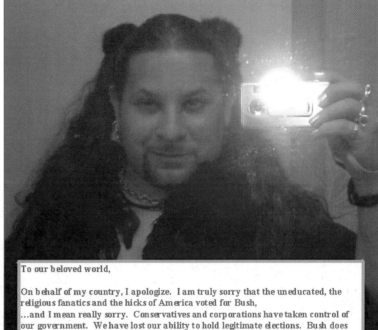

To our beloved world,

On behalf of my country, I apologize. I am truly sorry that the uneducated, the religious fanatics and the hicks of America voted for Bush, ...and I mean really sorry. Conservatives and corporations have taken control of our government. We have lost our ability to hold legitimate elections. Bush does not represent the majority of Americans, I hope the world can consider that until we can get rid of him. We know how dangerous he is, and we are just as angry as you.

 ---Alexi

Sorry world,

 I'm from New York, so my state was already won. Sorry I don't live in Ohio where I could really have helped.

 We have more reason to be afraid than you do.

 I think...

SORRY! OHIO MISUNDERESTIMATED "THEM AGAIN? PLEASE SEND HELP

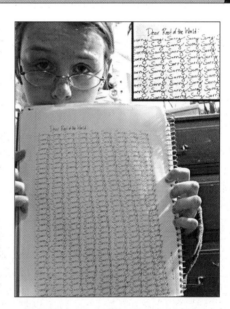

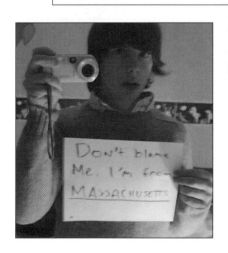

Don't blame Me. I'm from MASSACHUSETTS

W Still equals Wrong

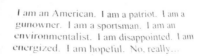

I am an American. I am a patriot. I am a gunowner. I am a sportsman. I am an environmentalist. I am disappointed. I am energized. I am hopeful. No, really...

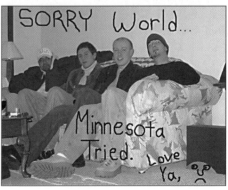

SORRY World... Minnesota Tried. Love Ya,

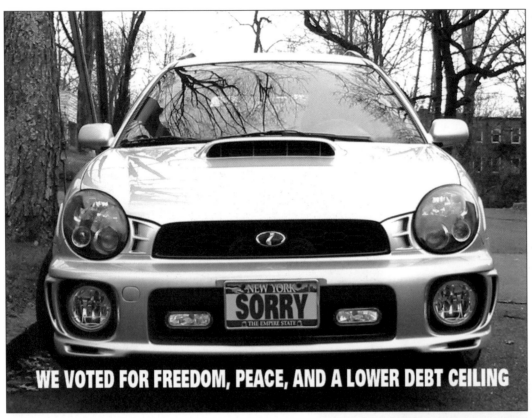

WE VOTED FOR FREEDOM, PEACE, AND A LOWER DEBT CEILING

From my Missouri family to the world: I'm Sorry.

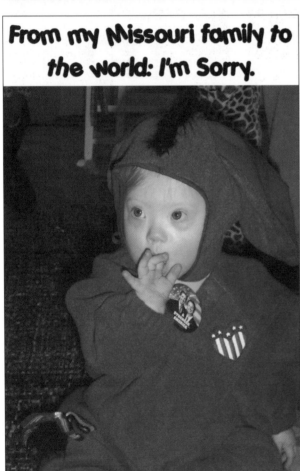

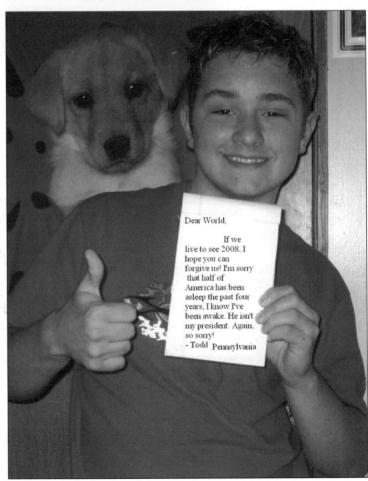

Dear World,

If we live to see 2008, I hope you can forgive us! I'm sorry that half of America has been asleep the past four years, I know I've been awake. He isn't my president. Again, so sorry!

- Todd Pennsylvania

Dear America, I cannot possibly express my sorrow. I can only apologize for the 55% of citizens from TN who are too dumb to think for themselves instead of voting the way their daddies tell them to.

45% of Tennessee is REALLY REALLY sorry. please don't hate us and call us inbred. kthx. <3

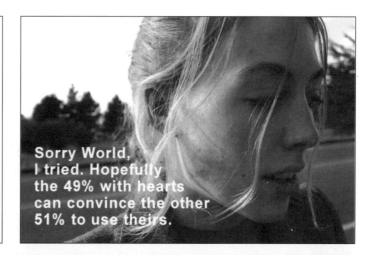

Sorry World, I tried. Hopefully the 49% with hearts can convince the other 51% to use theirs.

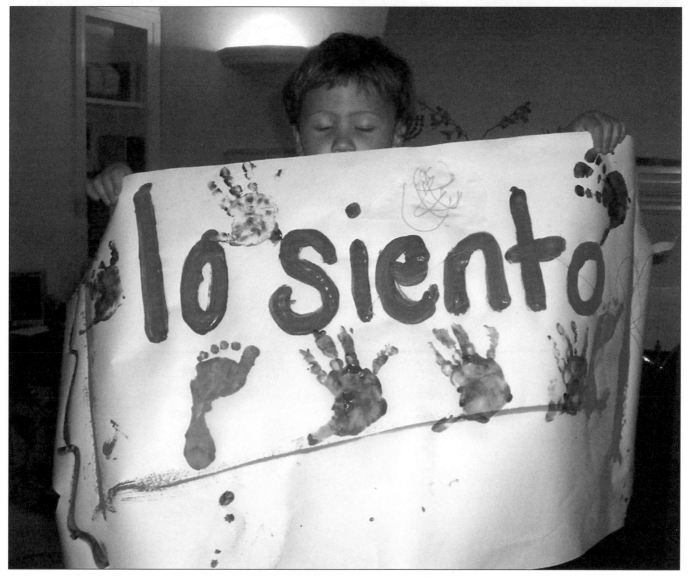

lo siento

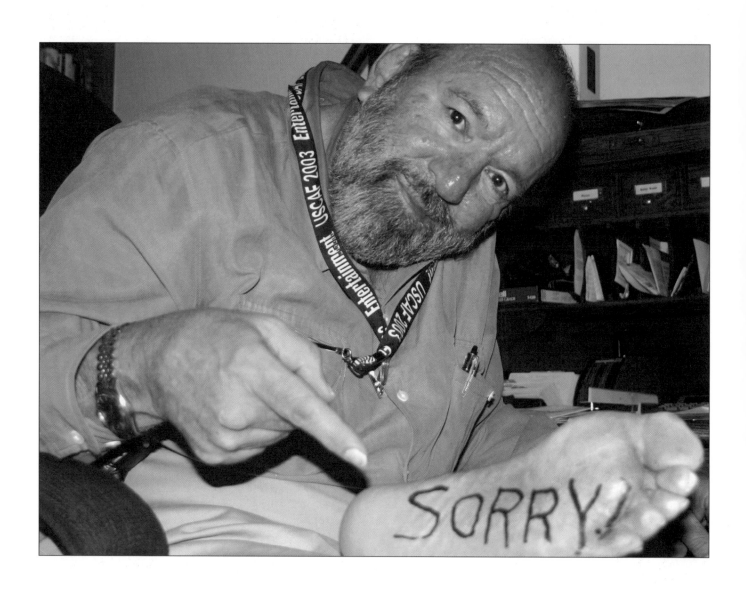

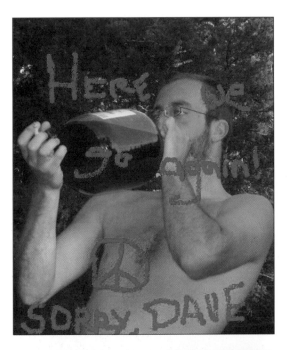

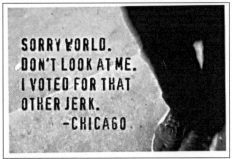

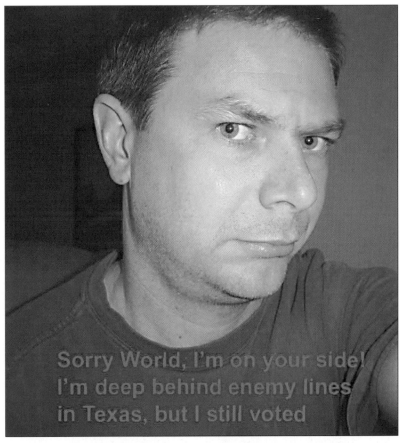

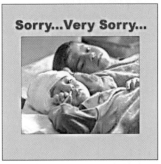

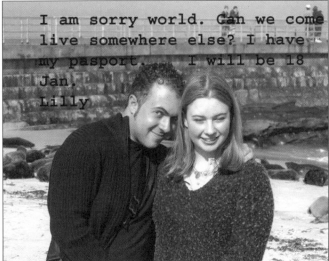

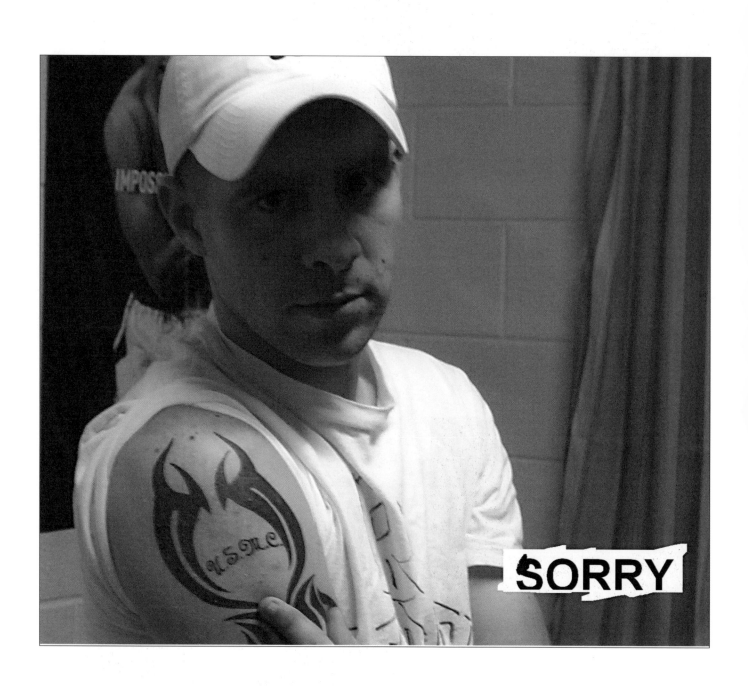

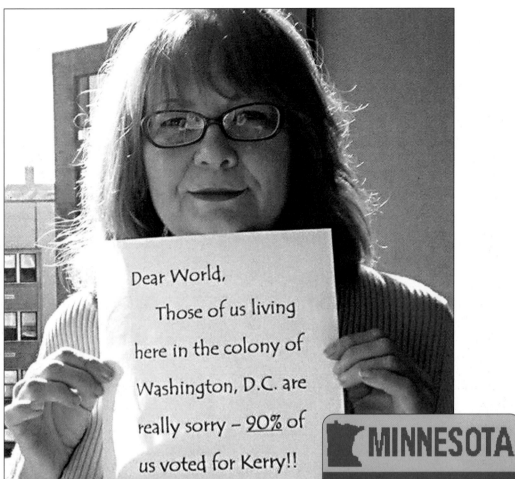

Dear World,

Those of us living here in the colony of Washington, D.C. are really sorry – 90% of us voted for Kerry!!

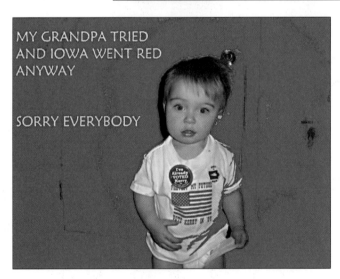

MY GRANDPA TRIED AND IOWA WENT RED ANYWAY

SORRY EVERYBODY

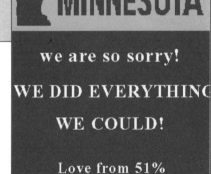

MINNESOTA

we are so sorry!

WE DID EVERYTHING WE COULD!

Love from 51%

On behalf of this entire state, I would like to apologize for our ignorance, foolishness, and outright stupidity. Let's just hope we aren't entirely destroyed in the next 4 years. Here's to hoping this state looks like this in 2008!

-Ohioan still in disbelief

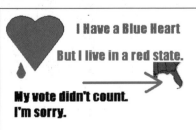

I Have a Blue Heart

But I live in a red state.

My vote didn't count. I'm sorry.

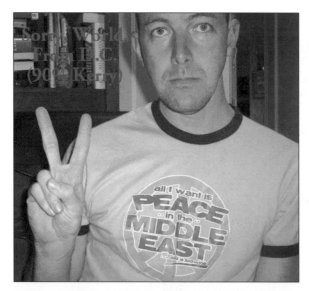

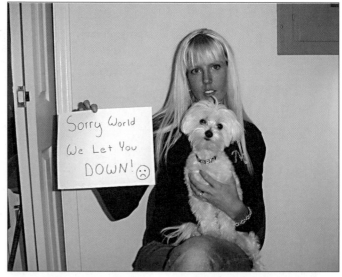

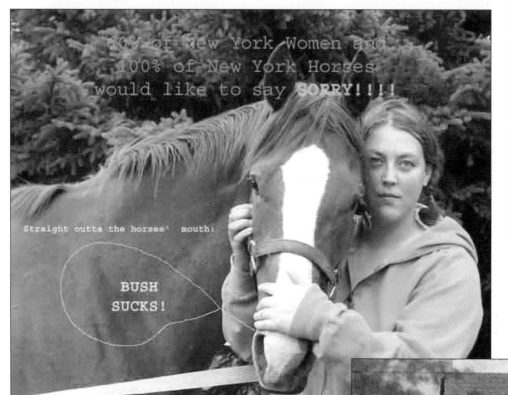

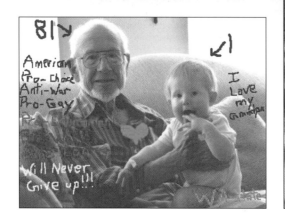

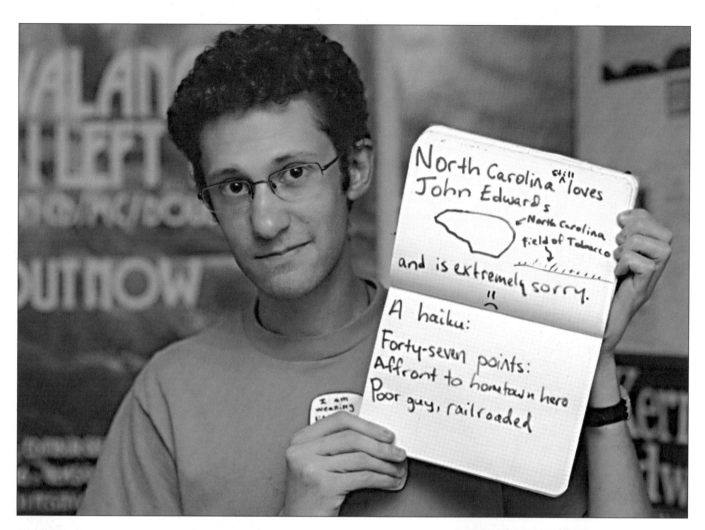

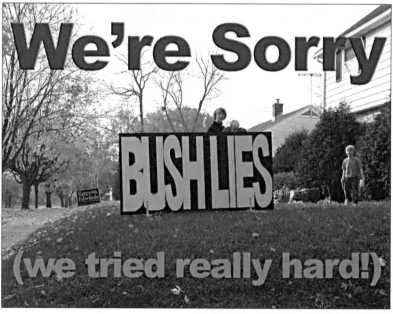

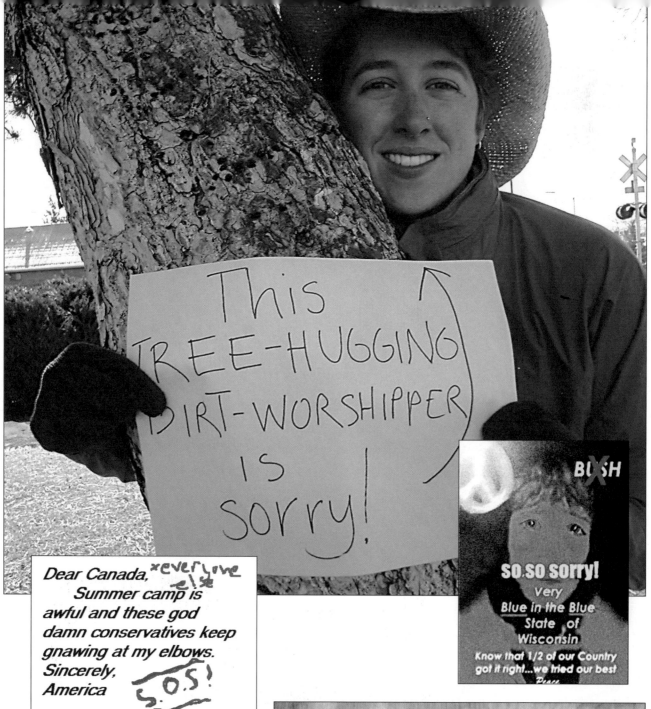

This TREE-HUGGING DIRT-WORSHIPPER IS SORRY!

Dear Canada, *never love else*
 Summer camp is awful and these god damn conservatives keep gnawing at my elbows.
Sincerely,
America S.O.S!

P.S. Send a flyswatter ... please... ~Ann Coulter~

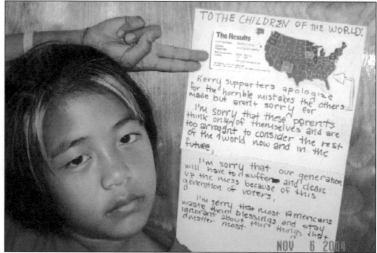

BUSH
SO.SO SORRY!
Very
Blue in the Blue
State of
Wisconsin
Know that 1/2 of our Country got it right...we tried our best
Peace

SORRY EVERYONE!
OUR PARENTS VOTED KERRY IN
DELAWARE
(true blue)

TO THE CHILDREN OF THE WORLD!

The Results

Kerry supporters apologize for the horrible mistakes the others made but aren't sorry for

I'M sorry that these parents think only of themselves and are too arrogant to consider the rest of the world now and in the future,

I'm sorry that our generation will have to suffer and clean up the mess because of this generation of voters,

I'm sorry that most Americans waste their blessings and stay ignorant about their things that matter most

NOV 6 2004

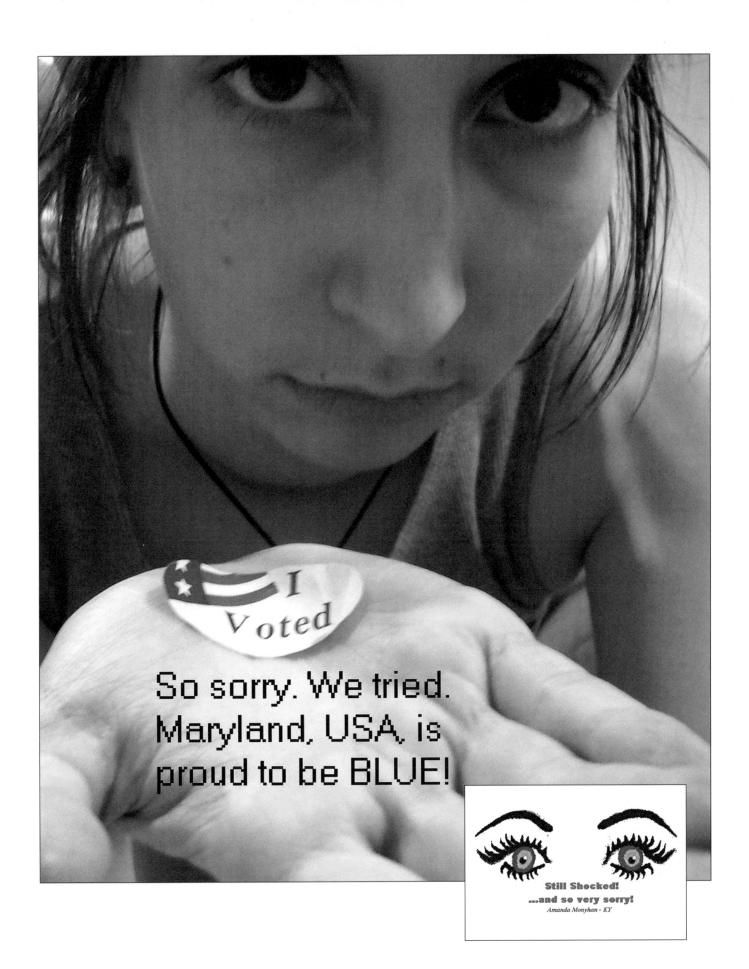

So sorry. We tried.
Maryland, USA, is
proud to be BLUE!

Still Shocked!
...and so very sorry!
Amanda Monyhan - KY

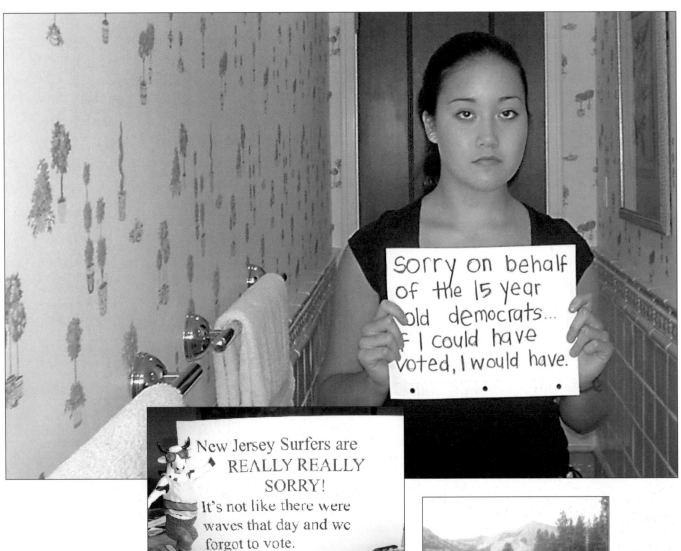

Sorry on behalf of the 15 year old democrats... If I could have voted, I would have.

New Jersey Surfers are REALLY REALLY SORRY! It's not like there were waves that day and we forgot to vote. Now if there were waves

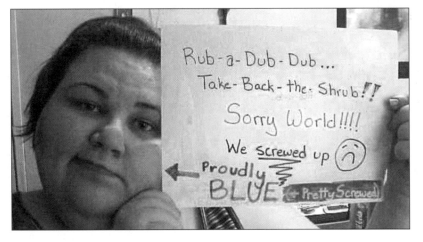

Rub-a-Dub-Dub... Take-Back-the-Shrub!!! Sorry World!!!! We screwed up ⌢ Proudly BLUE (+ Pretty Screwed)

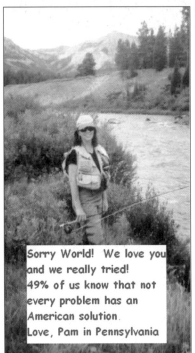

Sorry World! We love you and we really tried! 49% of us know that not every problem has an American solution. Love, Pam in Pennsylvania

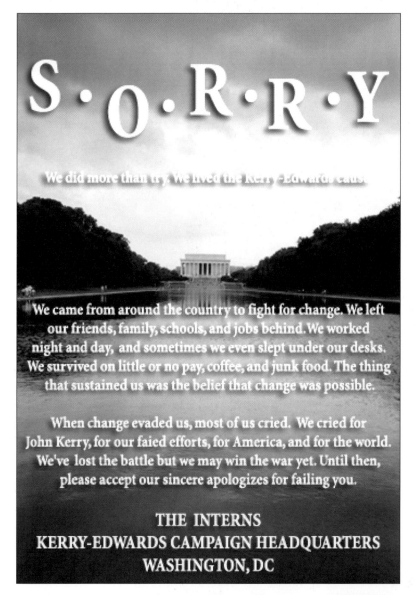

S·O·R·R·Y

We did more than try. We lived the Kerry-Edwards cause.

We came from around the country to fight for change. We left our friends, family, schools, and jobs behind. We worked night and day, and sometimes we even slept under our desks. We survived on little or no pay, coffee, and junk food. The thing that sustained us was the belief that change was possible.

When change evaded us, most of us cried. We cried for John Kerry, for our faied efforts, for America, and for the world. We've lost the battle but we may win the war yet. Until then, please accept our sincere apologizes for failing you.

THE INTERNS
KERRY-EDWARDS CAMPAIGN HEADQUARTERS
WASHINGTON, DC

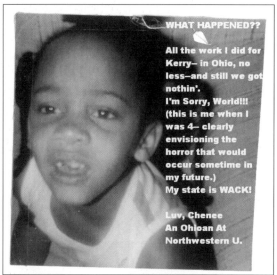

WHAT HAPPENED??
All the work I did for Kerry— in Ohio, no less—and still we got nothin'.
I'm Sorry, World!!!
(this is me when I was 4— clearly envisioning the horror that would occur sometime in my future.)
My state is WACK!

Luv, Chenee
An Ohioan At Northwestern U.

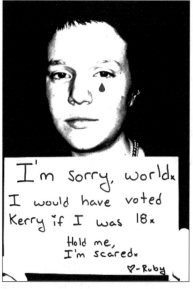

I'm sorry, world.
I would have voted Kerry if I was 18.
Hold me, I'm scared.
♥ -Ruby

So sorry.... please forgive us :(

I didn't vote for Bush....

The tunnel just got a little longer and darker...but eventually we will emerge into the light again. Stay strong; we will survive.
Love, a world citizen from blue CT.

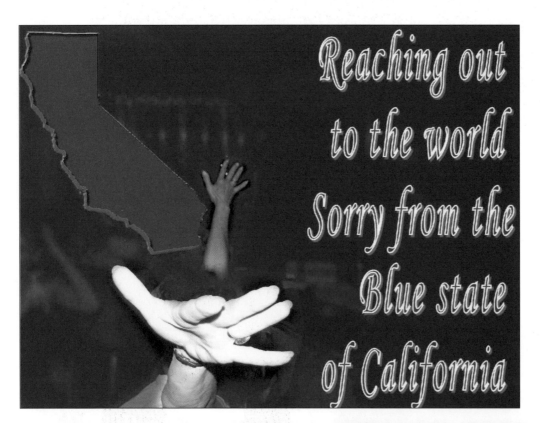

Reaching out to the world
Sorry from the Blue state of California

SORRY FROM AN AMERICAN ABROAD

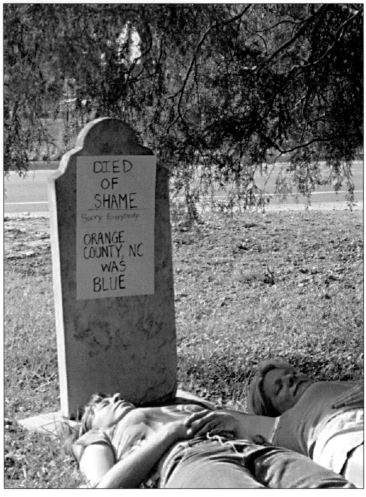

Sorry

from the 2007
Graduating Class
of Summerfeild - We were
Really Pissed Too ~

To Bad We Couldn't Vote

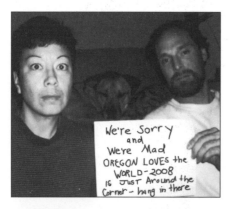

We're Sorry and We're Mad OREGON LOVES the WORLD - 2008 IS JUST Around the Corner - hang in there

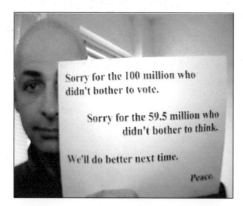

Sorry for the 100 million who didn't bother to vote.

Sorry for the 59.5 million who didn't bother to think.

We'll do better next time.

Peace.

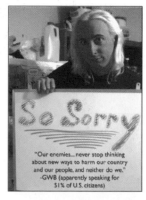

So Sorry

"Our enemies... never stop thinking about new ways to harm our country and our people, and neither do we."
-GWB (apparently speaking for 51% of U.S. citizens)

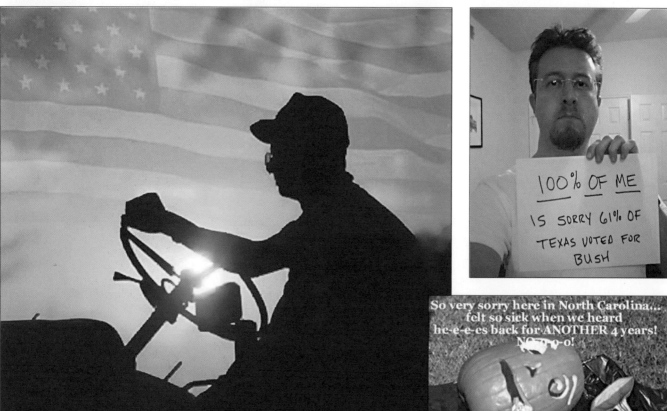

Don't much care if the guys on the next farm over want to hold hands or not. None of my business anyway. More concerned about my boy over in Afghanistan, how the economy is doing, the enviroment, things like that. Seems this president has got us into a real sorry situation here. Well, hope for the best and see what we can do about it in a couple of years. Maybe we can shake out the congress a bit

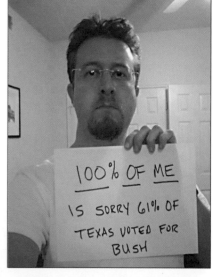

100% OF ME IS SORRY 61% OF TEXAS VOTED FOR BUSH

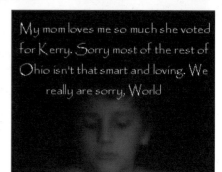

So very sorry here in North Carolina... felt so sick when we heard he-e-e-es back for ANOTHER 4 years! NO-o-o-o!

My mom loves me so much she voted for Kerry. Sorry most of the rest of Ohio isn't that smart and loving. We really are sorry, World

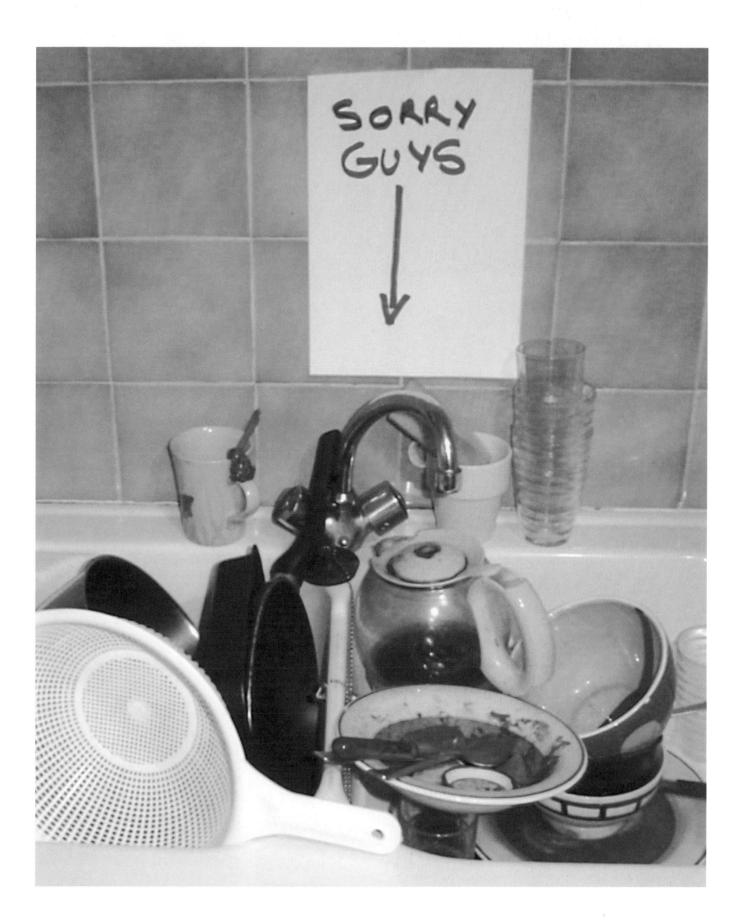

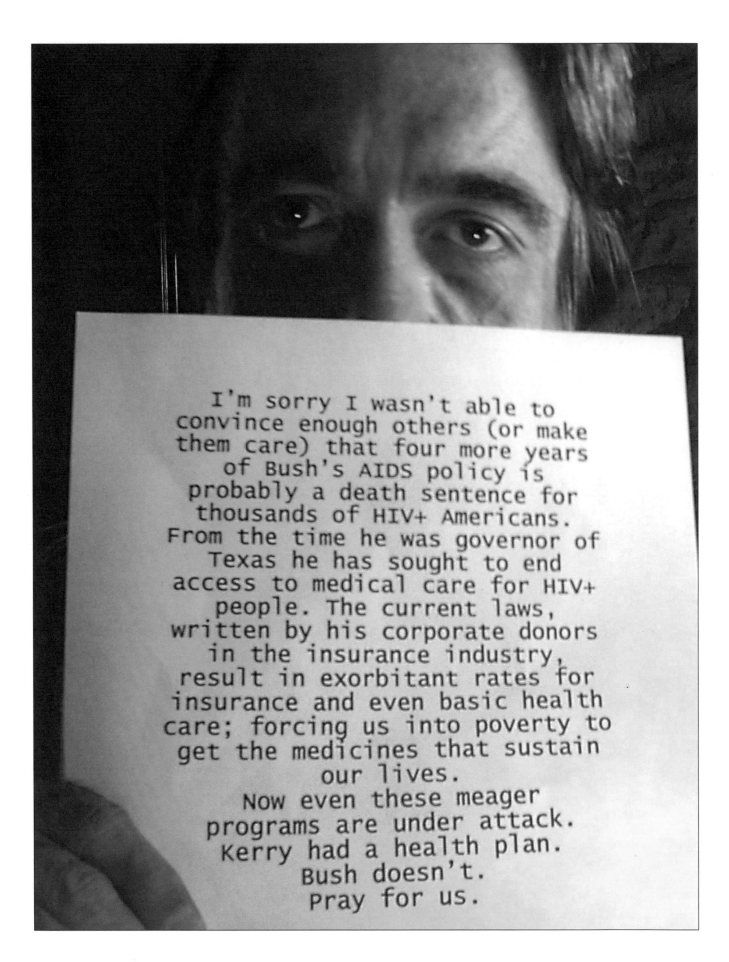

I'm sorry I wasn't able to
convince enough others (or make
them care) that four more years
of Bush's AIDS policy is
probably a death sentence for
thousands of HIV+ Americans.
From the time he was governor of
Texas he has sought to end
access to medical care for HIV+
people. The current laws,
written by his corporate donors
in the insurance industry,
result in exorbitant rates for
insurance and even basic health
care; forcing us into poverty to
get the medicines that sustain
our lives.
Now even these meager
programs are under attack.
Kerry had a health plan.
Bush doesn't.
Pray for us.

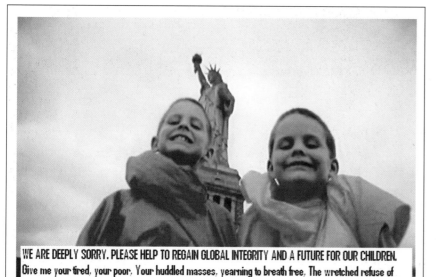

WE ARE DEEPLY SORRY. PLEASE HELP TO REGAIN GLOBAL INTEGRITY AND A FUTURE FOR OUR CHILDREN. Give me your tired, your poor, Your huddled masses, yearning to breath free, The wretched refuse of your teeming shore, Send these, the homeless, tempest tossed, I lift my lamp beside the golden door. WE lOVE THIS COUNTRY AND THE REST OF THE WORLD - WE NEED TO FIGHT TO GET OUR COUNTRY BACK!!!

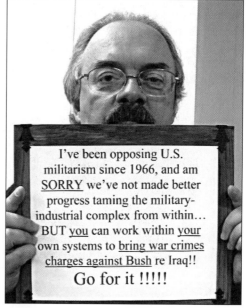

I've been opposing U.S. militarism since 1966, and am SORRY we've not made better progress taming the military-industrial complex from within... BUT you can work within your own systems to bring war crimes charges against Bush re Iraq!!
Go for it !!!!!

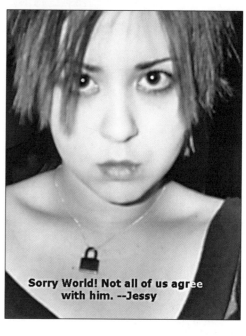

Sorry Everybody. Next time I will carve 4.

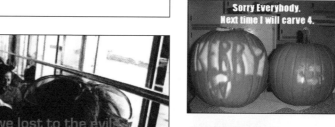

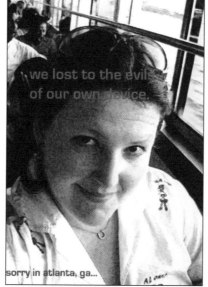

we lost to the evil of our own device.

sorry in atlanta, ga...

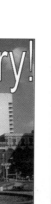

Sorry, from Minnesota We worked hard! But Fear Won!

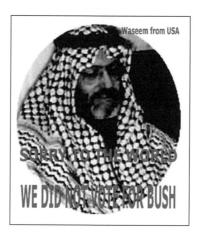

Waseem from USA

SORRY TO THE WORLD WE DID NOT VOTE FOR BUSH

Sorry World! Not all of us agree with him. --Jessy

141

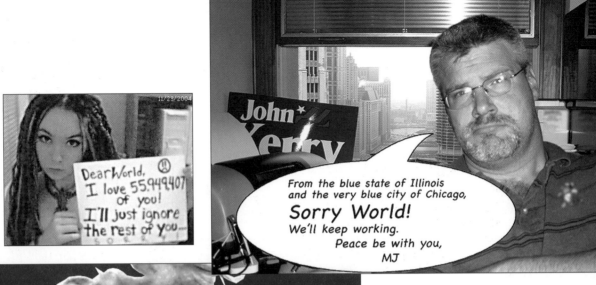

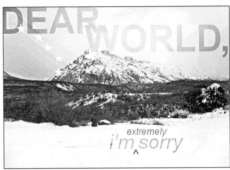

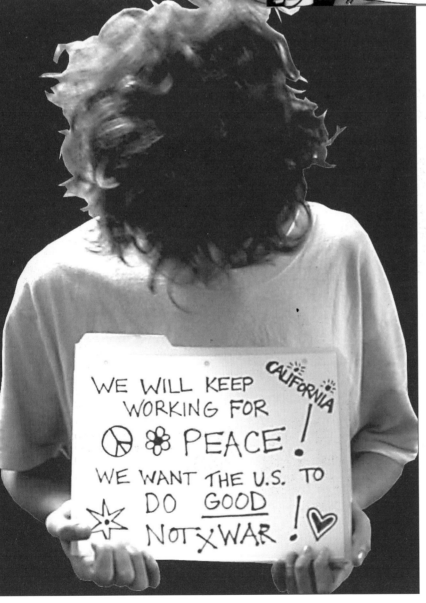

Sorry, mates.

Yeah, I'm worried too. But we'll make it...we are nothing if not resilient. Thanks for sticking it out with us.

– New York State

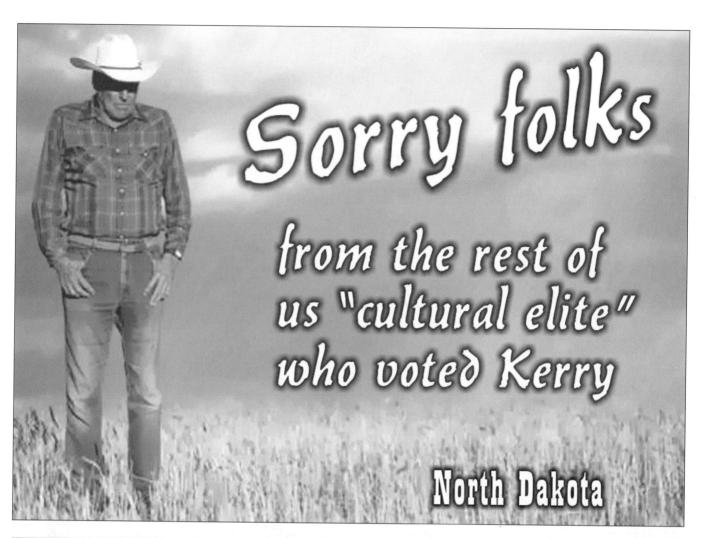

Sorry folks

from the rest of us "cultural elite" who voted Kerry

North Dakota

I'm sorry world... voted for the right... Remember, only you can prevent bad presidents.

From a sad art student in Boston Massachusetts who voted for Kerry...

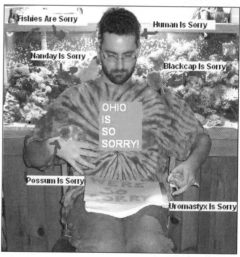

Fishies Are Sorry

Human Is Sorry

Nanday Is Sorry

Blackcap Is Sorry

OHIO IS SO SORRY!

Possum Is Sorry

Uromastyx Is Sorry

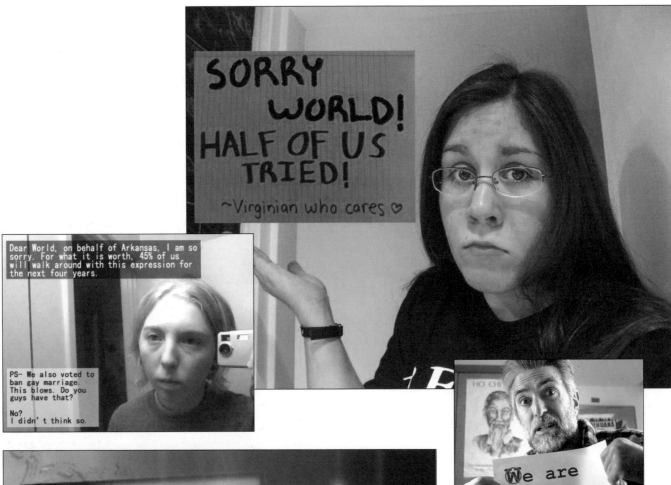

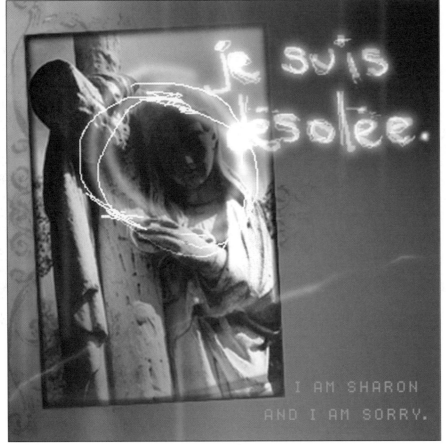

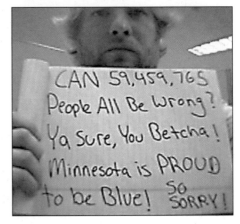

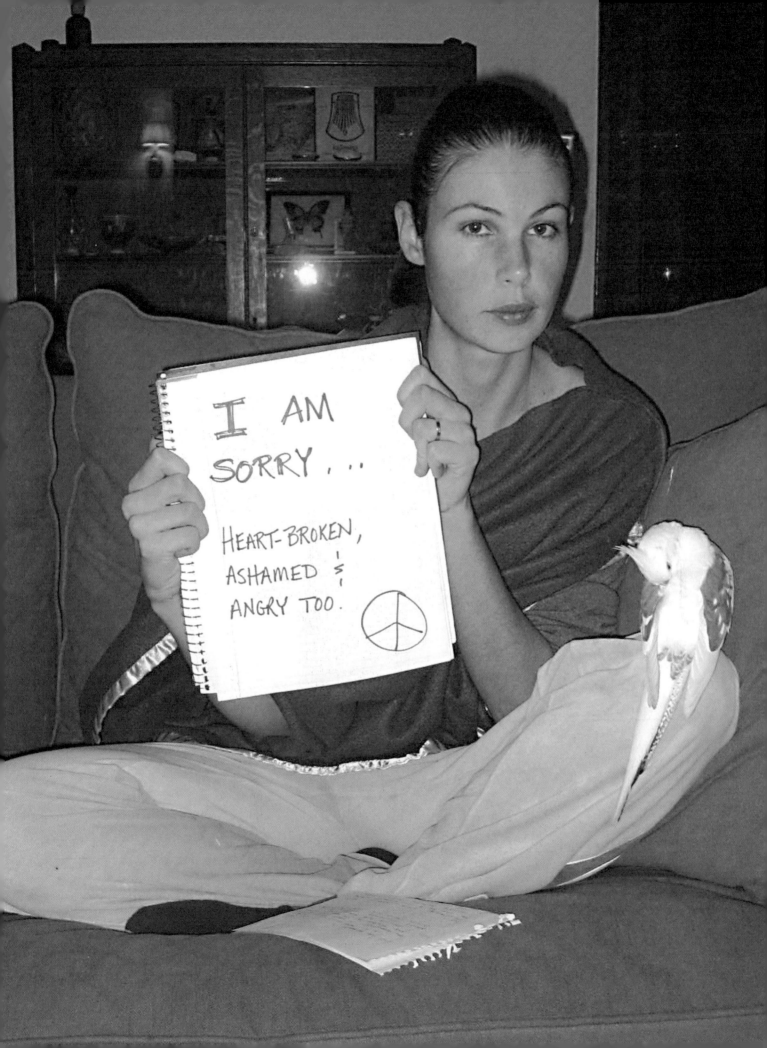

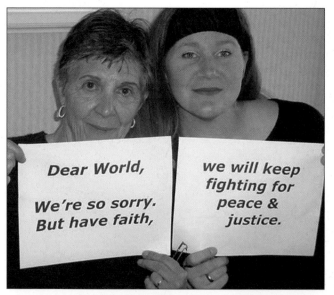

Dear World,

We're so sorry.
But have faith,

we will keep
fighting for
peace &
justice.

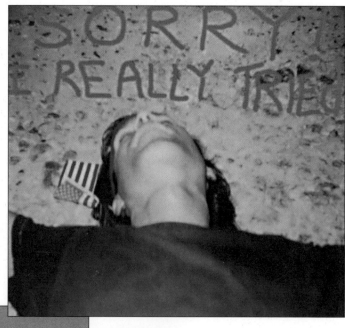

SORRY
I REALLY TRIED

MY COUNTRY HELD AN
ELECTION, AND ALL WE
GOT WAS THIS IDIOTIC
"~~PRESIDENT~~" MONKEY
I AM SORRY.
SORRY! BAD MONKEY!

SO SORRY

I am totally angry at our government and ready for some serious change. **We are going to fix this.** Art Schools across America love the rest of the world, there are no borders anymore only perceptions. **WE ARE ALL IN THIS TOGETHER!** We will help them see Artists and Designers everywhere are so sorry. Blue in minnesota...

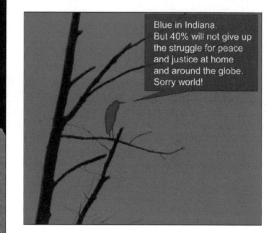

Blue in Indiana.
But 40% will not give up the struggle for peace and justice at home and around the globe. Sorry world!

146

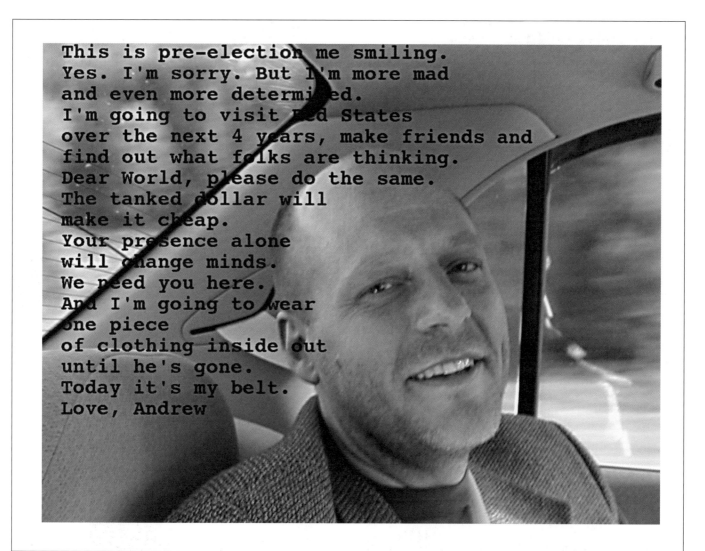

This is pre-election me smiling.
Yes. I'm sorry. But I'm more mad
and even more determined.
I'm going to visit Red States
over the next 4 years, make friends and
find out what folks are thinking.
Dear World, please do the same.
The tanked dollar will
make it cheap.
Your presence alone
will change minds.
We need you here.
And I'm going to wear
one piece
of clothing inside out
until he's gone.
Today it's my belt.
Love, Andrew

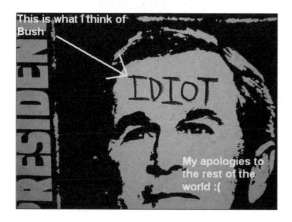

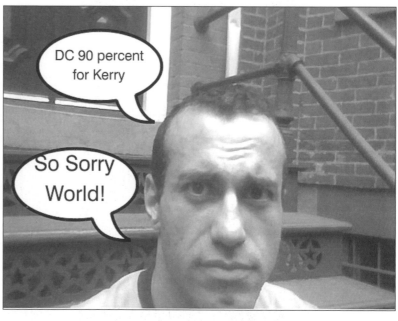

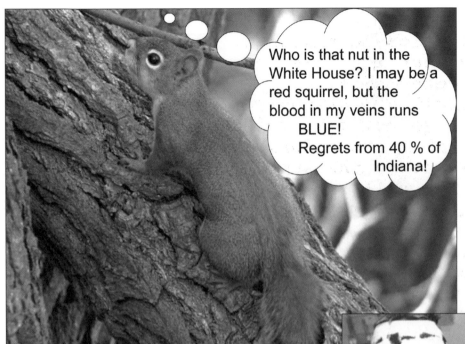

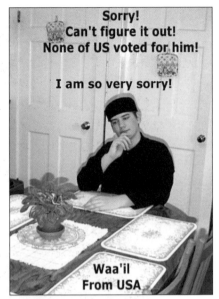

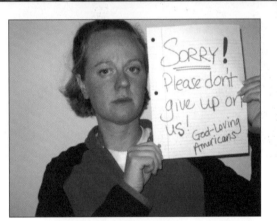

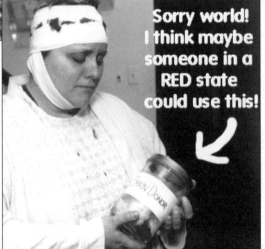

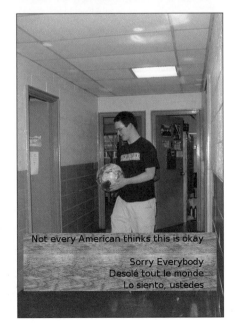

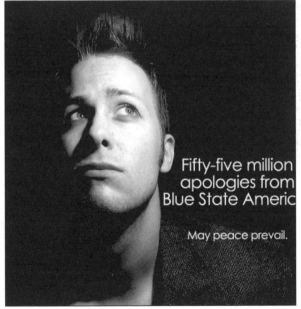

148

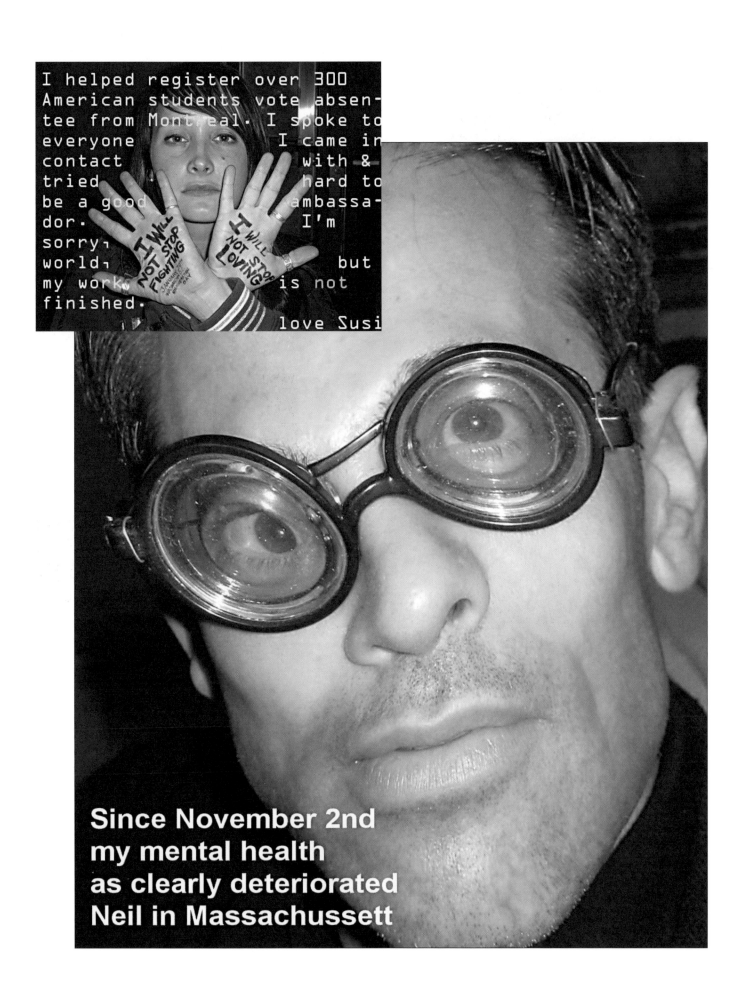

I helped register over 300
American students vote absen-
tee from Montreal. I spoke to
everyone I came in
contact with &
tried hard to
be a good ambassa-
dor. I'm
sorry,
world, but
my work is not
finished.

love Susi

I WILL NOT STOP FIGHTING

I WILL NOT STOP LOVING

**Since November 2nd
my mental health
as clearly deteriorated
Neil in Massachussett**

149

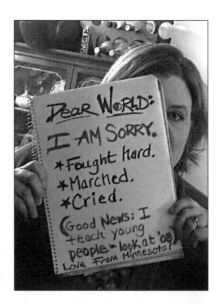

Sorry world, we tried.

But when a long train of abuses and usurpations, pursuing invariably the same Object evinces a design to reduce them under absolute Despotism, it is their right, it is their duty, to throw off such Government, and to provide new Guards for their future security.

The Declaration of Independence, 1776

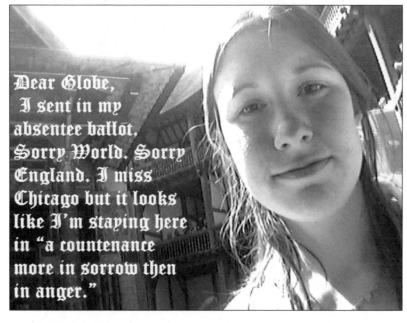

Dear Globe,
I sent in my
absentee ballot.
Sorry World. Sorry
England. I miss
Chicago but it looks
like I'm staying here
in "a countenance
more in sorrow then
in anger."

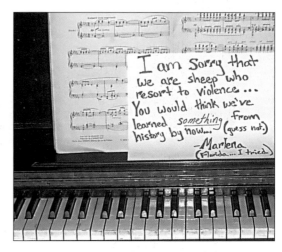

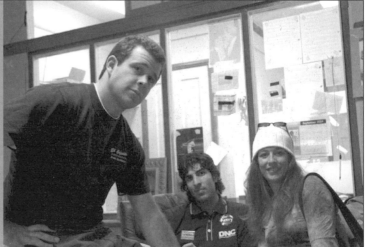

I'm sorry world. I sit to the right... my name is Judy Miller.
This is the office I worked in for John Kerry.
The guys to my left are Charlie and Matt.
They are very sorry too.
I personally worked everyday since John Kerry
accepted the nomination for President. I am sorry that I
didn't do more. I keep thinking if I could have reached
one more person, if I would have made
one more dollar....

I just want the world to know I tried. And I won't stop
trying! I hope the world tries too, please stand up to
Bush, 49% of us in the United States need your help too.
I worked for John Kerry not only for the United States, I
worked for him for the rest of the world too.

Love from Los Angeles,
Judy Miller

Help!
Please prosecute
our war criminals!

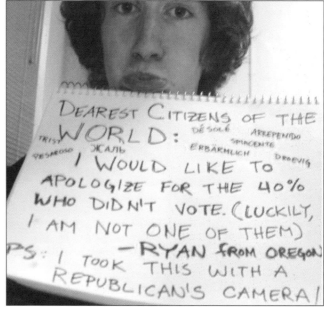

DEAREST CITIZENS OF THE
WORLD: DÉSOLÉ ARREPENTIDO
TRIST SINCENTE
PESAROSO ЖАЛЬ ERBÄRMLICH DROEVIG
I WOULD LIKE TO
APOLOGIZE FOR THE 40%
WHO DIDN'T VOTE. (LUCKILY,
I AM NOT ONE OF THEM)
—RYAN FROM OREGON
PS: I TOOK THIS WITH A
REPUBLICAN'S CAMERA!

"We are not hated because we practice democracy, value freedom, or uphold human rights. We are hated because our government denies these things to people in Third World countries whose resources are coveted by our multinational corporations. That hatred we have sown has come back to haunt us in the form of terrorism...Instead of sending our sons and daughters around the world to kill Arabs so we can have the oil under their sand, we should send them to rebuild their infrastructure, supply clean water, and feed starving children...In short, we should do good instead of evil. Who would try to stop us? Who would hate us? Who would want to bomb us? That is the truth American people need to hear."
-former lt. col. Robert Bowman, now a Catholic bishop
Sorry Sorry Sorry Sorry Sorry Sorry Sorry
Sorry Sorry Sorry Sorry Sorry Sorry Sorry

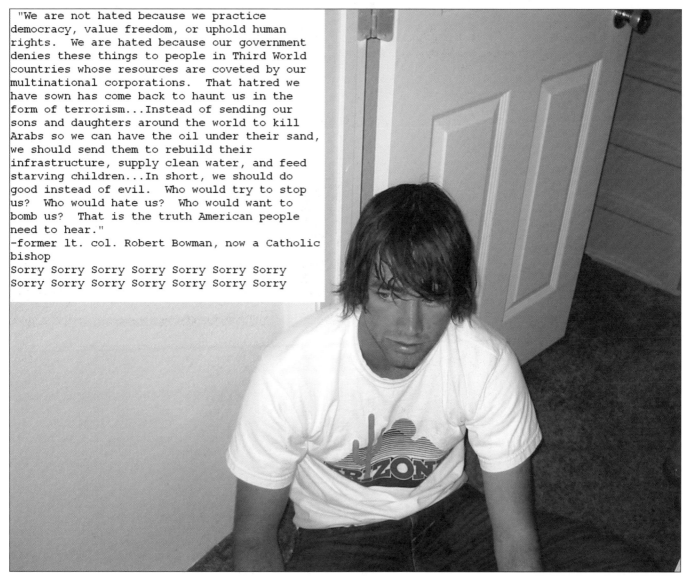

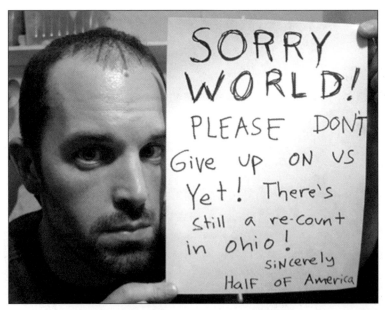

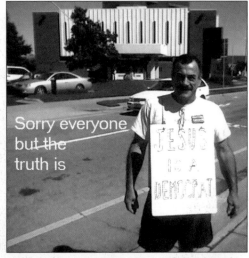

Sorry everyone but the truth is

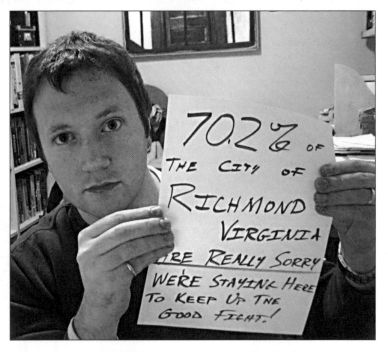

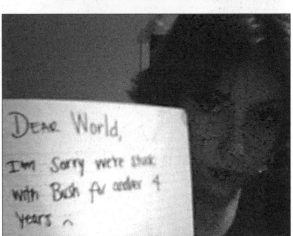

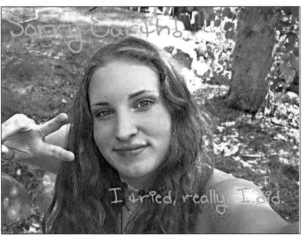

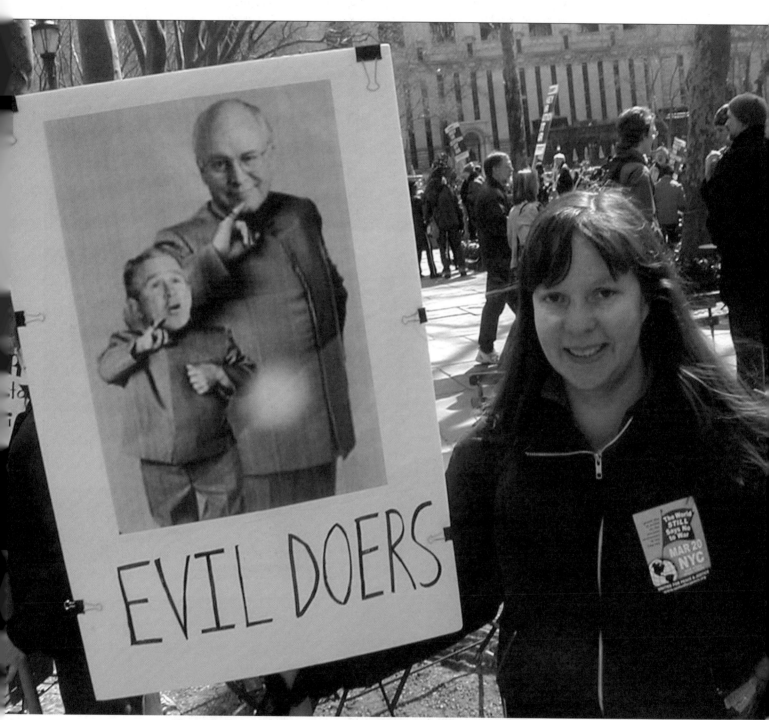

I am sorry world! I really tried.

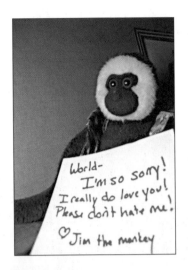

World—
I'm so sorry!
I really do love you!
Please don't hate me!
♡ Jim the monkey

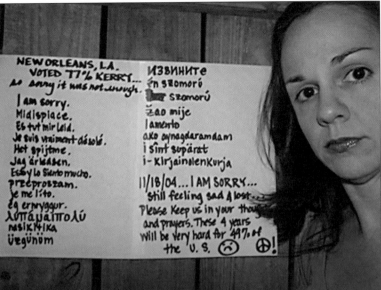

NEW ORLEANS, LA.
VOTED 77% KERRY...
so sorry it was not enough.

I am sorry.
Midispiace.
Es tut mir leid.
Je suis vraiment désolé.
Het spijtme.
Jag är ledsen.
Esby lo Siento mucho.
przepraszam.
je me l'ito.
ég erpryggur.
λυπάμαιπολύ
nasik14ika
üzgünüm

ИЗВИНИТЕ
én szomorú
szomorú
žao mije
lamento
ako oynagdaramdam
i sint supärat
i-klrjainolenkurja

11/18/04... I AM SORRY...
still feeling sad & lost...
Please keep us in your though
and prayers. These 4 years
will be very hard for 49% of
the U.S. ☹ ☮!

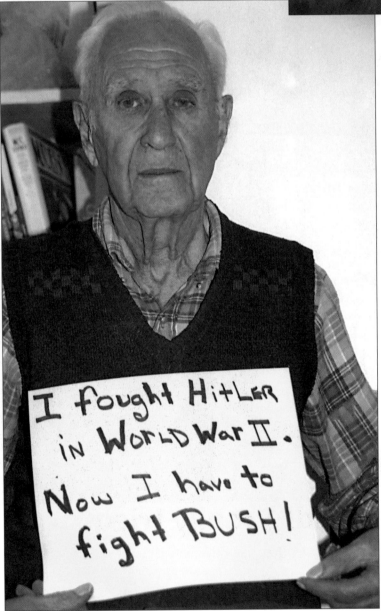

I fought Hitler
in World War II.
Now I have to
fight BUSH!

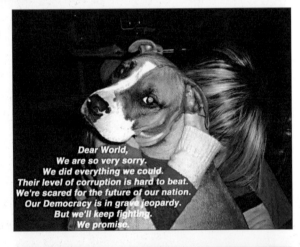

Dear World,
We are so very sorry.
We did everything we could.
Their level of corruption is hard to beat.
We're scared for the future of our nation.
Our Democracy is in grave jeopardy.
But we'll keep fighting.
We promise.

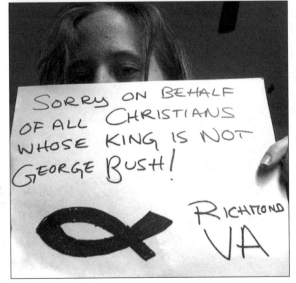

SORRY ON BEHALF
OF ALL CHRISTIANS
WHOSE KING IS NOT
GEORGE BUSH!

RICHMOND
VA

**Black Tuesday. November 22, 2004
The Day America Died**

Speechless
Sad
Sorrowful
Sickened
Stunned
Shocked
Scared
Suspicious
Stupefied
Stumped
Sullen
Seething
+
So
So
SORRY! :-(

The Dixie Chicks Were Right!
~ ~ ~ Houston Texas

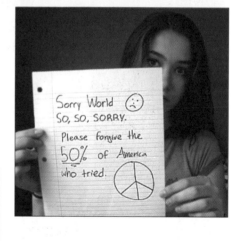

Sorry World 😟
SO, SO, SORRY.
Please forgive the
50% of America
who tried.

Empire-1
America-0

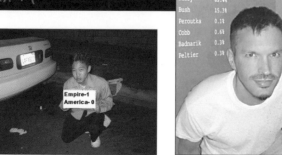

S.O.S.orry

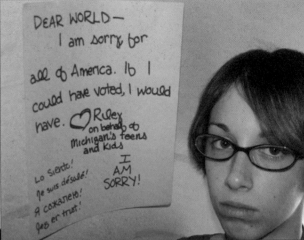

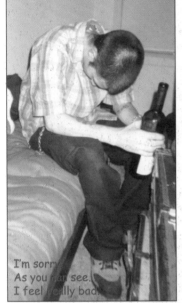

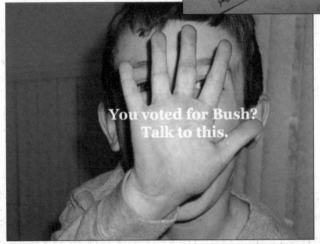

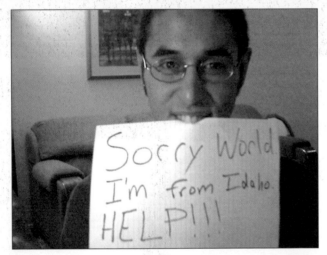

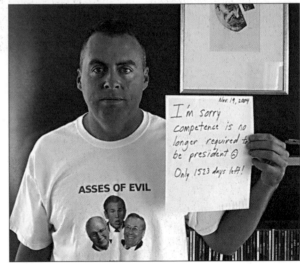

we're terribly sorry. 59 million americans took the bait

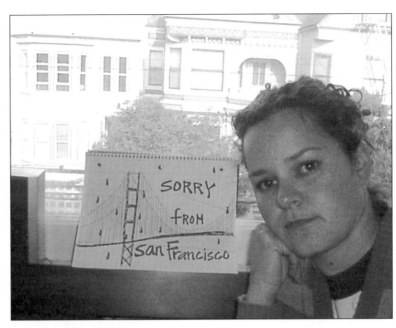

SORRY FROM San Francisco

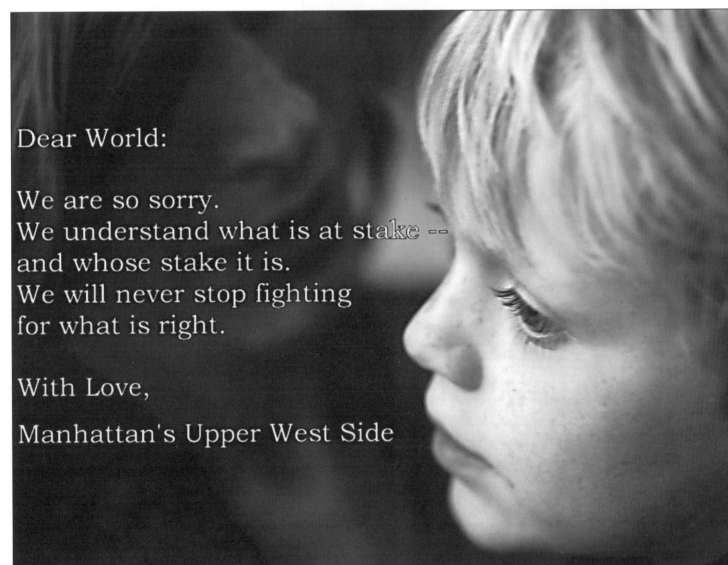

Dear World:

We are so sorry.
We understand what is at stake --
and whose stake it is.
We will never stop fighting
for what is right.

With Love,

Manhattan's Upper West Side

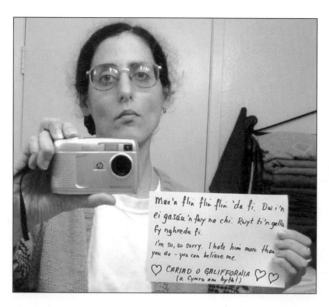

Mae'n flin flin flin 'da fi. Dw i'n
ei gasáu'n fwy na chi. Rwyt ti'n gallu
fy nghredu fi.
I'm so, so sorry. I hate him more than
you do - you can believe me.
♡ CARIAD O GALIFFORNIA ♡ ♡
(a Cymru am byth!)

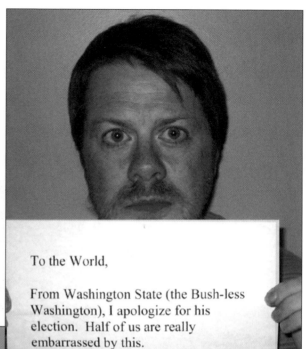

To the World,

From Washington State (the Bush-less
Washington), I apologize for his
election. Half of us are really
embarrassed by this.

(Geez, even my dad voted for him!)

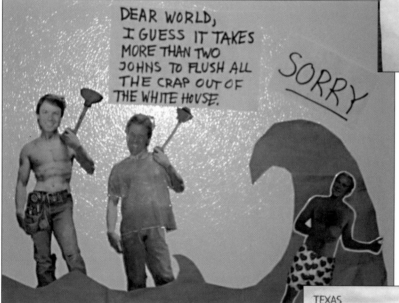

DEAR WORLD,
I GUESS IT TAKES
MORE THAN TWO
JOHNS TO FLUSH ALL
THE CRAP OUT OF
THE WHITE HOUSE.

SORRY

We Are Sorry

USA

I
Voted
For Peace
Jumaana Salma Amatullah

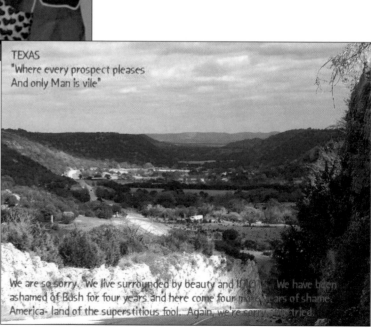

TEXAS
"Where every prospect pleases
And only Man is vile"

We are so sorry. We live surrounded by beauty and [...] We have been
ashamed of Bush for four years and here come four more years of shame.
America- land of the superstitious fool. Again, we're sorry we tried.

158

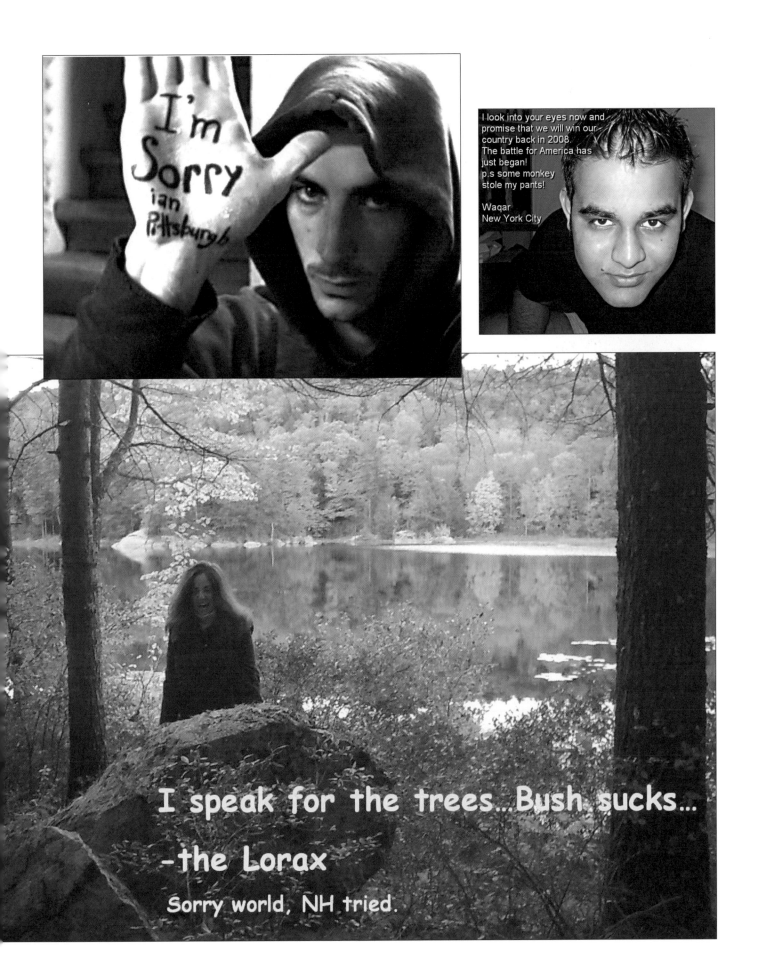

I'm Sorry ian Pittsburgh

I look into your eyes now and promise that we will win our country back in 2008. The battle for America has just began! p.s some monkey stole my pants!

Waqar
New York City

I speak for the trees...Bush sucks...

-the Lorax

Sorry world, NH tried.

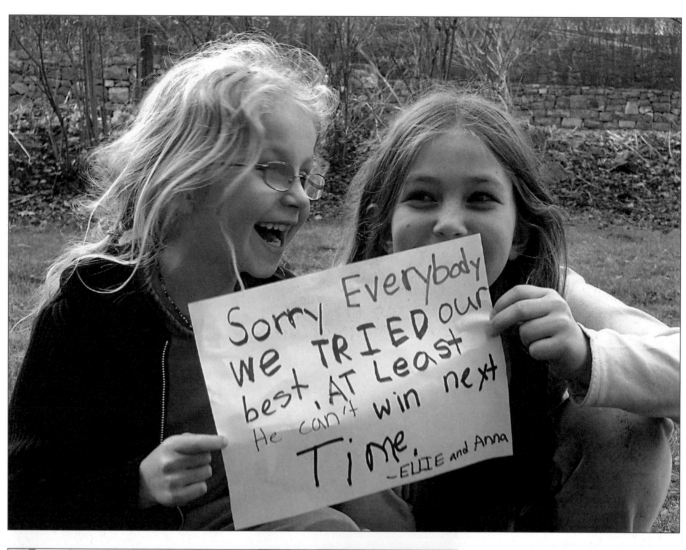

Sorry Everybody
we TRIED our
best. AT Least
He can't win next
Time.
—ELLIE and Anna

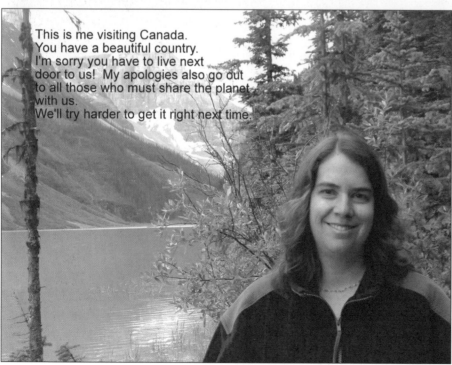

This is me visiting Canada.
You have a beautiful country.
I'm sorry you have to live next
door to us! My apologies also go out
to all those who must share the planet
with us.
We'll try harder to get it right next time.

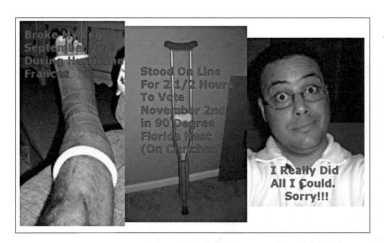

Broke My Leg
September 3rd
During Hurricane
Frances

Stood On Line
For 2 1/2 Hours
To Vote
November 2nd
in 90 Degree
Florida Heat
(On Crutches)

I Really Did
All I Could.
Sorry!!!

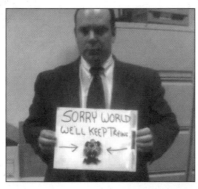

SORRY WORLD
WE'LL KEEP TRYING

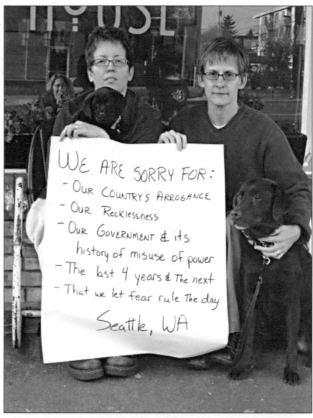

WE ARE SORRY FOR:
- Our Country's Arrogance
- Our Recklessness
- Our Government & its
 history of misuse of power
- The last 4 years & the next
- That we let fear rule the day

Seattle, WA

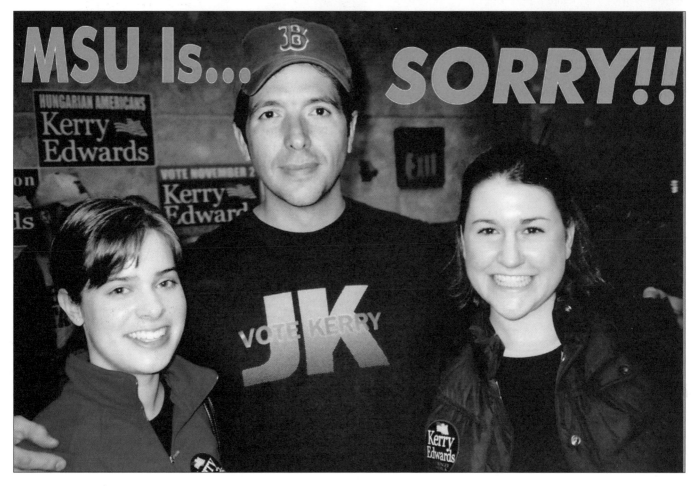

MSU Is... SORRY!!

161

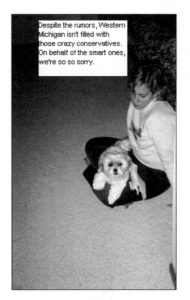

Despite the rumors, Western Michigan isn't filled with those crazy conservatives. On behalf of the smart ones, we're so so sorry.

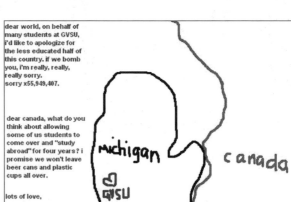

dear world, on behalf of many students at GVSU, i'd like to apologize for the less educated half of this country. if we bomb you, i'm really, really, really sorry.
sorry x55,949,407.

dear canada, what do you think about allowing some of us students to come over and "study abroad" for four years? i promise we won't leave beer cans and plastic cups all over.

lots of love,
the lakers of the blue hand

michigan
GVSU
canada

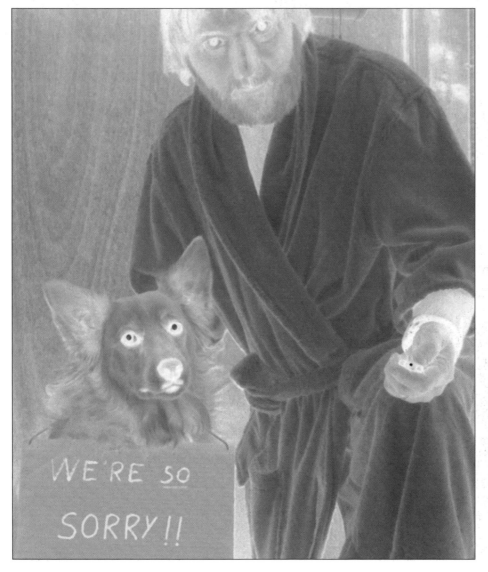

WE'RE SO SORRY!!

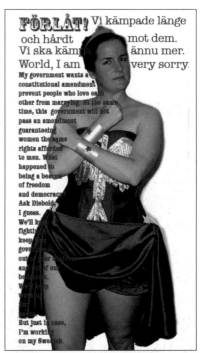

FÖRLÅT! Vi kämpade länge och hårdt mot dem. Vi ska kämpa ännu mer. World, I am very sorry.
My government wants a constitutional amendment to prevent people who love each other from marrying. At the same time, this government will not pass an amendment guaranteeing women the same rights afforded to men. What happened to being a beacon of freedom and democracy? Ask Diebold, I guess. We'll keep fighting to keep government out of our bedrooms.

But just in case, I'm working on my Swedish.

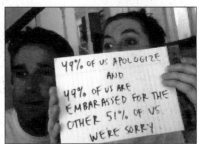

49% of us apologize and 49% of us are embarassed for the other 51% of us.
we're sorry

162

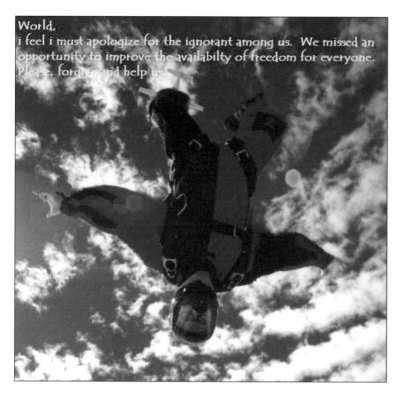

World,
i feel i must apologize for the ignorant among us. We missed an opportunity to improve the availabilty of freedom for everyone. Please, forgive and help us.

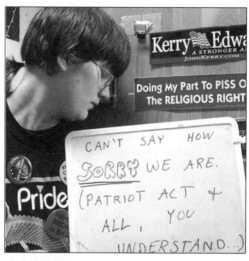

CAN'T SAY HOW SORRY WE ARE. (PATRIOT ACT + ALL, YOU UNDERSTAND...)

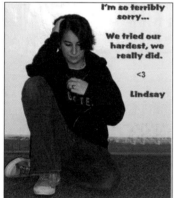

I'm so terribly sorry...

We tried our hardest, we really did.

<3

Lindsay

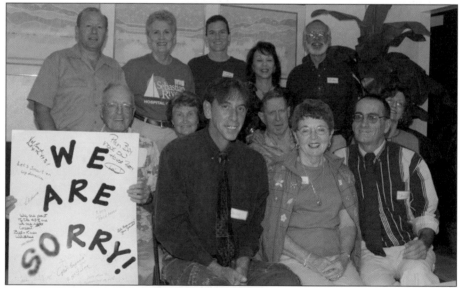

WE ARE SORRY!

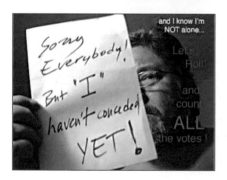

Sorry Everybody! But "I" haven't conceded YET!

and I know I'm NOT alone...

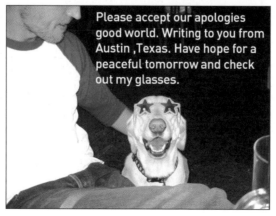

Please accept our apologies good world. Writing to you from Austin ,Texas. Have hope for a peaceful tomorrow and check out my glasses.

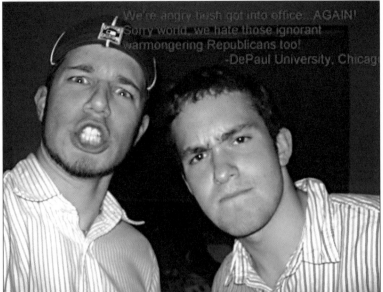

dearest world,
please forgive our big, dumb country.

love,
one huge, sad,
fully awake
insurgency.

♥

your gay marriage.

p.s. we may need your help.

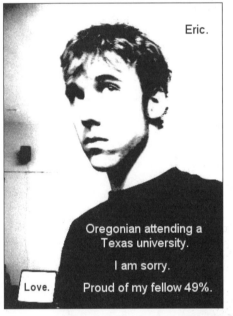

Eric.

Oregonian attending a Texas university.

I am sorry.

Love.

Proud of my fellow 49%.

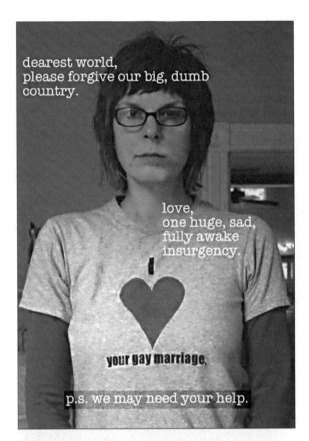

Even us kids are shocked... so sorry from New York

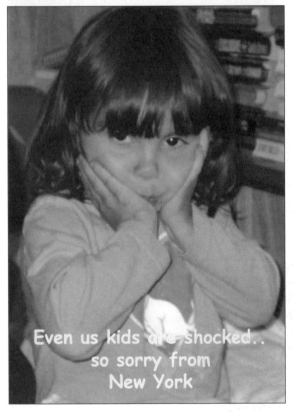

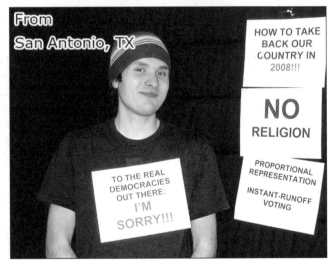

164

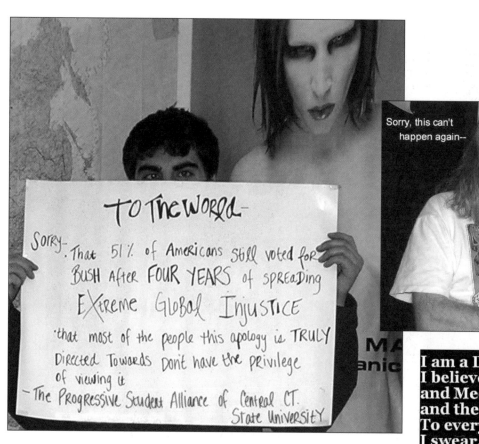

TO THE WORLD--

SORRY-. That 51% of Americans still voted for BUSH After FOUR YEARS of spreading EXtreme Global Injustice

'that most of the people this apology is TRULY Directed Towards Dont have the Privilege of viewing it

- The Progressive Student Alliance of Central CT. State University

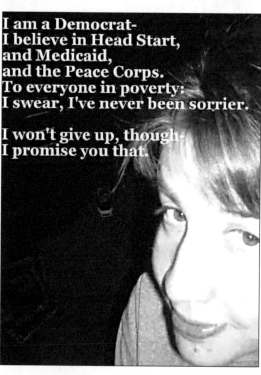

Sorry, this can't happen again--

"We are all outlaws in the eyes of Amerika"

I am a Democrat-
I believe in Head Start,
and Medicaid,
and the Peace Corps.
To everyone in poverty:
I swear, I've never been sorrier.

I won't give up, though-
I promise you that.

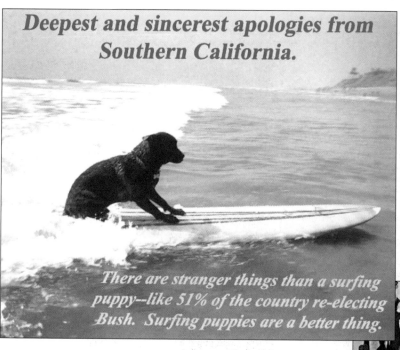

Deepest and sincerest apologies from Southern California.

There are stranger things than a surfing puppy--like 51% of the country re-electing Bush. Surfing puppies are a better thing.

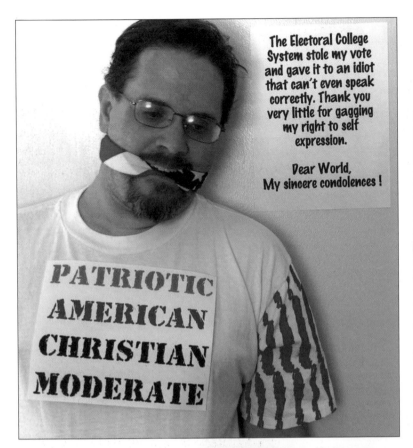

The Electoral College System stole my vote and gave it to an idiot that can't even speak correctly. Thank you very little for gagging my right to self expression.

Dear World,
My sincere condolences !

PATRIOTIC AMERICAN CHRISTIAN MODERATE

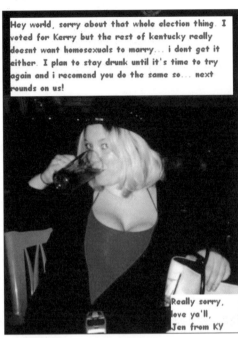

Hey world, sorry about that whole election thing. I voted for Kerry but the rest of kentucky really doesnt want homosexuals to marry... i dont get it either. I plan to stay drunk until it's time to try again and i recomend you do the same so... next rounds on us!

Really sorry, love ya'll, Jen from KY

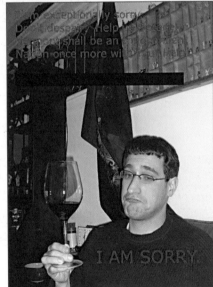

I'm exceptionally sorry. Don't despair. Help is coming. Reason shall be an American Nation once more with your help.

I AM SORRY.

Je suis désolée

This is our French poodle. 51 % of Americans might prefer calling him a "freedom" poodle. Regardless of what we call him, he's very smart. He wonders if those 51 % realize that their votes have moved our country perilously closer to the philosophy of the monomaniacal, fundamentalist terrorists who inhabit the Axis of Evil. One nation under whose god?

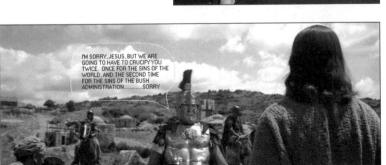

I'M SORRY, JESUS, BUT WE ARE GOING TO HAVE TO CRUCIFY YOU TWICE. ONCE FOR THE SINS OF THE WORLD, AND THE SECOND TIME FOR THE SINS OF THE BUSH ADMINISTRATION............SORRY

Pagan, bisexual, Pro-choice, Libertarian... Guess who I DIDN'T vote for.

I'M SO SORRY so many of my brethren are so terribly blind!

Hugs & Hope!
Bri in Albuquerque

Ticket to Belgium = $600
Pints at the bar = $30
Meeting the world in one small city and knowing they still like us, if not our leaders....

TOTALLY PRICELESS!

Thanks for the fun and sorry for the Idiot Man Chimp President.

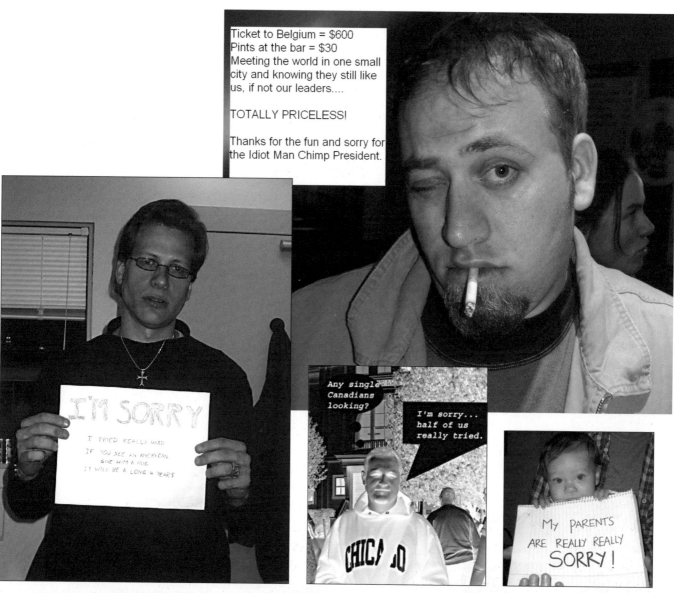

I'M SORRY

I TRIED REALLY HARD.
IF YOU SEE AN AMERICAN,
GIVE HIM A HUG.
IT WILL BE A LONG 4 YEARS

Any single Canadians looking?

I'm sorry... half of us really tried.

CHICAGO

MY PARENTS ARE REALLY REALLY SORRY!

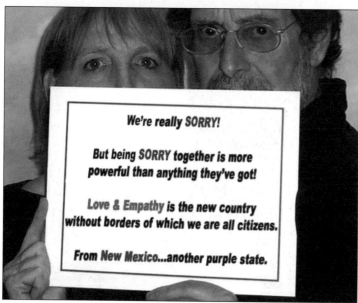

We're really SORRY!

But being SORRY together is more powerful than anything they've got!

Love & Empathy is the new country without borders of which we are all citizens.

From New Mexico...another purple state.

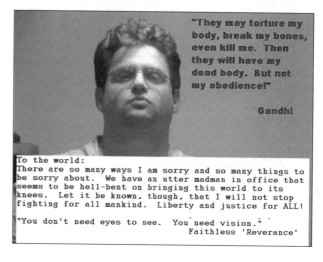

"They may torture my body, break my bones, even kill me. Then they will have my dead body. But not my obedience!"

Gandhi

To the world:
There are so many ways I am sorry and so many things to be sorry about. We have an utter madman in office that seems to be hell-bent on bringing this world to its knees. Let it be known, though, that I will not stop fighting for all mankind. Liberty and justice for ALL!

"You don't need eyes to see. You need vision."
Faithless 'Reverance'

167

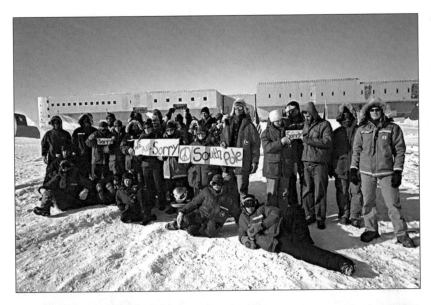

I WANT TO APOLOGIZE WHILE I'M STILL ALLOWED TO SPEAK...

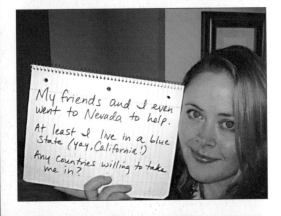

My friends and I even went to Nevada to help.

At least I live in a blue state (yay, California!)

Any countries willing to take me in?

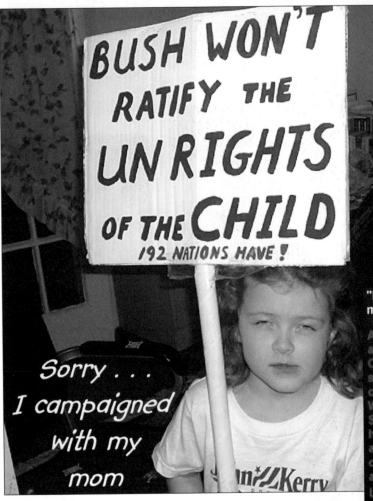

BUSH WON'T RATIFY THE UN RIGHTS OF THE CHILD

192 NATIONS HAVE!

Sorry . . . I campaigned with my mom

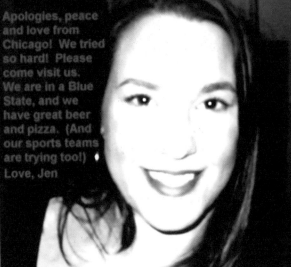

"In the depths of winter I finally learned that within me there lay an invincible summer." - Albert Camus

Apologies, peace and love from Chicago! We tried so hard! Please come visit us. We are in a Blue State, and we have great beer and pizza. (And our sports teams are trying too!) Love, Jen

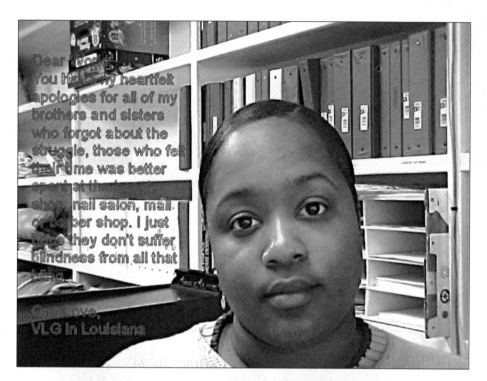

Dear world,
You have my heartfelt apologies for all of my brothers and sisters who forgot about the struggle, those who felt their time was better spent at the beauty shop, nail salon, mail, or barber shop. I just hope they don't suffer blindness from all that ...

One Love,
VLG in Louisiana

Sorry, Everybody!
He's not MY president. I didn't vote for him either time. I do believe the true scope of his unconscionable actions will come to light, however. We certainly live in interesting times. Please bear with us while we raise consciousness -- and hold a vision of the future you want to create. It can only get BETTER from now on!
Blessings,
Cathryn Tezha Swann

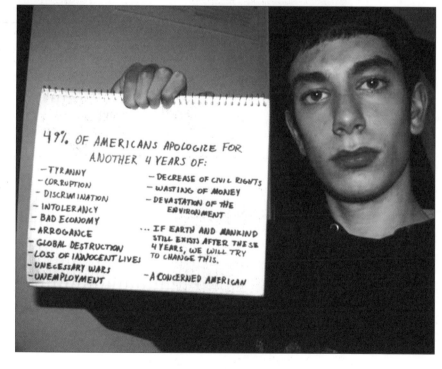

49% OF AMERICANS APOLOGIZE FOR ANOTHER 4 YEARS OF:
- TYRANNY
- CORRUPTION
- DISCRIMINATION
- INTOLERANCY
- BAD ECONOMY
- ARROGANCE
- GLOBAL DESTRUCTION
- LOSS OF INNOCENT LIVES
- UNECESSARY WARS
- UNEMPLOYMENT
- DECREASE OF CIVIL RIGHTS
- WASTING OF MONEY
- DEVASTATION OF THE ENVIRONMENT

... IF EARTH AND MANKIND STILL EXISTS AFTER THESE 4 YEARS, WE WILL TRY TO CHANGE THIS.

- A CONCERNED AMERICAN

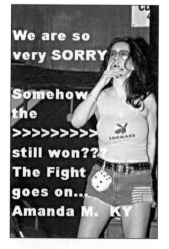

We are so very SORRY
Somehow the >>>>>>>> still won???
The Fight goes on...
Amanda M. KY

sorry...

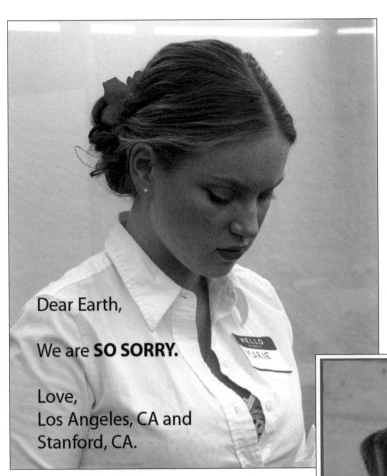

Dear Earth,

We are **SO SORRY.**

Love,
Los Angeles, CA and
Stanford, CA.

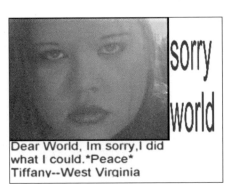

Dear World, Im sorry, I did
what I could. *Peace*
Tiffany--West Virginia

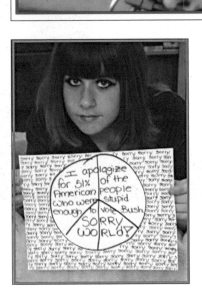

I am Talullah-Bod'

Dear World, I am sorry that
so many Americans seem
more comfortable denying
so many others the same freedom
and peace they themselves enjoy.
Our North Carolina family voted
Kerry/Edwards, we believe in peace
and civility like that shown out here.
Thankfully they have not taken the
Internet away from all of us
... at least not yet. Hillary 2008,
Bless all troops. Peace to All now!

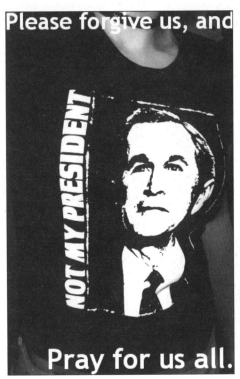

Please forgive us, and

NOT MY PRESIDENT

Pray for us all.

I apologize
for 51% of the
American people
who were stupid
enough to vote Bush
SORRY
WORLD!

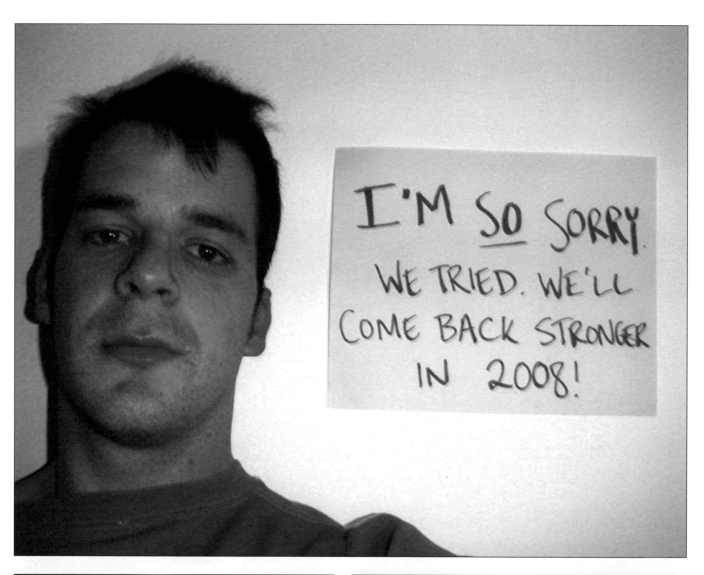

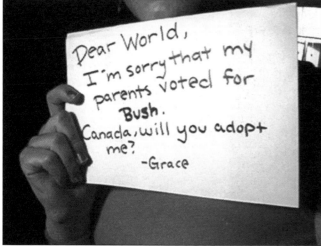

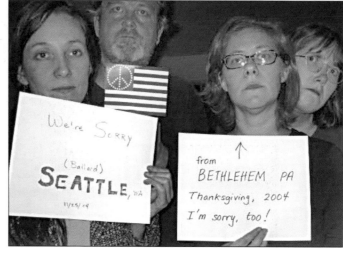

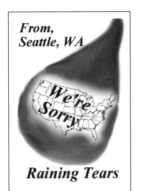

From, Seattle, WA
We're Sorry
Raining Tears

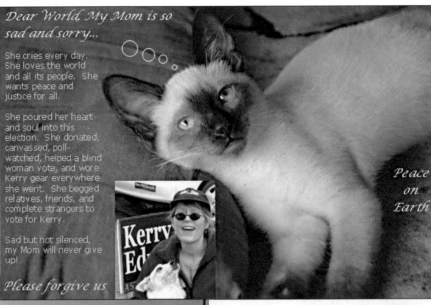

Dear World, My Mom is so sad and sorry...

She cries every day. She loves the world and all its people. She wants peace and justice for all.

She poured her heart and soul into this election. She donated, canvassed, poll-watched, helped a blind woman vote, and wore Kerry gear everywhere she went. She begged relatives, friends, and complete strangers to vote for Kerry.

Sad but not silenced, my Mom will never give up!

Please forgive us

Peace on Earth

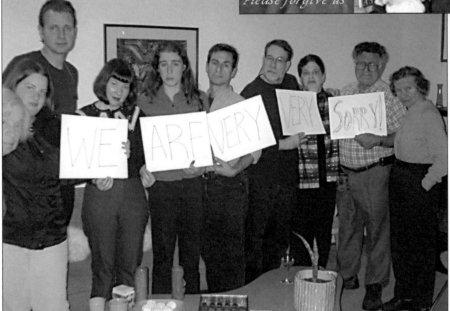

WE ARE VERY VERY SORRY!

"He who learns must suffer. And even in our sleep, pain that cannot forget falls drop by drop upon the heart, and in our own despair, against our will, comes wisdom to us by the awful grace of God."
- Robert F. Kennedy

CONNECTICUT AND MAINE ARE <u>VERY</u> <u>SORRY</u>, EVERYBODY

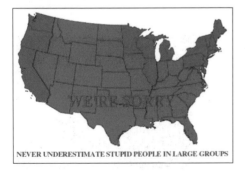

WE'RE SORRY

NEVER UNDERESTIMATE STUPID PEOPLE IN LARGE GROUPS

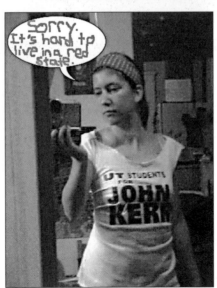

Sorry. It's hard to live in a red state.

What fools these mortals be! + Sorry!
- The non-voting-age US citizens

PS- Finland, does that offer still stand? I don't mind cold.

My apologies for America's first President with a DUI.

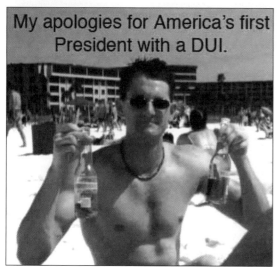

Dear World, especially the people of Iraq, we are so sorry here in Joshua Tree, California.

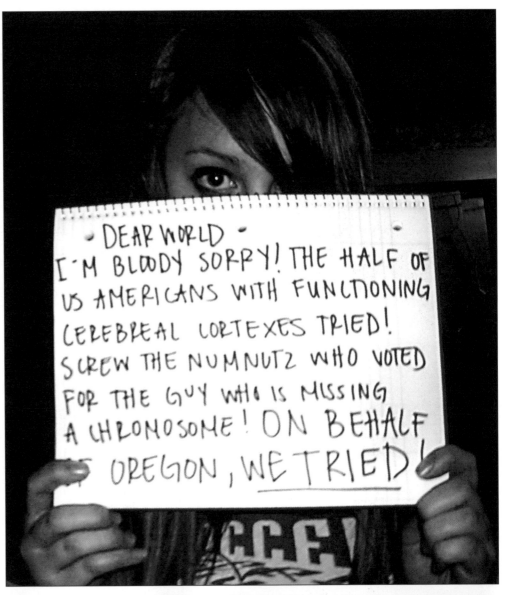

DEAR WORLD
I'M BLOODY SORRY! THE HALF OF
US AMERICANS WITH FUNCTIONING
CEREBREAL CORTEXES TRIED!
SCREW THE NUMNUTZ WHO VOTED
FOR THE GUY WHO IS MISSING
A CHROMOSOME! ON BEHALF
OF OREGON, WE TRIED!

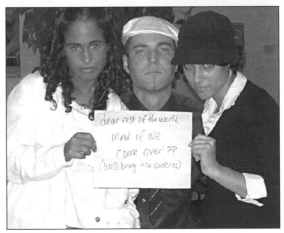

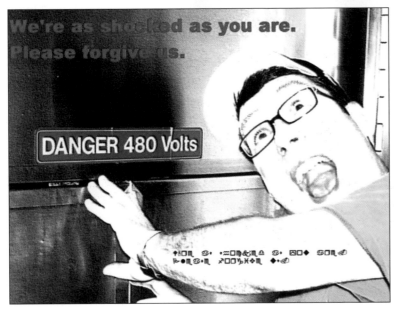

We're as shocked as you are.
Please forgive us.

DANGER 480 Volts

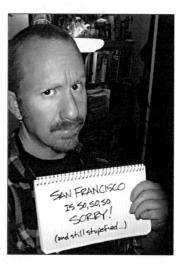

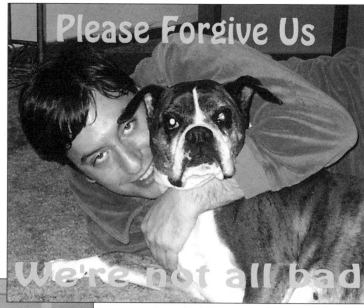

Please Forgive Us

We're not all bad

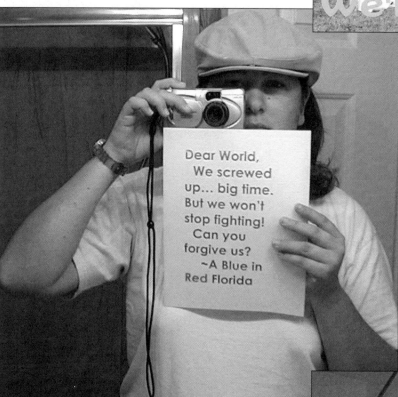

Dear World,
We screwed up... big time. But we won't stop fighting! Can you forgive us?
~A Blue in Red Florida

HERE IN THE NORTHWEST WE TRIED OUR BEST TO BE RID OF THE PEST, BUT WE FAILED. FORGIVE US WORLD.

I COULD'NT BE MORE SORRY.

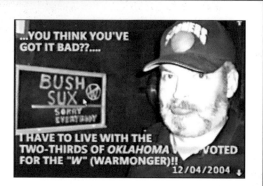

...YOU THINK YOU'VE GOT IT BAD??....

BUSH SUX, SORRY EVERYBODY

I HAVE TO LIVE WITH THE TWO-THIRDS OF OKLAHOMA WHO VOTED FOR THE "W" (WARMONGER)!!
12/04/2004

SO SORRY...
to the 1000s of innocent victims in Iraq,
to the future victims of our imperialistic policies,
to Alaska, our parks, air, water, animals,
to our gay & lesbian friends...
I tried, & will keep trying.
ROCHESTER, NY

Howard DEAN for America
www.DeanForAmerica.c

175

VERMONT SAYS NO TO WAR IN THE PERSIAN GULF

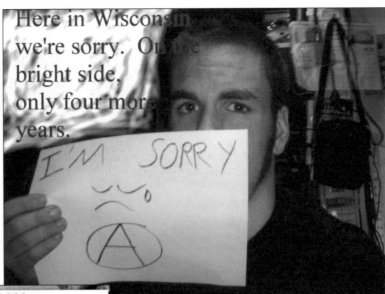

Here in Wisconsin we're sorry. On the bright side, only four more years.

I'M SORRY

If the electorial college hadn't failed us in 2000, we wouldn't be dealing with this shit now. Sorry World, we are suffering with you. New York

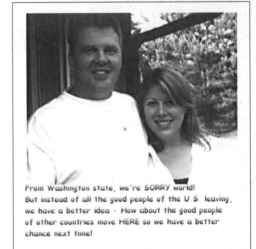

From Washington state, we're SORRY world! But instead of all the good people of the U.S. leaving, we have a better idea - How about the good people of other countries move HERE so we have a better chance next time!

www.schweitzerfamily.net

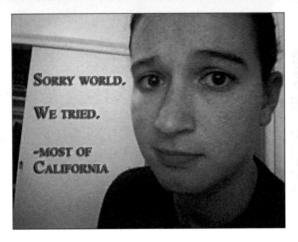

SORRY WORLD.

WE TRIED.

-MOST OF CALIFORNIA

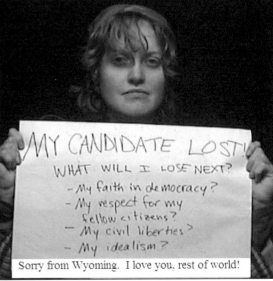

MY CANDIDATE LOST!
WHAT WILL I LOSE NEXT?
- My faith in democracy?
- My respect for my fellow citizens?
- My civil liberties?
- My idealism?

Sorry from Wyoming. I love you, rest of world!

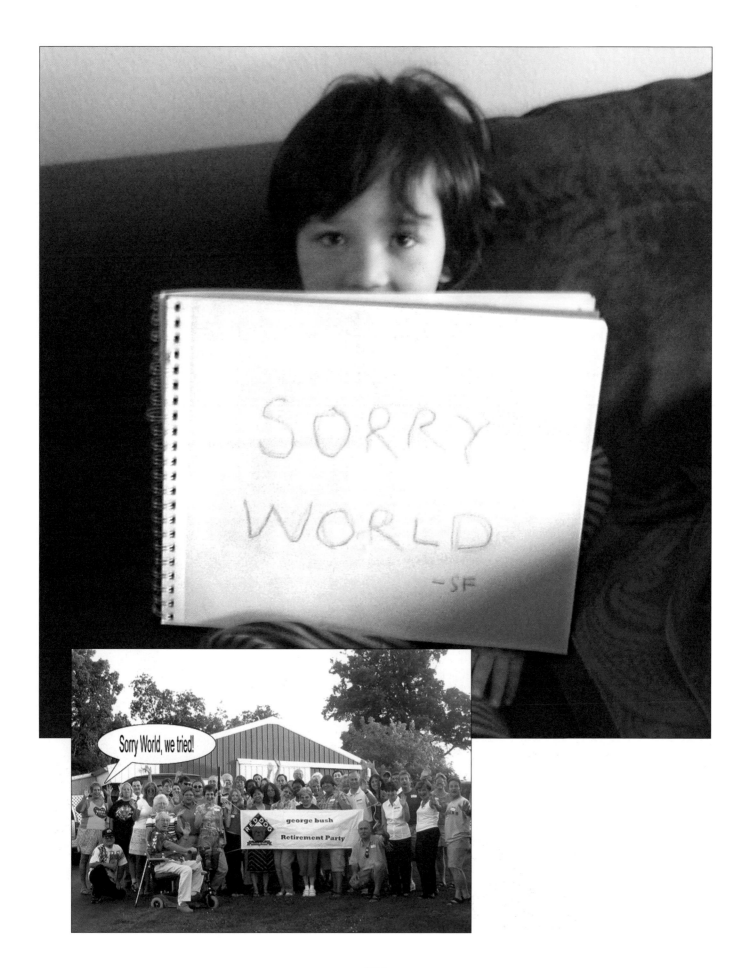

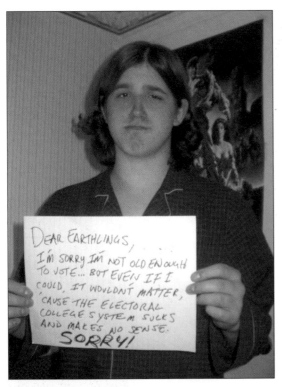

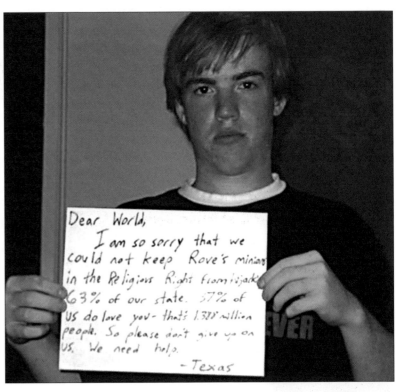

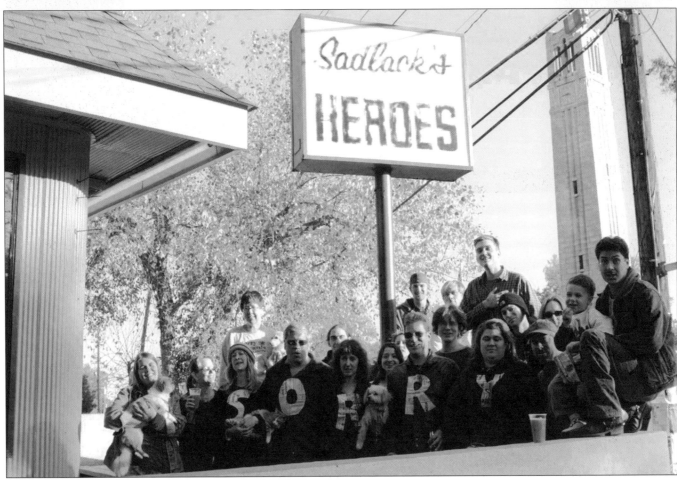

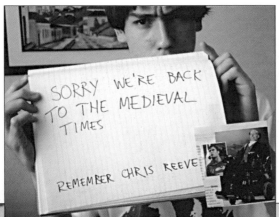

SORRY WE'RE BACK TO THE MEDIEVAL TIMES

REMEMBER CHRIS REEVE

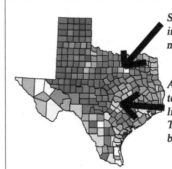

Some of us really tried in Fort Worth, TX, but no one was listening.

At least our capital went to Kerry this time, just like the US capital. Those that know Bush best, like him least.

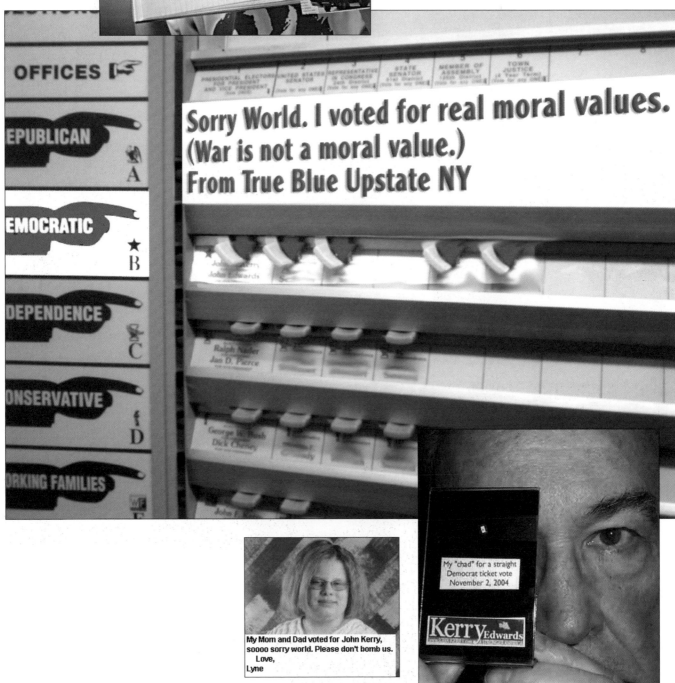

Sorry World. I voted for real moral values. (War is not a moral value.) From True Blue Upstate NY

My Mom and Dad voted for John Kerry, soooo sorry world. Please don't bomb us.
 Love,
Lyne

My "chad" for a straight Democrat ticket vote November 2, 2004

Kerry Edwards

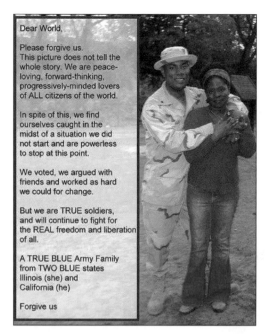

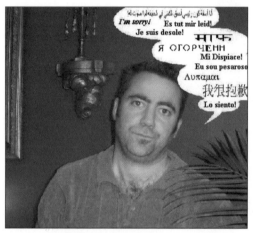

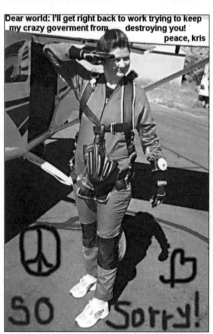

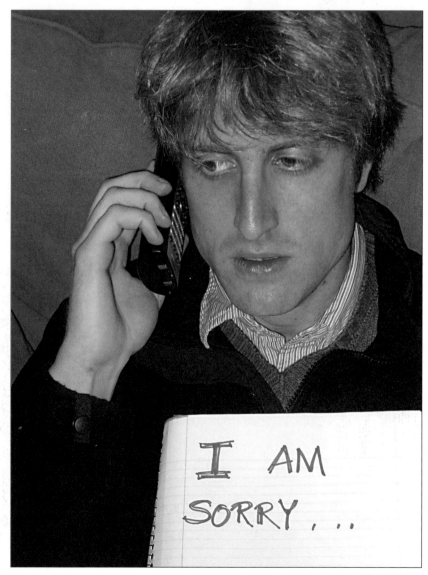

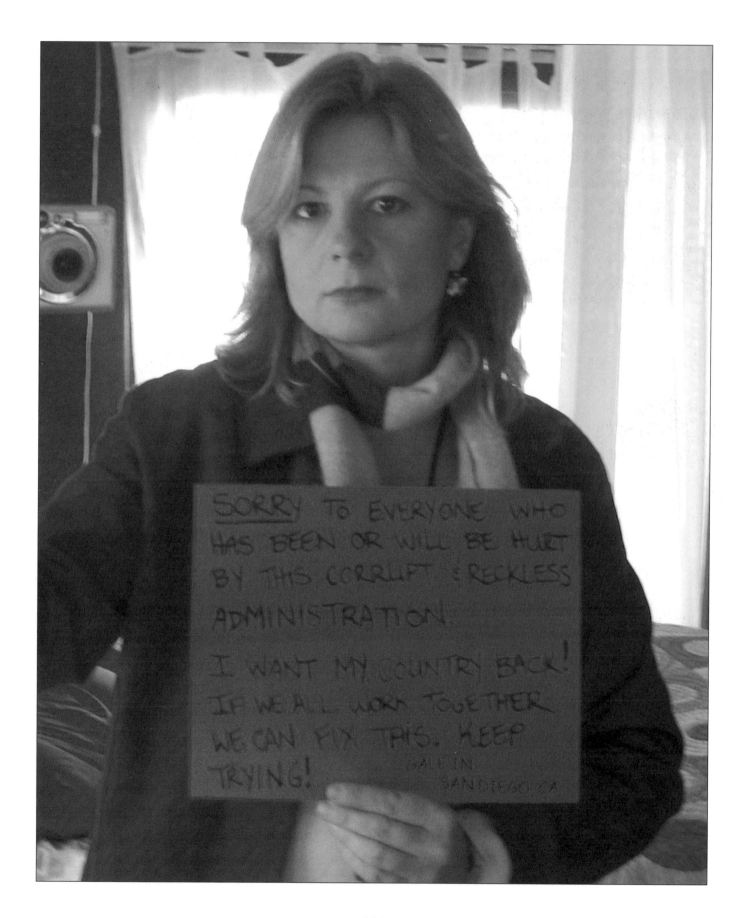

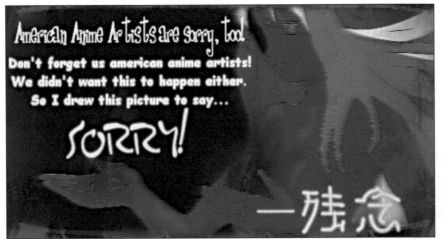

American Anime Artists are sorry, too!

Don't forget us american anime artists!
We didn't want this to happen either.
So I drew this picture to say...

SORRY!

一残念

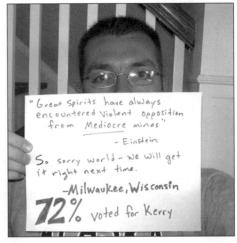

"Great Spirits have always encountered violent opposition from Mediocre minds"
— Einstein

So sorry world — We will get it right next time.

—Milwaukee, Wisconsin

72% voted for Kerry

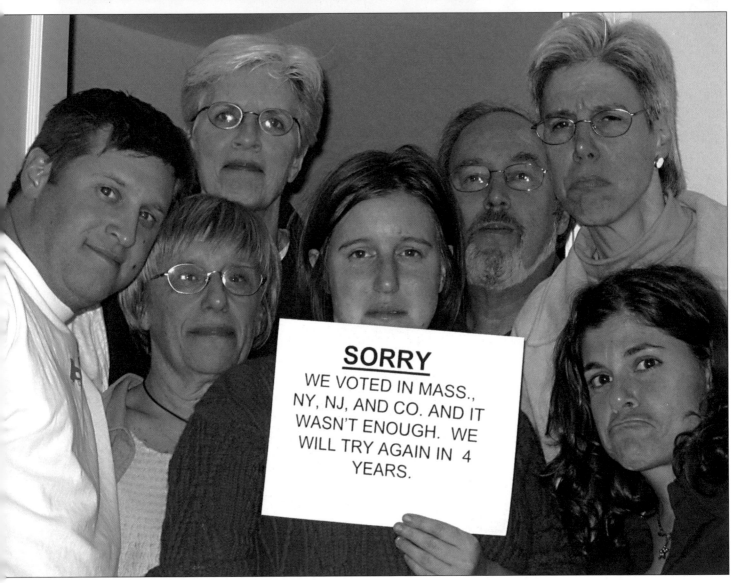

SORRY
WE VOTED IN MASS., NY, NJ, AND CO. AND IT WASN'T ENOUGH. WE WILL TRY AGAIN IN 4 YEARS.

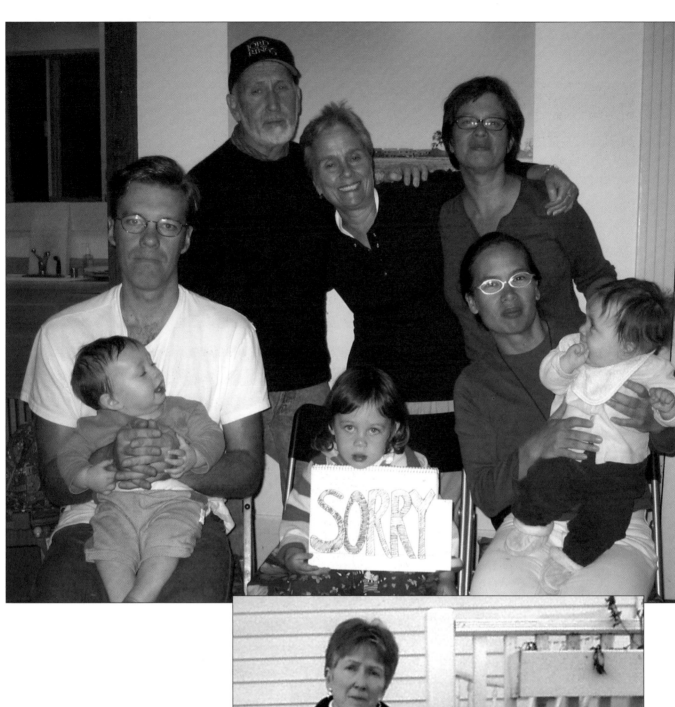

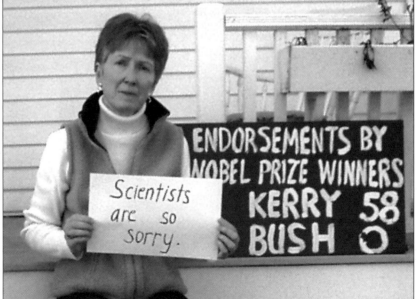

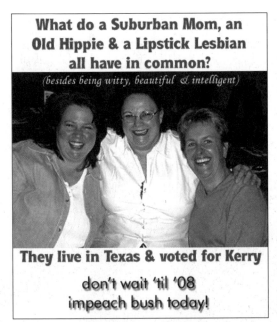

What do a Suburban Mom, an Old Hippie & a Lipstick Lesbian all have in common?

(besides being witty, beautiful & intelligent)

They live in Texas & voted for Kerry

don't wait 'til '08
impeach bush today!

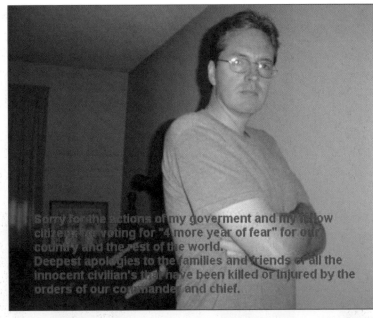

Sorry for the actions of my goverment and my fellow citizens for voting for "4 more year of fear" for our country and the rest of the world.
Deepest apologies to the families and friends of all the innocent civilian's that have been killed or injured by the orders of our commander and chief.

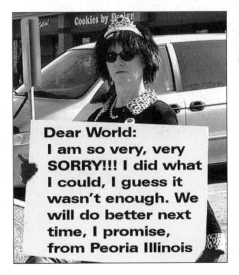

Dear World:
I am so very, very SORRY!!! I did what I could, I guess it wasn't enough. We will do better next time, I promise, from Peoria Illinois

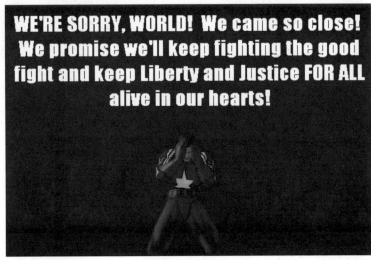

WE'RE SORRY, WORLD! We came so close! We promise we'll keep fighting the good fight and keep Liberty and Justice FOR ALL alive in our hearts!

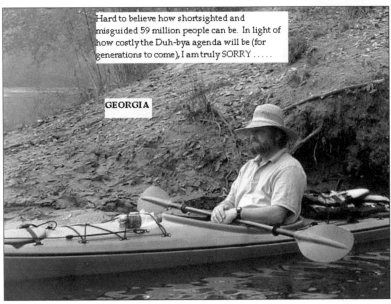

Hard to believe how shortsighted and misguided 59 million people can be. In light of how costly the Duh-bya agenda will be (for generations to come), I am truly SORRY

GEORGIA

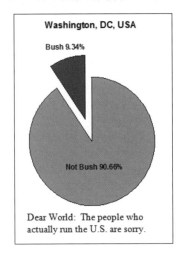

Washington, DC, USA

Bush 9.34%

Not Bush 90.66%

Dear World: The people who actually run the U.S. are sorry.

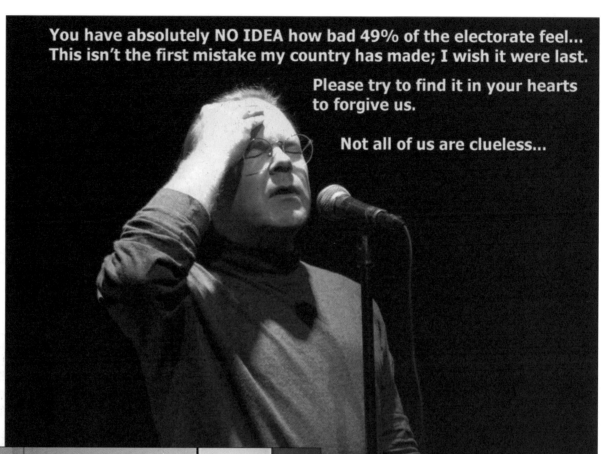

You have absolutely NO IDEA how bad 49% of the electorate feel...
This isn't the first mistake my country has made; I wish it were last.

Please try to find it in your hearts to forgive us.

Not all of us are clueless...

Yeah, We suck right now come back in four years!

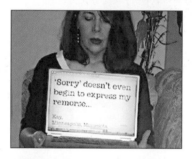

'Sorry' doesn't even begin to express my remorse...

Kay,
Minneapolis, Minnesota

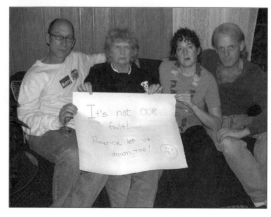

It's not OUR fault! America let us down too! :(

So sorry from Jacksonville, Alabama.
3 houses on our street had Kerry/Edwards signs in their yards and only 1 house had a Bush/Cheney sign. See, not all of us are stupid. Me and my husband and daughter are sooo considering moving to Canada. Who can we crash with???

185

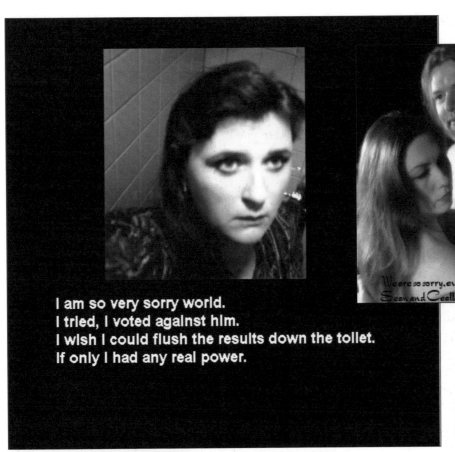

I am so very sorry world.
I trled, I voted agalnst hlm.
I wlsh I could flush the results down the toilet.
If only I had any real power.

We are so sorry, everyone.
Sean and Ceelleigh

Lullaby

O for a voice like thunder, and a tongue
to drown the throat of war! - When the senses
are shaken, and the soul is driven to madness,
who can stand?

When the souls of the oppressed
fight in the troubled air that rages,
who can stand?

When the whirlwind of fury comes from the
throne of god, when the frowns of his countenance
drive the nations together,
who can stand?

When Sin claps his broad wings over the battle,
and sails rejoicing in the flood of Death;
when souls are torn to everlasting fire,
and fiends of Hell rejoice upon the slain.
O who can stand?

O who hath caused this?
O who can answer at the throne of God?
The Kings and Nobles of the Land have done it!
Hear it not, Heaven, thy Ministers have done it!

William Blake

Leo Says:
My mommy and daddy are trying to help make things better.

GOD is NOT a Republican
...or a Democrat

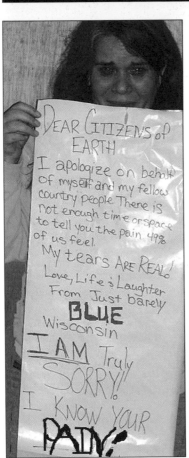

Dear Citizens of Earth
I apologize on behalf of myself and my fellow country people. There is not enough time or space to tell you the pain 49% of us feel.
My tears ARE REAL!
Love, Life & Laughter From Just barely
BLUE Wisconsin
I AM Truly SORRY!!
I KNOW YOUR PAIN!

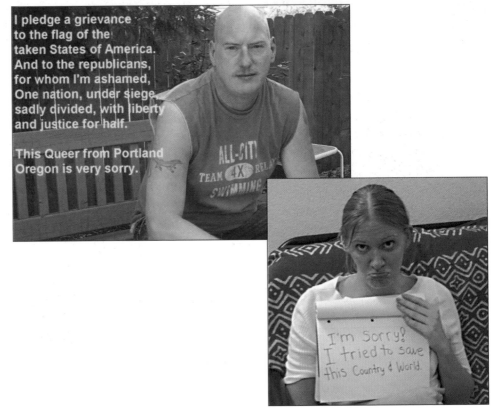

I pledge a grievance
to the flag of the
taken States of America.
And to the republicans,
for whom I'm ashamed,
One nation, under siege,
sadly divided, with liberty
and justice for half.

This Queer from Portland
Oregon is very sorry.

I'm Sorry!
I tried to save this Country & World.

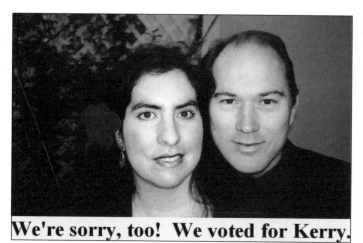

We're sorry, too! We voted for Kerry.

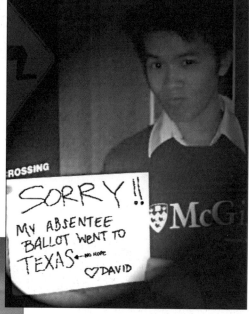

SORRY !!
MY ABSENTEE
BALLOT WENT TO
TEXAS ← NO HOPE
♡DAVID

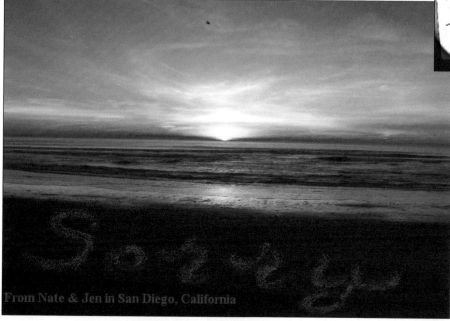

From Nate & Jen in San Diego, California

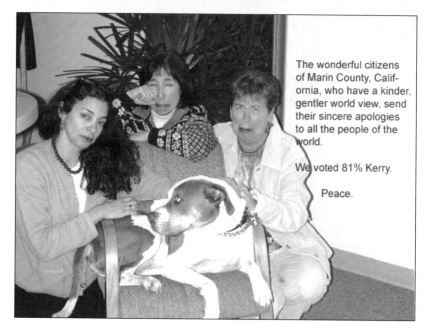

The wonderful citizens of Marin County, California, who have a kinder, gentler world view, send their sincere apologies to all the people of the world.

We voted 81% Kerry.

Peace.

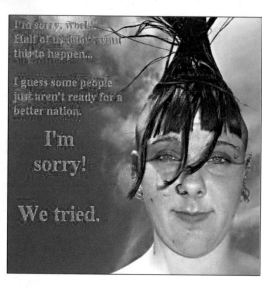

I'm sorry, world. Half of us didn't want this to happen...

I guess some people just aren't ready for a better nation.

I'm sorry!

We tried.

187

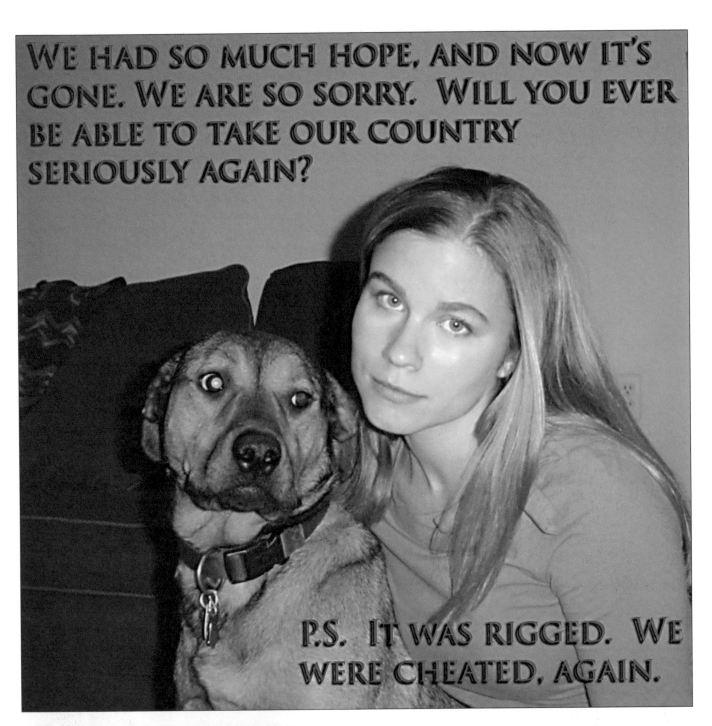

WE HAD SO MUCH HOPE, AND NOW IT'S GONE. WE ARE SO SORRY. WILL YOU EVER BE ABLE TO TAKE OUR COUNTRY SERIOUSLY AGAIN?

P.S. IT WAS RIGGED. WE WERE CHEATED, AGAIN.

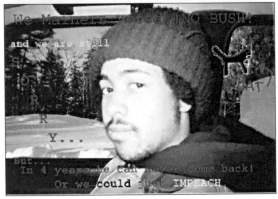

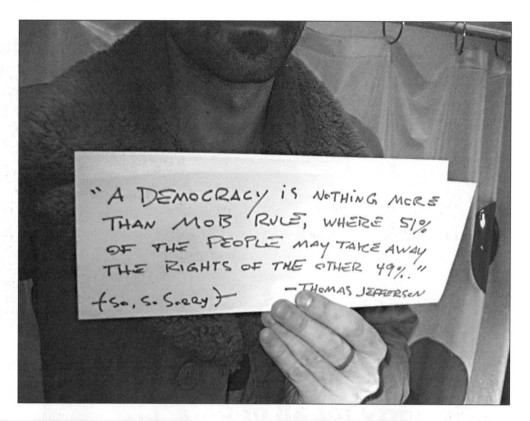

"A DEMOCRACY iS NoTHiNG MoRE THAN MoB RULE, WHERE 51% OF THE PEOPLE MAY TAKE AWAY THE RIGHTS OF THE OTHER 49%."

—THOMAS JEFFERSON

{So, So Sorry}

I am sorry.

We are not just responsible for an election, but we own the fruit of that election. We buy the bullets that kill We own the court that will address Roe

We are a country that has lost our way we are occupying a different country. We are threatening soveriegn nations.

Every Iraqi and American mother, widow and orphan chooses their own forgiveness to give us or withhold.

I AM SORRY TO YOU ALL !!!

I thought I was engaged.. I was wrong I will fight harder and harder

Niskayuna,New York

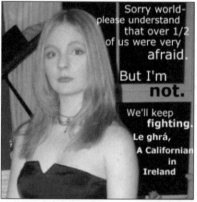

Sorry world- please understand that over 1/2 of us were very **afraid.**

But I'm **not.**

We'll keep **fighting.** Le ghrá, A Californian in Ireland

Richard Lai and Anthony Sahagun are truly sorry for being ugly...but also for not educating enough of America that many ethnicities such as Vietnamese (Richard) and Mexican (Anthony) live in this country also.

p.s. They don't believe in God either.

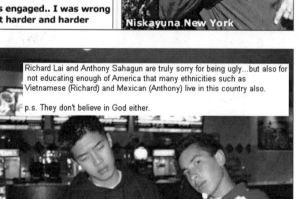

We really messed up...

..how could half the country be so blind?

But we tried, and even though we didn't win this time...he won't be around after 2008.

Hopefully we won't elect another mistake in the next eleciton.

Please forgive all of us.

Anyone in another country want to take me in for 4 years?

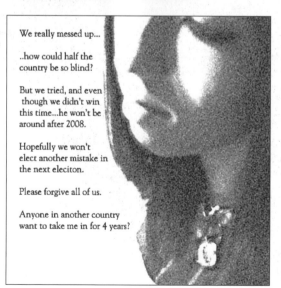

189

So Sorry

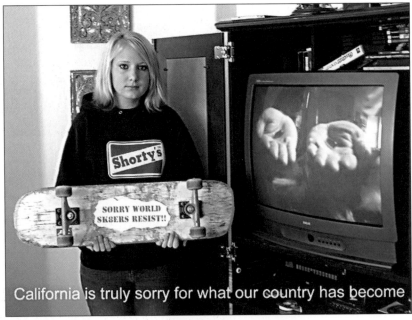

California is truly sorry for what our country has become

Bush ≠ My Moral Values
--So sorry for all of us *from Ohio*

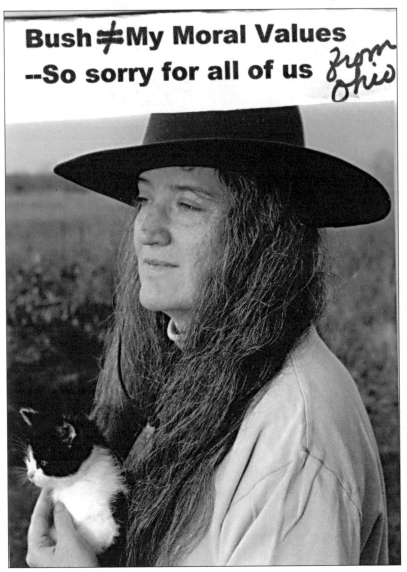

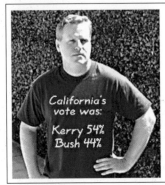

California's vote was:
Kerry 54%
Bush 44%

Never have sex with Republicans or conservatives. Just let them die out as a species, or succumb to inbreeding. They are the ones that use Viagra - ask Bob Dole. Before you do anything, ask questions!

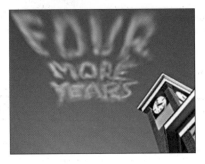

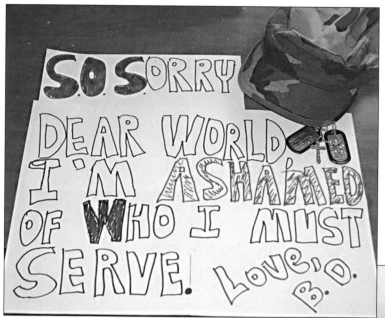

S.O. SORRY DEAR WORLD I'M ASHAMED OF WHO I MUST SERVE. Love, B.O.

Where The Mind is Without Fear

Where the mind is without fear and the head is held high;
Where knowledge is free;
Where the world has not been broken up into fragments by narrow
 domestic walls;
Where words come out from the depth of truth;
Where tireless striving stretches its arms towards perfection;
Where the clear stream of reason has not lost its way into the
 dreary desert sand of dead habit;
Where the mind is led forward by thee into ever-widening thought
 and action--
Into that heaven of freedom, my Father, let my country awake.

 -- Rabindranath Tagore

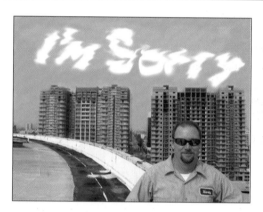

I'm Sorry

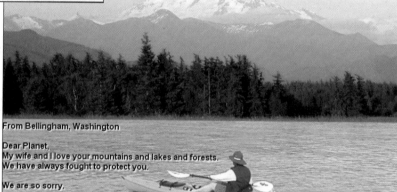

From Bellingham, Washington

Dear Planet,
My wife and I love your mountains and lakes and forests.
We have always fought to protect you.

We are so sorry.

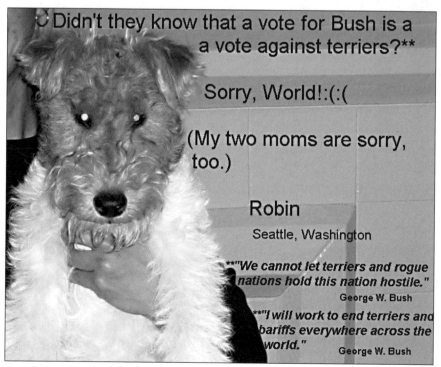

Didn't they know that a vote for Bush is a
a vote against terriers?**

Sorry, World!:(:(

(My two moms are sorry,
too.)

Robin

Seattle, Washington

**"We cannot let terriers and rogue
nations hold this nation hostile."
George W. Bush

**"I will work to end terriers and
bariffs everywhere across the
world."
George W. Bush

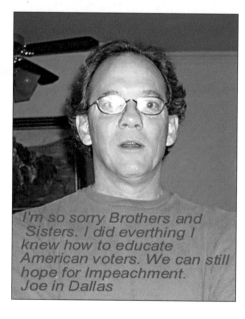

I'm so sorry Brothers and
Sisters. I did everthing I
knew how to educate
American voters. We can still
hope for Impeachment.
Joe in Dallas

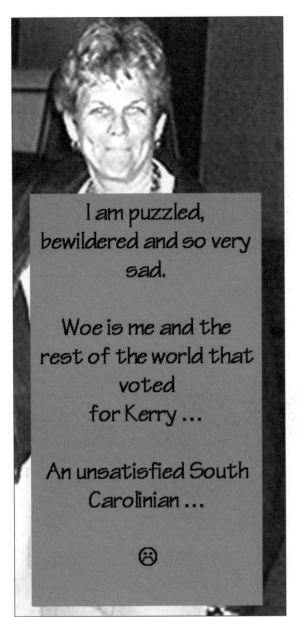

I am puzzled, bewildered and so very sad.

Woe is me and the rest of the world that voted for Kerry …

An unsatisfied South Carolinian …

☹

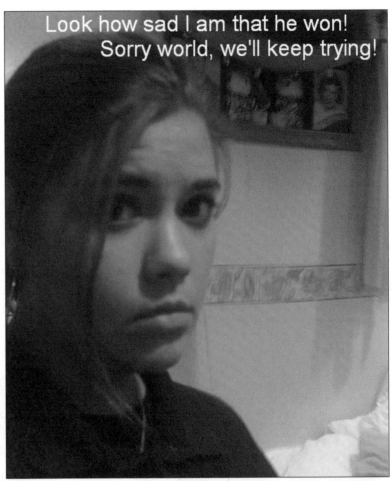

Look how sad I am that he won!
Sorry world, we'll keep trying!

For The Students At University of Iowa And The Intelligent 49% Of The United States…..I Say…

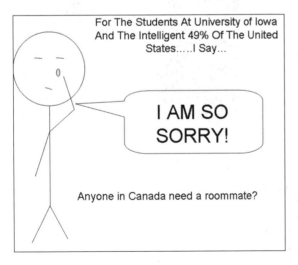

I AM SO SORRY!

Anyone in Canada need a roommate?

Cool Dudez in Sunglasses R Sorry !!!11

SORRY FROM MI, @ LEAST We're BLUE baby

192

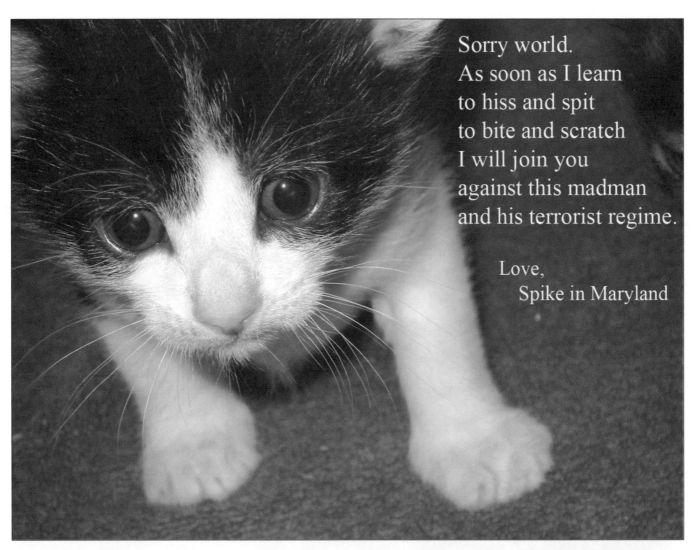

Sorry world.
As soon as I learn
to hiss and spit
to bite and scratch
I will join you
against this madman
and his terrorist regime.

Love,
 Spike in Maryland

Sorry World.

SORRY FOR THE OUTCOME !!!

...OHIO IS STILL COUNTING VOTES. A REQUEST FOR A RECOUNT IN DECEMBER IS PENDING. Let us all pray!

-blue in OHIO

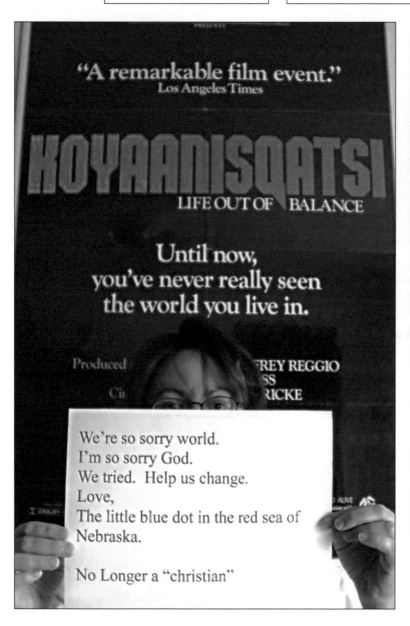

We're so sorry world.
I'm so sorry God.
We tried. Help us change.
Love,
The little blue dot in the red sea of Nebraska.

No Longer a "christian"

47% OF Colorado Is Sorry oh So SO Sorry Please be our friends

Sorry!! Can I Stay w/ A cute Canadian Girl?

Sorry, from a blue county in a red state.

Unfortunately, what happens in Vegas stays in Vegas, I guess.

Sorry again.

So Sorry,

It is going

to be a long

4 years...

Dogtired

TEXAS "SECURITY MOM'S" ARE SORRY TOO.

yeah... I guess "sorry" about covers it.

--Oregon

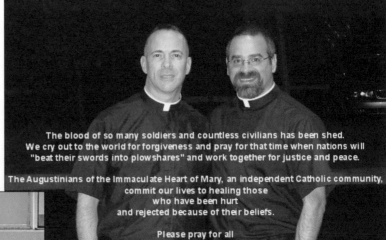

The blood of so many soldiers and countless civilians has been shed.
We cry out to the world for forgiveness and pray for that time when nations will
"beat their swords into plowshares" and work together for justice and peace.

The Augustinians of the Immaculate Heart of Mary, an independent Catholic community,
commit our lives to healing those
who have been hurt
and rejected because of their beliefs.

Please pray for all
who justify hatred and war
in the holy name of God,
and join us in working to become
one people, one family, one world.

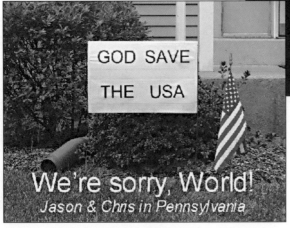

GOD SAVE THE USA

We're sorry, World!
Jason & Chris in Pennsylvania

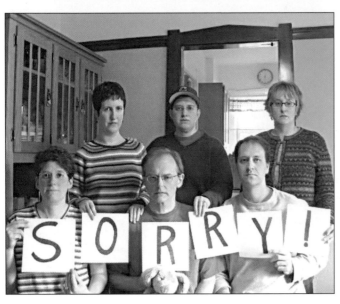

I am sorry for everyone that we must be around to bear witness to a once-great nation descending into the bread-and-circus stage of a failing democracy. I am sorry on account of the people who voted for tax cuts and decreased rights and living in fear over consideration for their fellow humans and the world on which we all live. I am sorry for the pain and suffering that has been caused by this administration, and I am sorry in advance for the damage that has yet to be done. I am sorry that every day, each of us has the ability to make America a better place, even on a small scale, and that, by and large, we do not take that chance. I am sorry that our failings hurt people who had no say in this administraton.

love, hope, and peace.
-Marina, New York

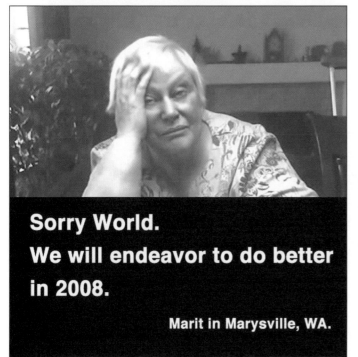

Sorry World.
We will endeavor to do better in 2008.

Marit in Marysville, WA.

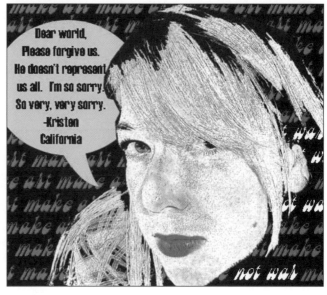

Dear world,
Please forgive us.
He doesn't represent
us all. I'm so sorry.
So very, very sorry.
-Kristen
California

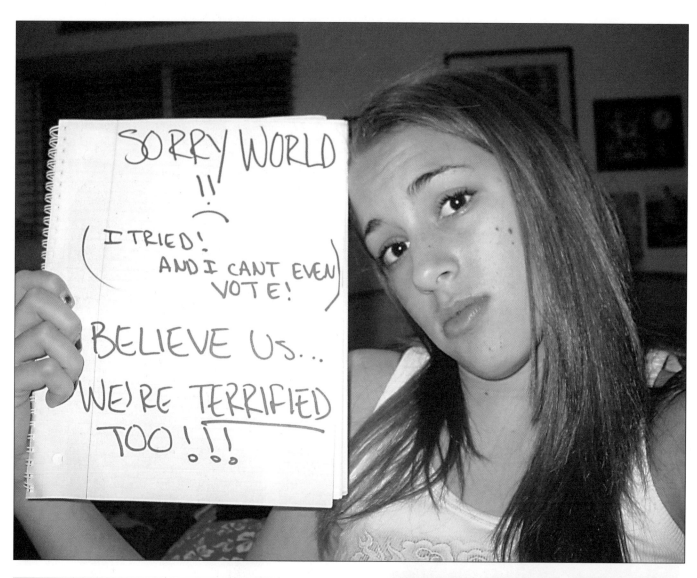

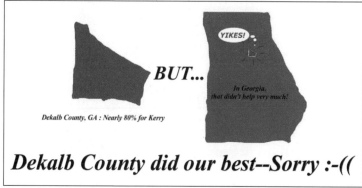

Dekalb County, GA : Nearly 80% for Kerry

Dekalb County did our best--Sorry :-((

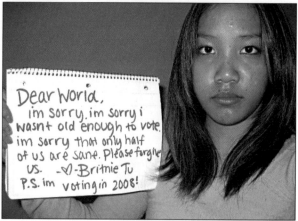

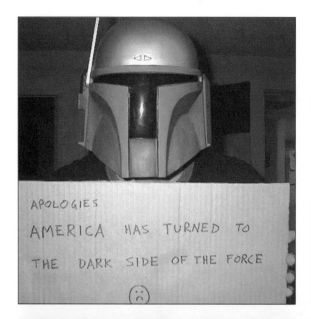

APOLOGIES

AMERICA HAS TURNED TO

THE DARK SIDE OF THE FORCE

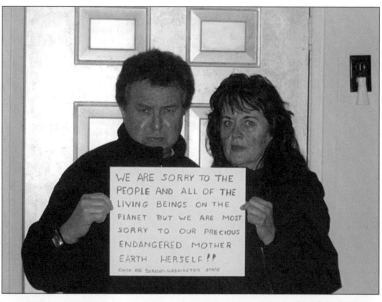

WE ARE SORRY TO THE
PEOPLE AND ALL OF THE
LIVING BEINGS ON THE
PLANET BUT WE ARE MOST
SORRY TO OUR PRECIOUS
ENDANGERED MOTHER
EARTH HERSELF!!

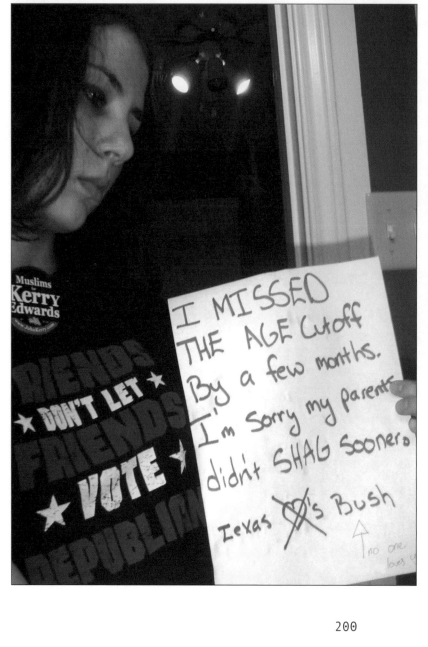

I MISSED
THE AGE Cutoff
By a few months.
I'm Sorry my parents
didn't SHAG Sooner.

Texas 's Bush

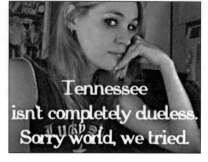

Tennessee
isn't completely clueless.
Sorry world, we tried.

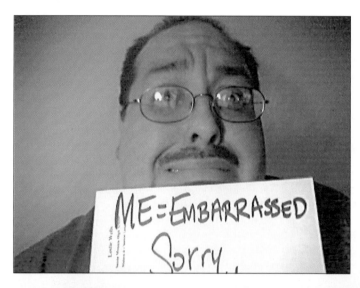

ME=EMBARRASSED

Sorry.

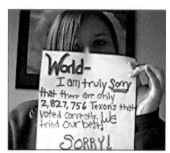

World—
I am truly sorry that there are only 2,827,756 Texans that voted correctly. We tried our best.
SORRY!

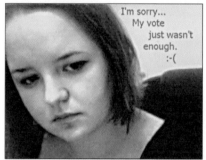

I'm sorry...
My vote just wasn't enough.
:-(

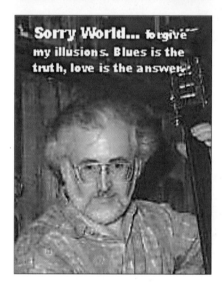

Sorry World... forgive my illusions. Blues is the truth, love is the answer.

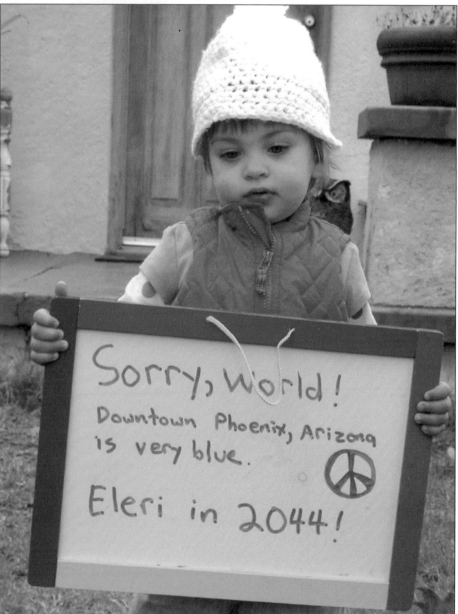

Sorry, World!
Downtown Phoenix, Arizona is very blue.

Eleri in 2044!

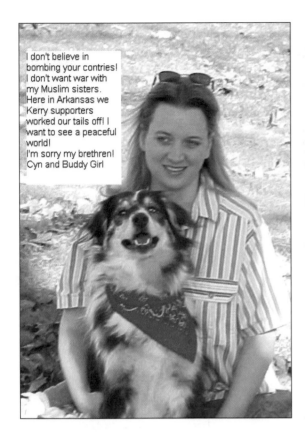

I don't believe in bombing your contries! I don't want war with my Muslim sisters. Here in Arkansas we Kerry supporters worked our tails off! I want to see a peaceful world!
I'm sorry my brethren!
Cyn and Buddy Girl

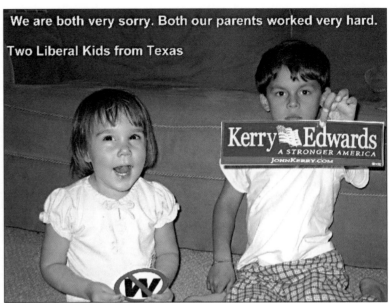

We are both very sorry. Both our parents worked very hard.

Two Liberal Kids from Texas

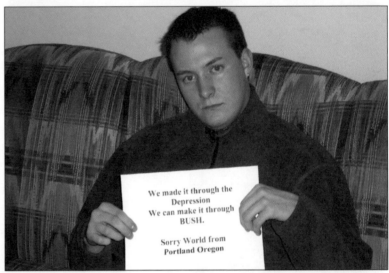

We made it through the Depression
We can make it through BUSH.

Sorry World from Portland Oregon

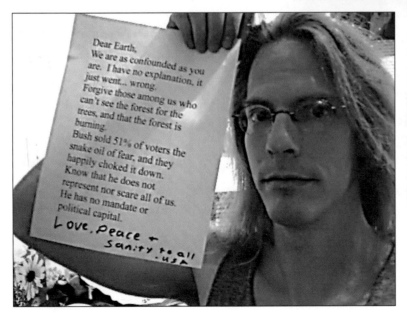

Dear Earth,
We are as confounded as you are. I have no explanation, it just went... wrong.
Forgive those among us who can't see the forest for the trees, and that the forest is burning.
Bush sold 51% of voters the snake oil of fear, and they happily choked it down.
Know that he does not represent nor scare all of us. He has no mandate or political capital.
Love, Peace + sanity to all .usa

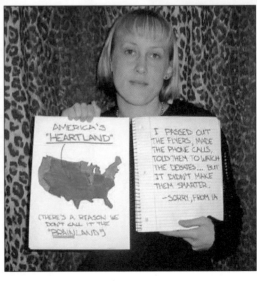

AMERICA'S "HEARTLAND"

(THERE'S A REASON WE DON'T CALL IT THE "BRAINLAND")

I PASSED OUT THE FLYERS, MADE THE PHONE CALLS, TOLD THEM TO WATCH THE DEBATES... BUT IT DIDN'T MAKE THEM SMARTER.

—SORRY, FROM IA

202

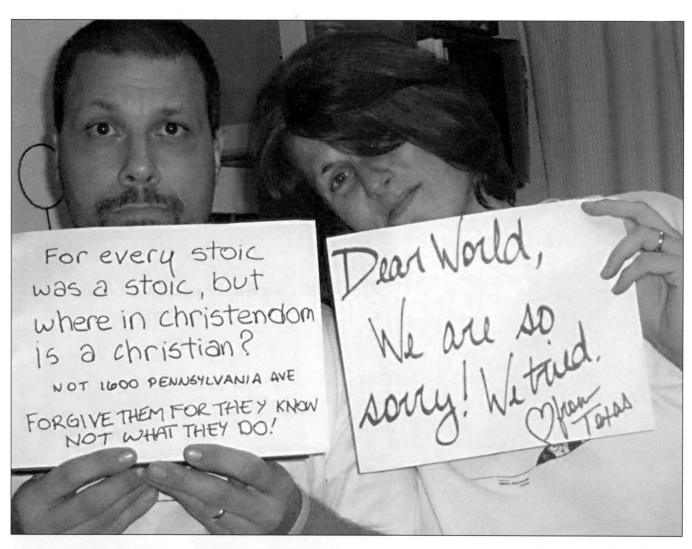

For every stoic
was a stoic, but
where in christendom
is a christian?

NOT 1600 PENNSYLVANIA AVE

FORGIVE THEM FOR THEY KNOW
NOT WHAT THEY DO!

Dear World,
We are so
sorry! We tried.
♡ from Texas

My humans are sorry.

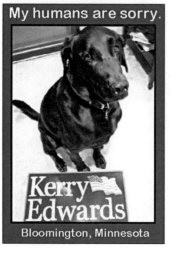

Kerry Edwards

Bloomington, Minnesota

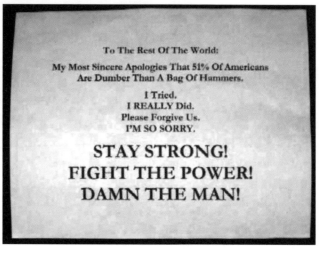

To The Rest Of The World:

My Most Sincere Apologies That 51% Of Americans
Are Dumber Than A Bag Of Hammers.

I Tried.
I REALLY Did.
Please Forgive Us.
I'M SO SORRY.

STAY STRONG!
FIGHT THE POWER!
DAMN THE MAN!

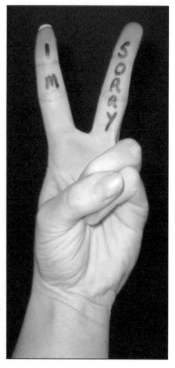

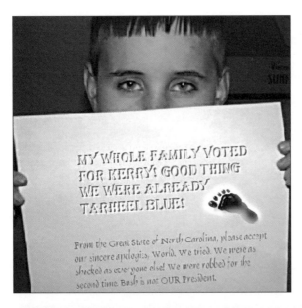

MY WHOLE FAMILY VOTED FOR KERRY! GOOD THING WE WERE ALREADY TARHEEL BLUE!

From the Great State of North Carolina, please accept our sincere apologies, World. We tried. We were as shocked as everyone else! We were robbed for the second time. Bush is not OUR President.

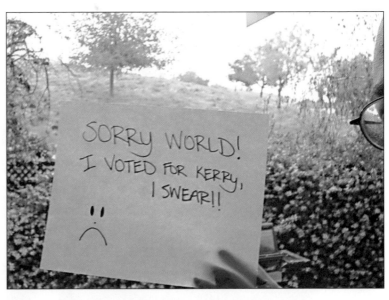

SORRY WORLD! I VOTED FOR KERRY, I SWEAR!!

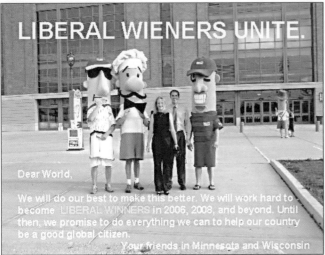

LIBERAL WIENERS UNITE.

Dear World,

We will do our best to make this better. We will work hard to become LIBERAL WINNERS in 2006, 2008, and beyond. Until then, we promise to do everything we can to help our country be a good global citizen.
Your friends in Minnesota and Wisconsin

Sorry :(
- from Syracuse, NY

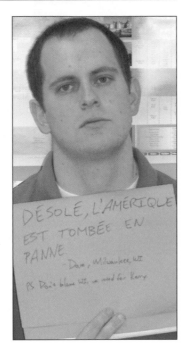

DÉSOLÉ, L'AMÉRIQUE EST TOMBÉE EN PANNE.
- Dave, Milwaukee, WI
PS Don't blame WI, we voted for Kerry.

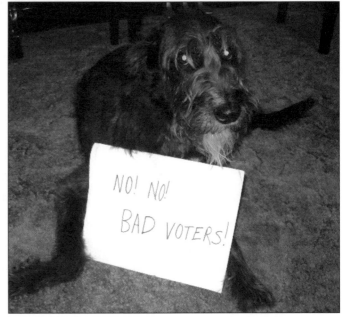

NO! NO! BAD VOTERS!

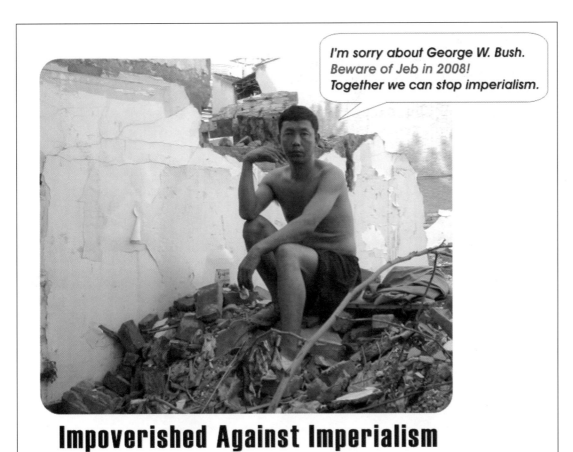

Impoverished Against Imperialism

Here in New York, we who have actually **experienced** terrorism firsthand are astonished and appalled by the outcome of this election. Who would have thought it could happen here! I apologize in advance for the evil deeds of this crooked regime.

Regards,
Sad In Brooklyn

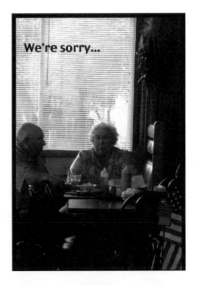

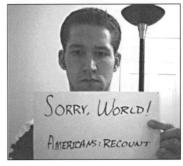

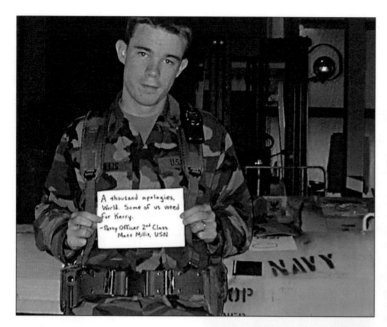

A thousand apologies,
World. Some of us voted
for Kerry.
-Petty Officer 2nd Class
Matt Mills, USN

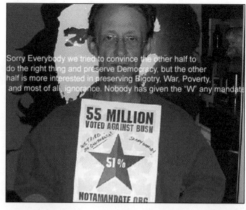

Sorry Everybody we tried to convince the other half to
do the right thing and preserve Democracy, but the other
half is more interested in preserving Bigotry, War, Poverty,
and most of all, ignorance. Nobody has given the "W" any mandate.

55 MILLION
VOTED AGAINST BUSH
51%
NOTAMANDATE.ORG

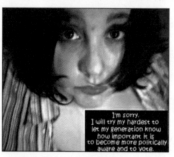

I'm sorry.
I will try my hardest to
let my generation know
how important it is
to become more politically
aware and to vote.

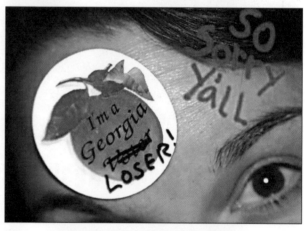

I'm a
Georgia
LOSER!

SO
SORRY
Y'ALL

X

world,
I am so sorry
I'M SO VERY SICKENED
OH, I AM SO SICKENED
noW so blue that we will
see so much red...
love, nyc

The people of Washington are
truly sorry. ...Even the ones
who can't vote yet.
We all tried the best we could.
Please remember democracy
for what it was, not what
it has become.

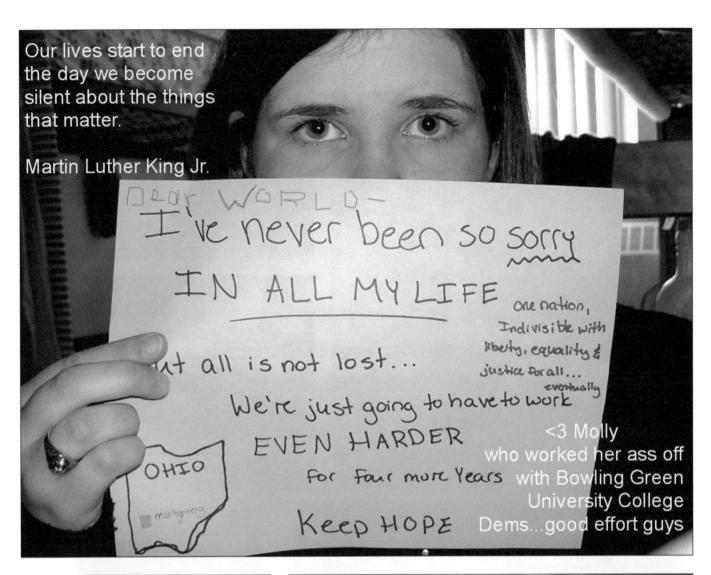

Our lives start to end the day we become silent about the things that matter.

Martin Luther King Jr.

Dear WORLD —
I've never been so sorry
IN ALL MY LIFE

one nation, Indivisible with liberty, equality & justice for all... eventually

but all is not lost...
We're just going to have to work
EVEN HARDER
for four more years

OHIO
Montgomery

Keep HOPE

<3 Molly who worked her ass off with Bowling Green University College Dems...good effort guys

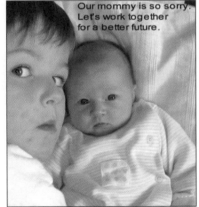

Our mommy is so sorry. Let's work together for a better future.

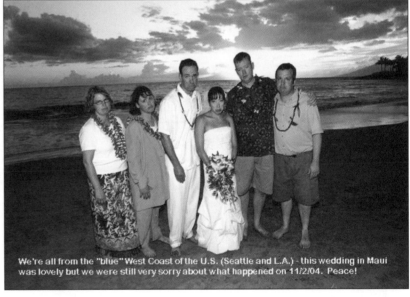

We're all from the "blue" West Coast of the U.S. (Seattle and L.A.) - this wedding in Maui was lovely but we were still very sorry about what happened on 11/2/04. Peace!

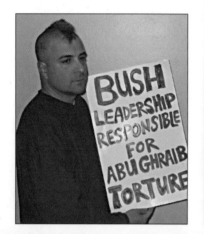

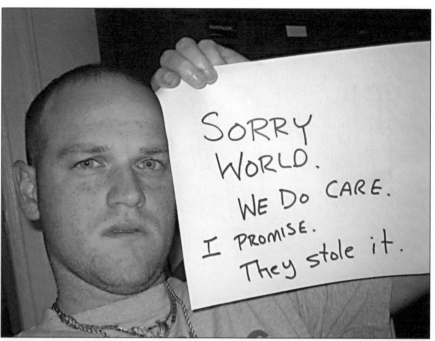

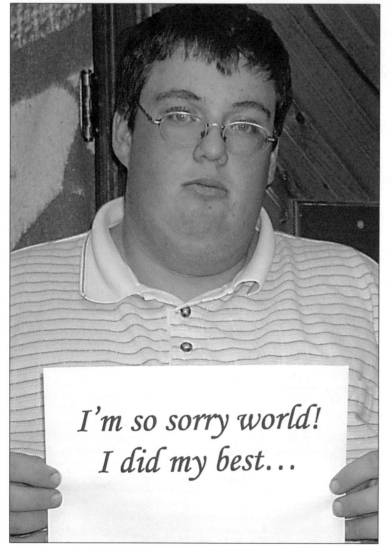

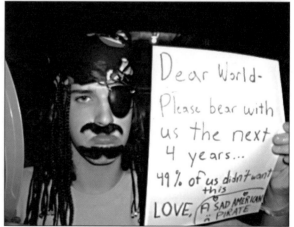

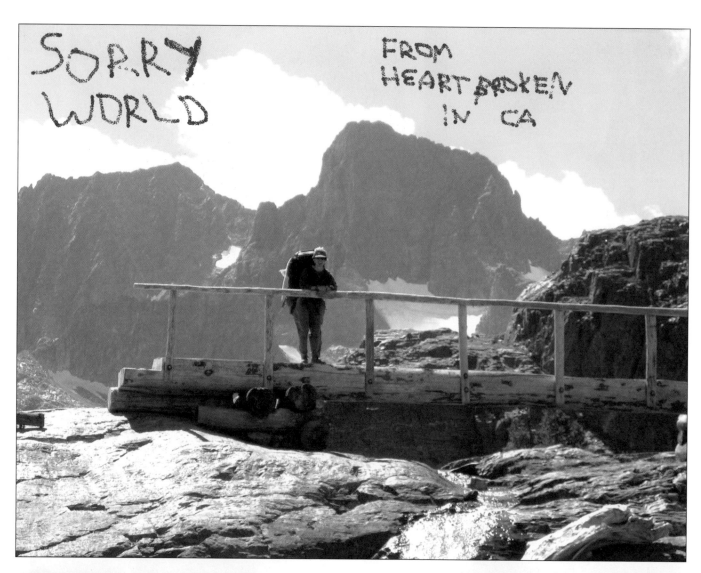

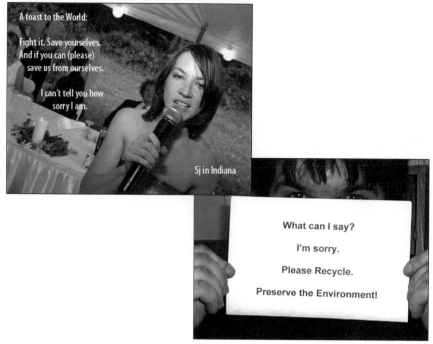

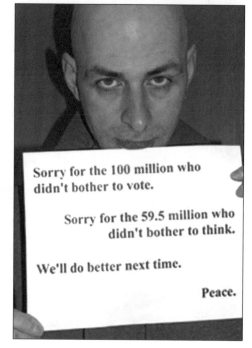

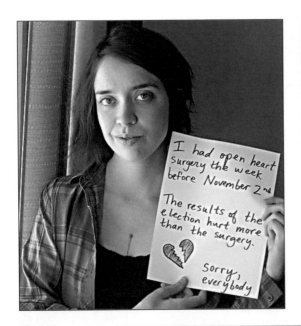

I had open heart surgery the week before November 2nd

The results of the election hurt more than the surgery.

Sorry, everybody

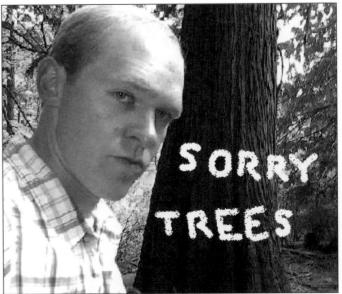

SORRY TREES

Dear World...

I am really sorry. Some of us are peaceful and wish the same thing the rest of the world does. Peace and Unity. The election was rigged and only the rich have a voice. And the rich make up only one percent of the population! As a college student, I am receiving very bad options for both my present and future. I am so so so sorry! I dont know what else to say...

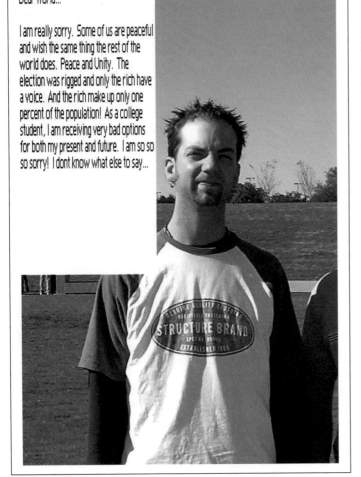

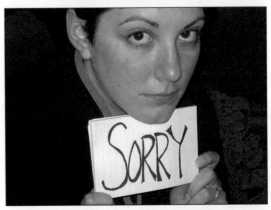

SORRY

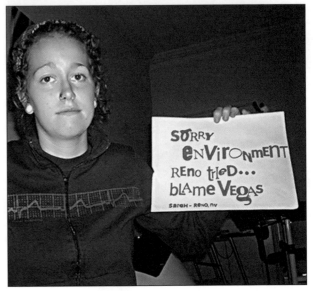

SORRY ENVIRONMENT RENO tRIED... blAME VEGAS

SARAH - RENO, NV

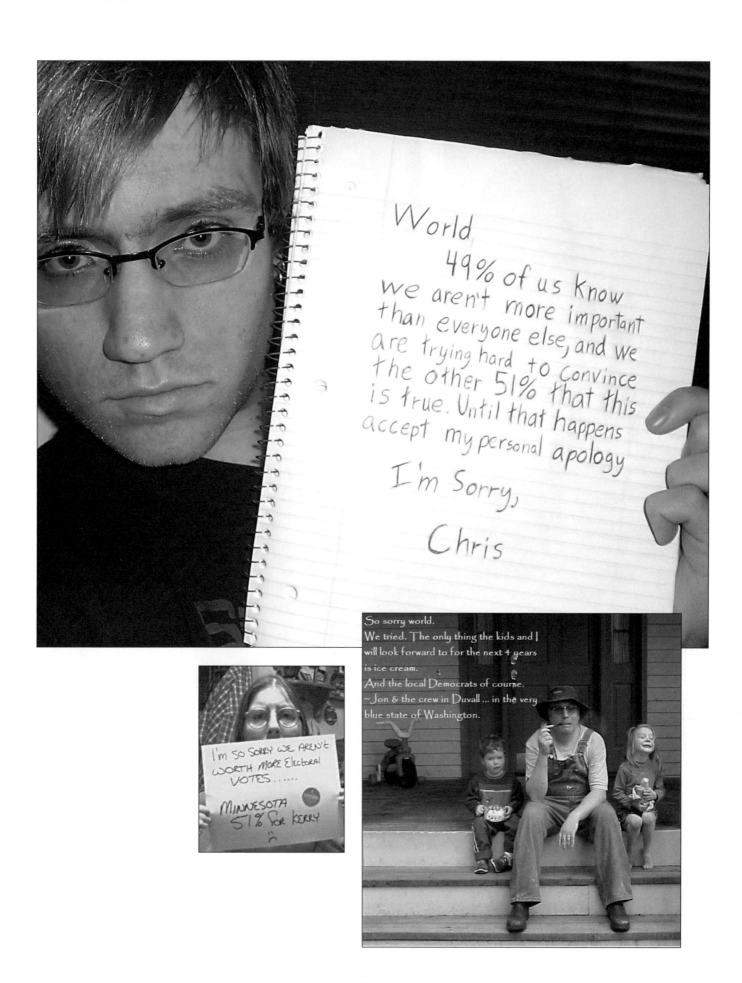

World,

49% of us know we aren't more important than everyone else, and we are trying hard to convince the other 51% that this is true. Until that happens accept my personal apology

I'm Sorry,

Chris

So sorry world.
We tried. The only thing the kids and I will look forward to for the next 4 years is ice cream.
And the local Democrats of course.
~Jon & the crew in Duvall ... in the very blue state of Washington.

I'm so sorry we aren't worth more Electoral votes......

Minnesota
51% for Kerry

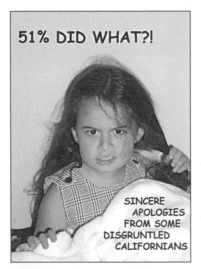

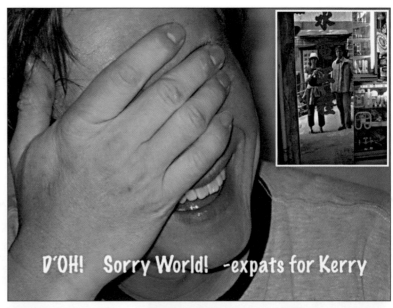

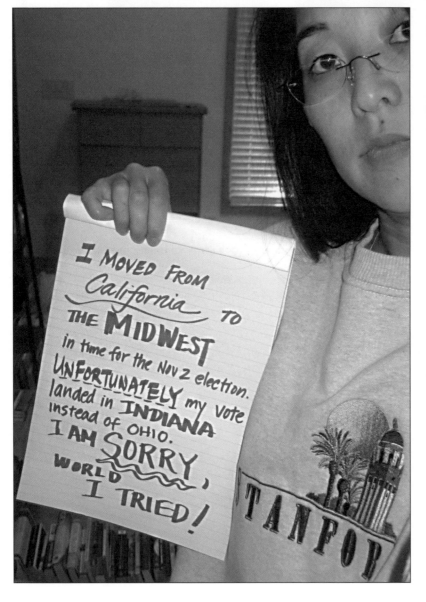

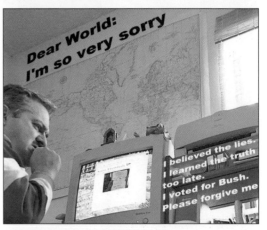

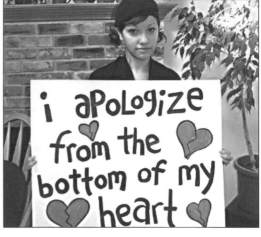

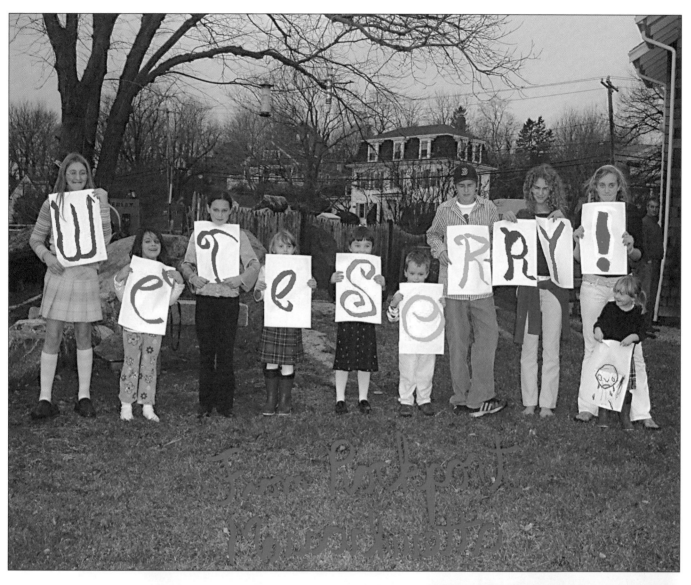

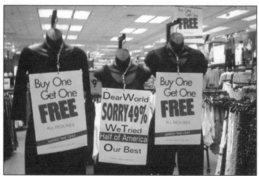

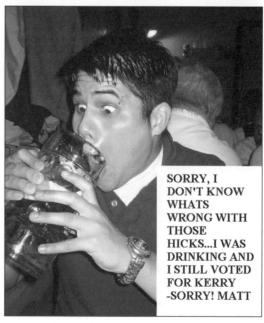

SORRY, I DON'T KNOW WHATS WRONG WITH THOSE HICKS...I WAS DRINKING AND I STILL VOTED FOR KERRY -SORRY! MATT

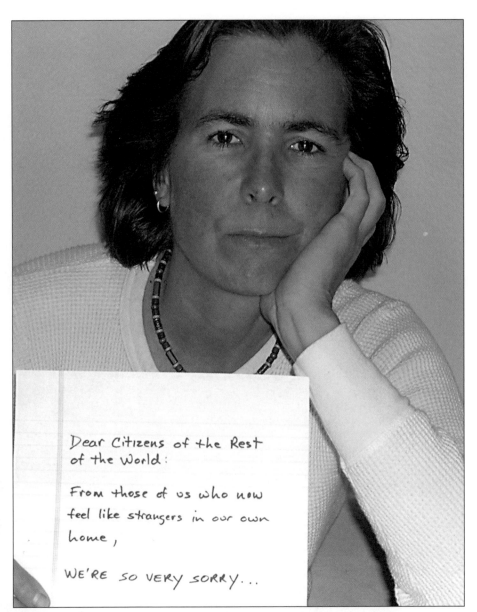

Dear Citizens of the Rest of the World:

From those of us who now feel like strangers in our own home,

WE'RE SO VERY SORRY...

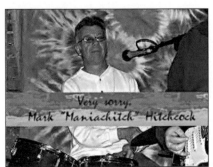

Very sorry.
Mark "Maniachitch" Hitchcock

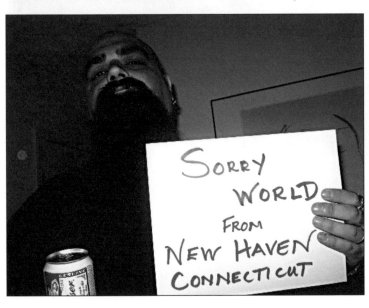

SORRY WORLD FROM NEW HAVEN CONNECTICUT

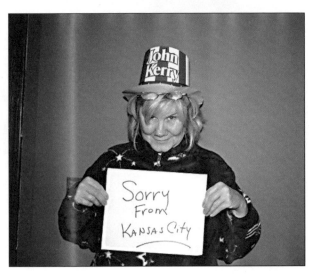

Sorry From KANSAS City

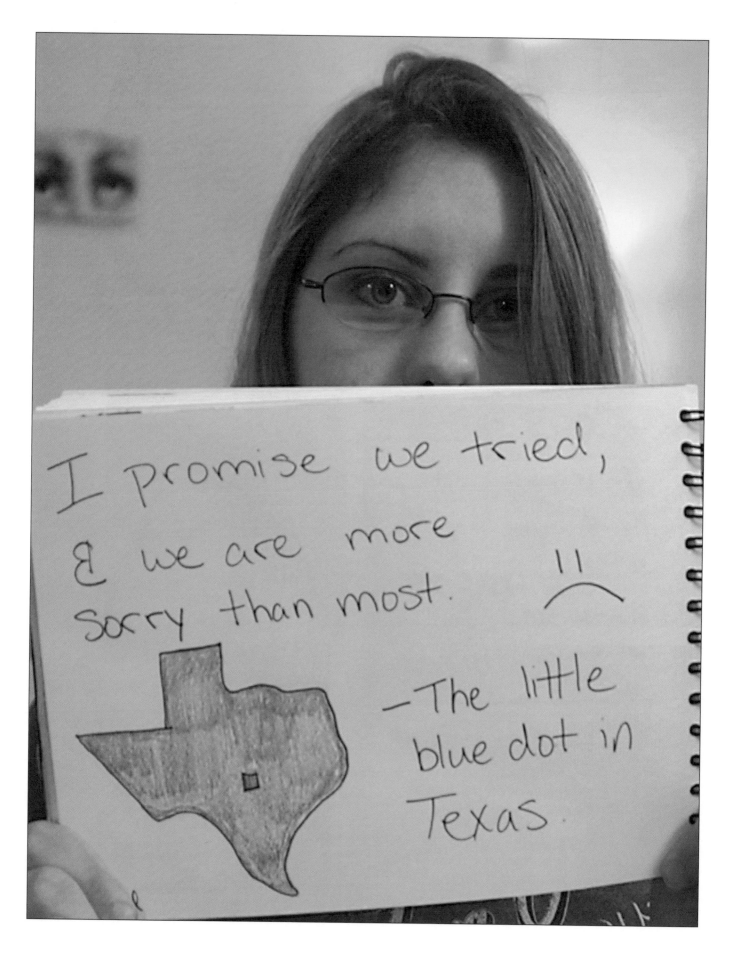

I promise we tried, & we are more sorry than most. ⌢"

—The little blue dot in Texas.

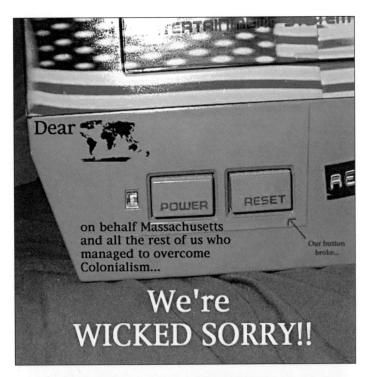

Dear 🗺,

on behalf Massachusetts and all the rest of us who managed to overcome Colonialism...

Our button broke...

We're WICKED SORRY!!

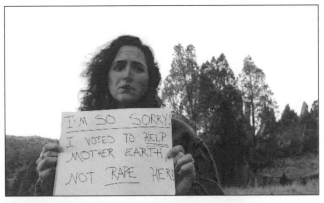

I'M SO SORRY! I VOTED TO HELP MOTHER EARTH, NOT RAPE HER!

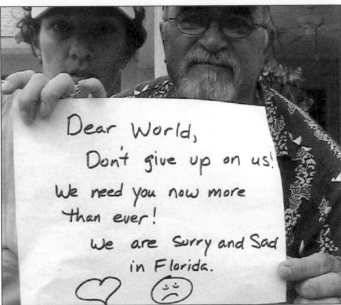

Dear World,
Don't give up on us! We need you now more than ever!
We are Sorry and Sad in Florida.

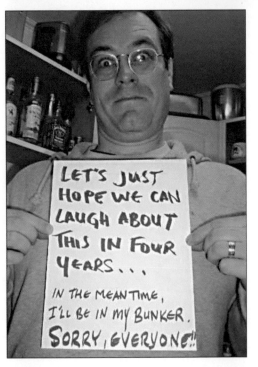

LET'S JUST HOPE WE CAN LAUGH ABOUT THIS IN FOUR YEARS...

IN THE MEANTIME, I'LL BE IN MY BUNKER.
SORRY, EVERYONE!!

I am so so sorry! But I still love my country and the people who live here, even if I don't agree with them. Freedom makes America strong. Those who forget this will live to regret it later.

xxx ooo - A Northwest girl

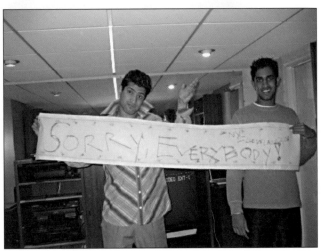

SORRY, EVERYBODY!

216

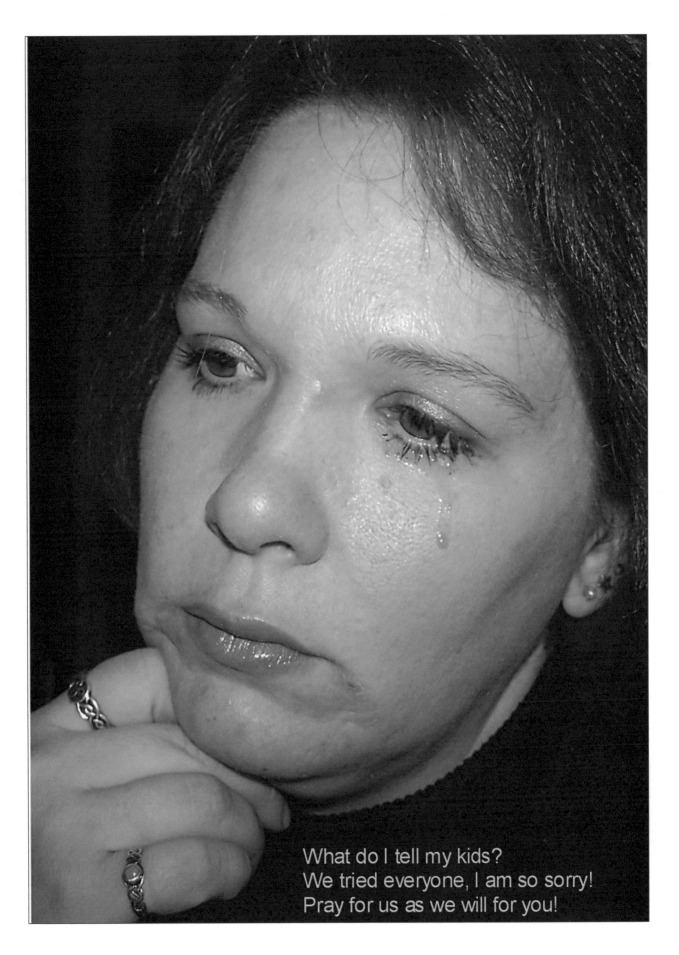

What do I tell my kids?
We tried everyone, I am so sorry!
Pray for us as we will for you!

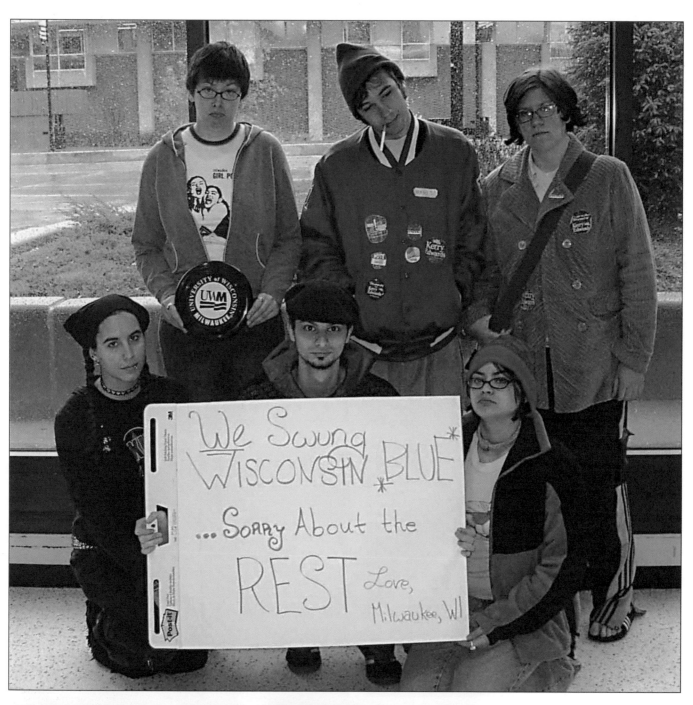

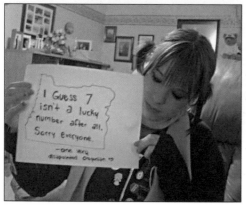

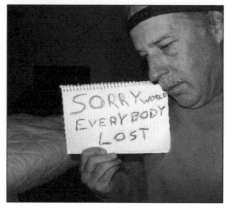

218

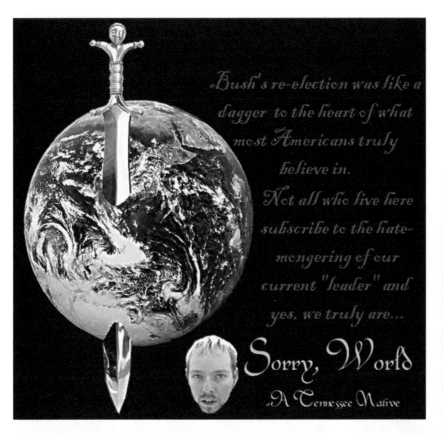

Bush's re-election was like a dagger to the heart of what most Americans truly believe in. Not all who live here subscribe to the hate-mongering of our current "leader" and yes, we truly are...

Sorry, World

A Tennessee Native

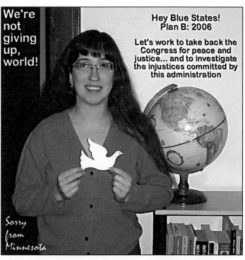

We're not giving up, world!

Hey Blue States! Plan B: 2006

Let's work to take back the Congress for peace and justice... and to investigate the injustices committed by this administration

Sorry from Minnesota

I did everything I could to stop them — I swear! Well, tomorrow is another day. See you in the streets. ♡

Sorry
Lo siento
Désolé
Entschuldigung
Spiacente
Droevig
Pesaroso
Очень жаль
Trist
对不起！

American AOL atheists are truly sorry... and JUST as disgusted! We did everything but pray!

Simply S.O.R.R.Y!

:(

Nina

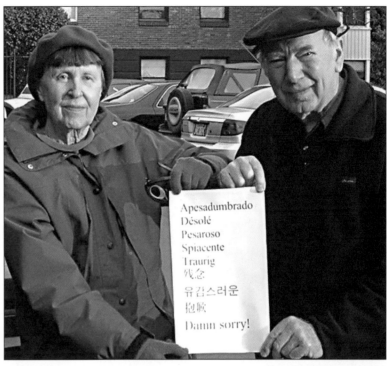

Apesadumbrado
Désolé
Pesaroso
Spiacente
Traurig
残念
유감스러운
抱歉

Damn sorry!

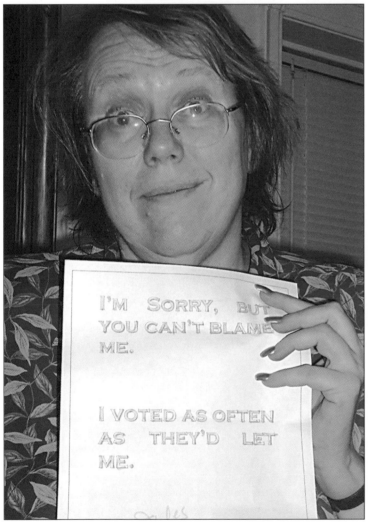

I'M SORRY, BUT YOU CAN'T BLAME ME.

I VOTED AS OFTEN AS THEY'D LET ME.

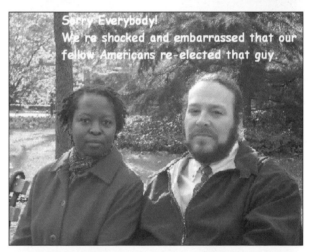

Sorry Everybody!
We're shocked and embarrassed that our fellow Americans re-elected that guy.

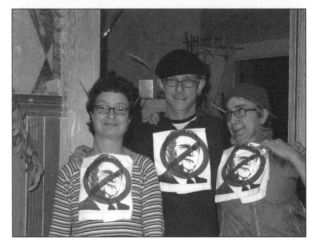

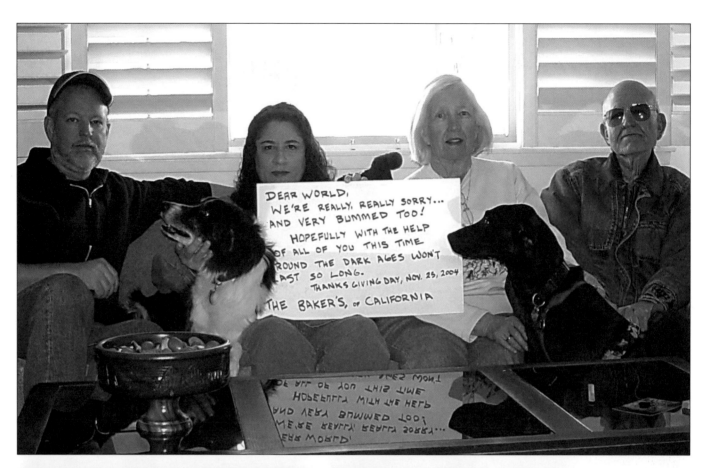

DEAR WORLD,
WE'RE REALLY, REALLY SORRY...
AND VERY BUMMED TOO!
HOPEFULLY WITH THE HELP
OF ALL OF YOU THIS TIME
AROUND THE DARK AGES WON'T
LAST SO LONG.
THANKS GIVING DAY, NOV. 25, 2004
THE BAKER'S, OF CALIFORNIA

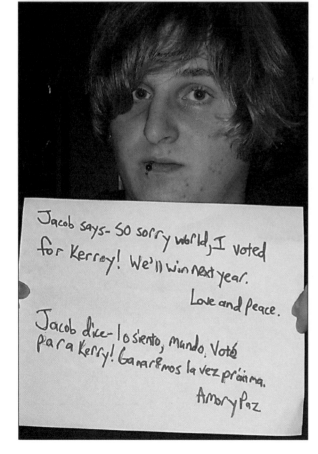

Jacob says- So sorry world, I voted for Kerroy! We'll win next year.
Love and peace.

Jacob dice- lo siento, mundo. Voté para Kerry! Ganaremos la vez próxima.
Amor y Paz

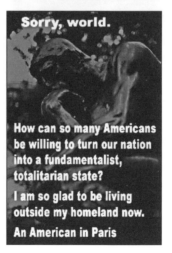

16 year olds can't do much... EXCEPt bE REALLY sorry

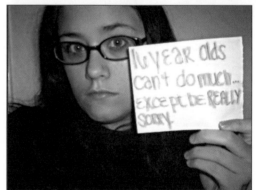

Sorry, world.

How can so many Americans be willing to turn our nation into a fundamentalist, totalitarian state?

I am so glad to be living outside my homeland now.

An American in Paris

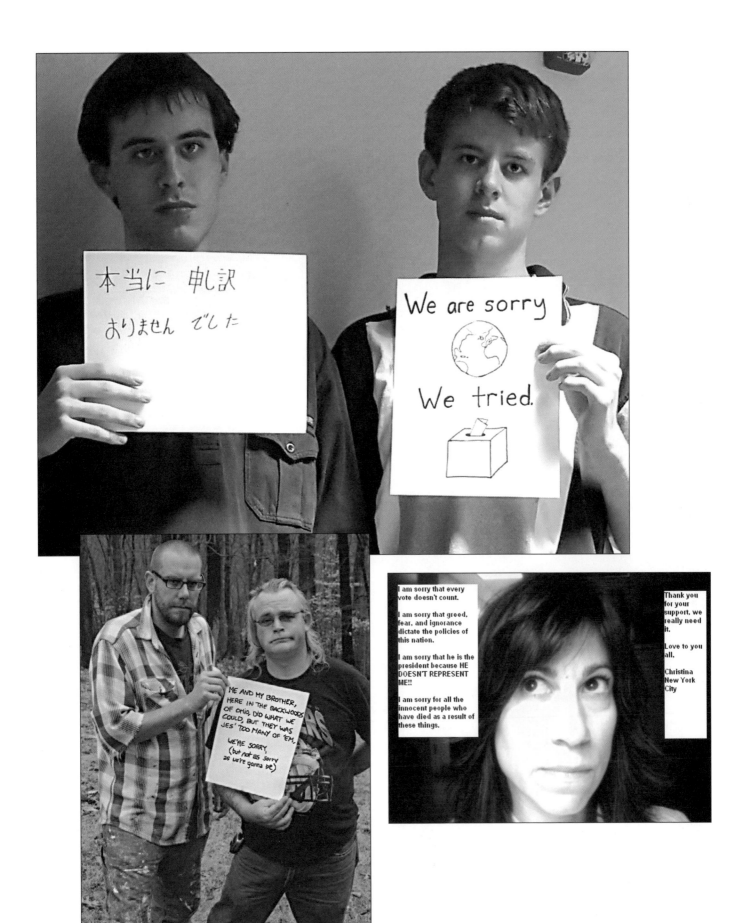

me and deez womens iz real sorry, we voted for da ova dude.

balex

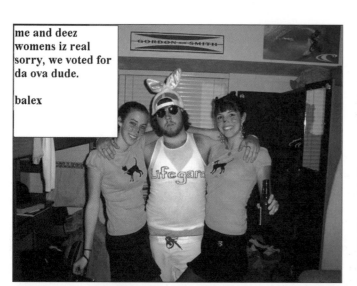

<u>70.4 %(the majority)of Americans did NOT vote for stupid curious George!</u>

40% who didn't vote at all (stupid people but not as stupid as Bush supporters)
29.4% who voted for Kerry(48% of the 60% Americans who voted-Very SmartPeople)
1.0% who voted for Nader (at least they didn't vote for Bush!)

Sorry, but I tried to help those stupid lazy non-voters cause I think most of them would've preferred Kerry. All I can say is I'm ashamed of some Americans and at least my state, Minnesota, did their part.

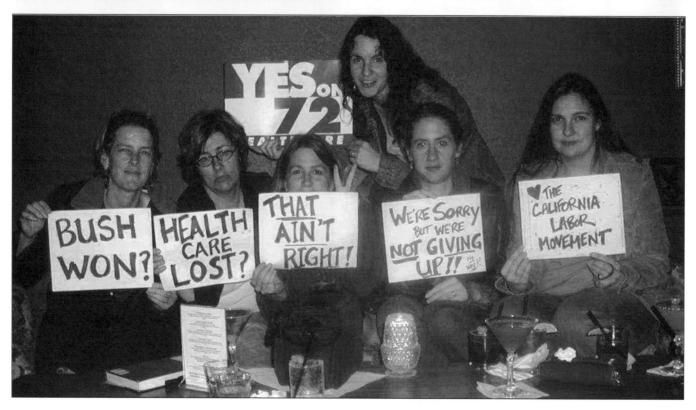

America needs YOU to vote Kerry-Edwards

Sep. 2004

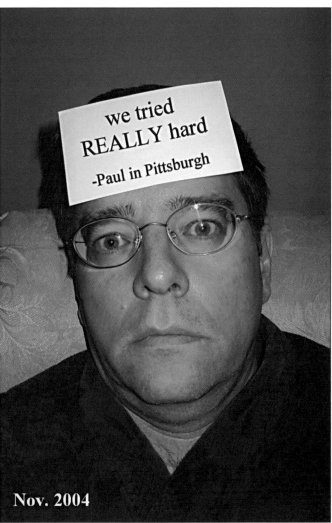

we tried REALLY hard

-Paul in Pittsburgh

Nov. 2004

MICHIGAN · 49% of US HAVE A BRAIN

On behalf of the U of M... sorry world.

88% for Kerry ~ You know how I feel.
Please world, come and visit me.
I get lonely sometimes.
Love, San Francisco, CA

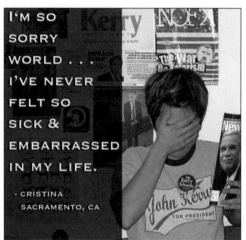

I'M SO SORRY WORLD... I'VE NEVER FELT SO SICK & EMBARRASSED IN MY LIFE.
— CRISTINA SACRAMENTO, CA

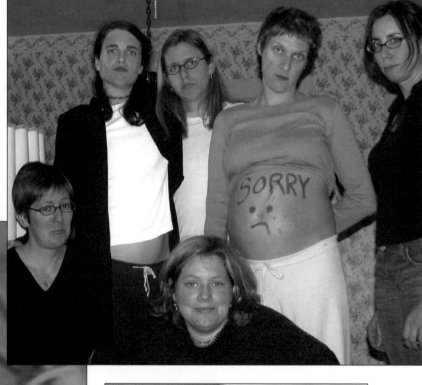

SORRY

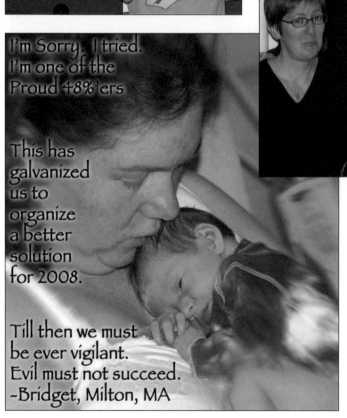

I'm Sorry. I tried.
I'm one of the
Proud 48%'ers

This has
galvanized
us to
organize
a better
solution
for 2008.

Till then we must
be ever vigilant.
Evil must not succeed.
-Bridget, Milton, MA

I'm sorry...and yeah, scared. Good luck! Don't let him push you around. If you see me roaming around your country, say hi! I probably moved there...I can't take it!!
Love, me in
PA

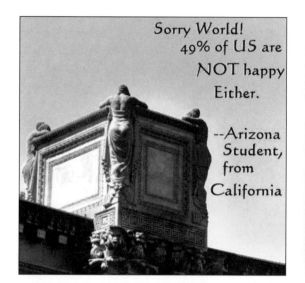

Sorry World!
49% of US are
NOT happy
Either.

--Arizona
Student,
from
California

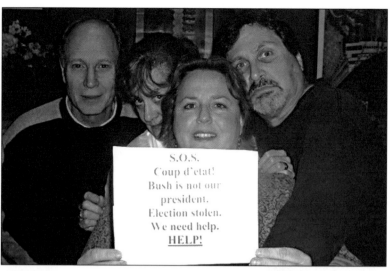

S.O.S.
Coup d'etat!
Bush is not our
president.
Election stolen.
We need help.
HELP!

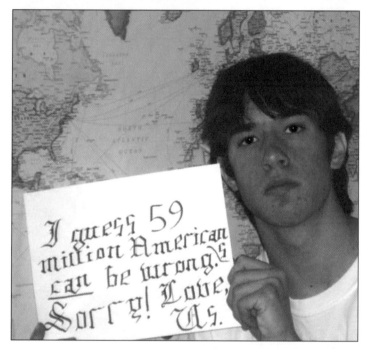

I guess 59
million American
can be wrongs
Sorry! Love,
US.

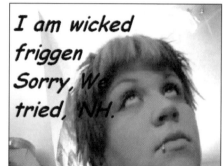

I am wicked
friggen
Sorry, We
tried, NH.

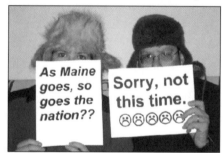

As Maine
goes, so
goes the
nation??

Sorry, not
this time.

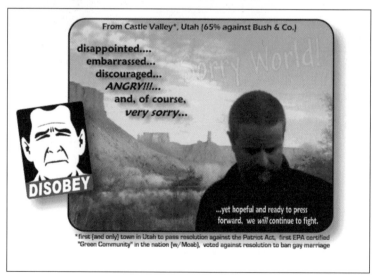

From Castle Valley*, Utah (65% against Bush & Co.)

disappointed....
embarrassed...
discouraged...
ANGRY!!!...
and, of course,
very sorry...

DISOBEY

Sorry World!

...yet hopeful and ready to press
forward, we will continue to fight.

*first (and only) town in Utah to pass resolution against the Patriot Act, first EPA certified
"Green Community" in the nation (w/Moab), voted against resolution to ban gay marriage

227

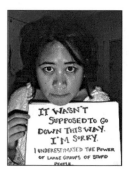

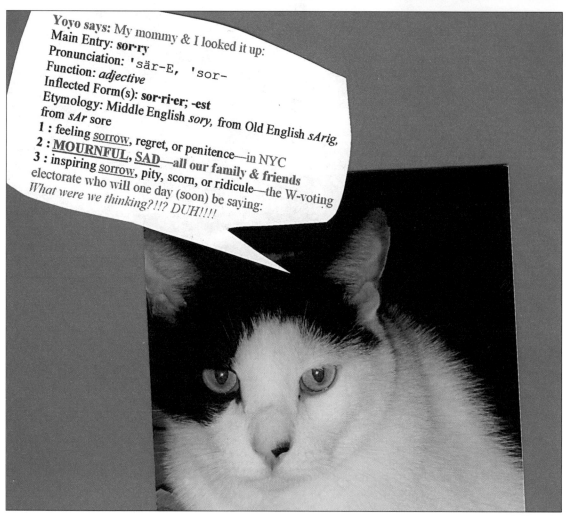

Yoyo says: My mommy & I looked it up:

Main Entry: **sor·ry**

Pronunciation: ˈsär-E, ˈsor-

Function: *adjective*

Inflected Form(s): **sor·ri·er; -est**

Etymology: Middle English *sory*, from Old English *sArig*, from *sAr* sore

1 : feeling <u>sorrow</u>, regret, or penitence—in NYC

2 : <u>**MOURNFUL**</u>, <u>**SAD**</u>—all our family & friends

3 : inspiring <u>sorrow</u>, pity, scorn, or ridicule—the W-voting electorate who will one day (soon) be saying: *What were we thinking?!!? DUH!!!!*

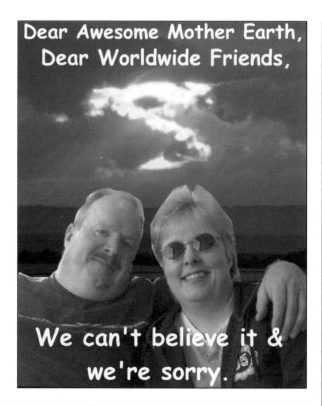

Dear Awesome Mother Earth,
Dear Worldwide Friends,

We can't believe it & we're sorry.

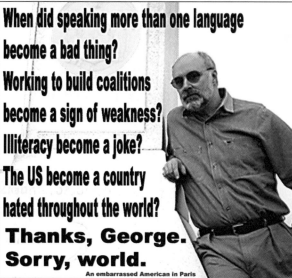

When did speaking more than one language become a bad thing?

Working to build coalitions become a sign of weakness?

Illiteracy become a joke?

The US become a country hated throughout the world?

Thanks, George.
Sorry, world.

An embarrassed American in Paris

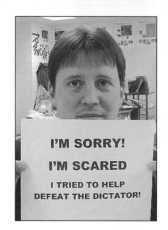

I'M SORRY!

I'M SCARED

I TRIED TO HELP
DEFEAT THE DICTATOR!

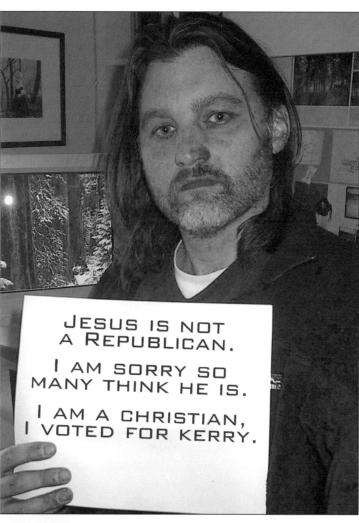

JESUS IS NOT A REPUBLICAN.

I AM SORRY SO MANY THINK HE IS.

I AM A CHRISTIAN, I VOTED FOR KERRY.

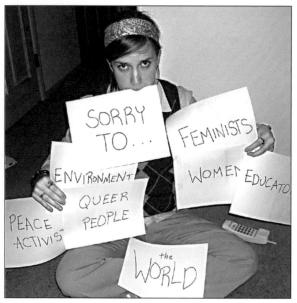

SORRY TO...

FEMINISTS

ENVIRONMENT

WOMEN EDUCATO

QUEER PEOPLE

PEACE ACTIVIS

the WORLD

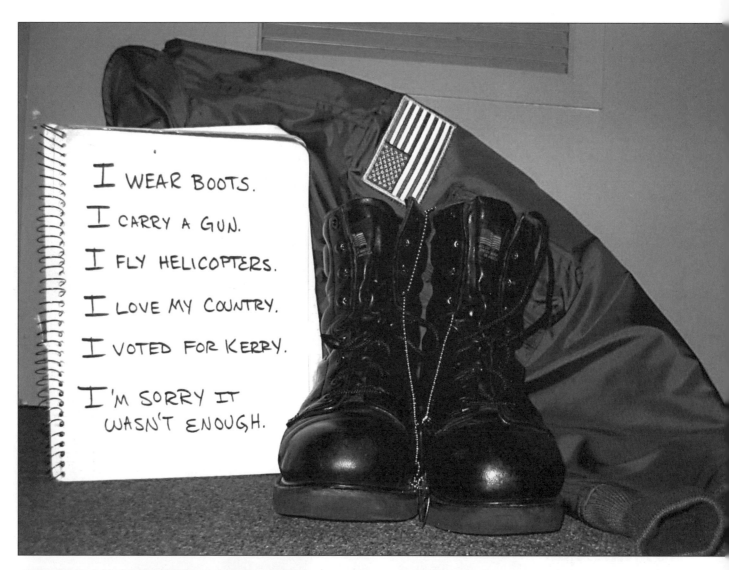

I WEAR BOOTS.
I CARRY A GUN.
I FLY HELICOPTERS.
I LOVE MY COUNTRY.
I VOTED FOR KERRY.

I'M SORRY IT
WASN'T ENOUGH.

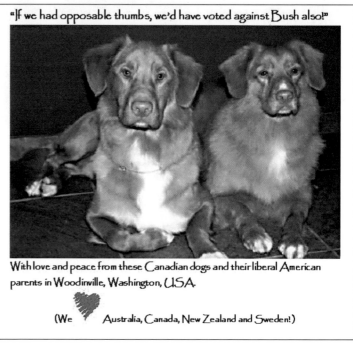

"If we had opposable thumbs, we'd have voted against Bush also!"

With love and peace from these Canadian dogs and their liberal American parents in Woodinville, Washington, USA.

(We ♥ Australia, Canada, New Zealand and Sweden!)

230

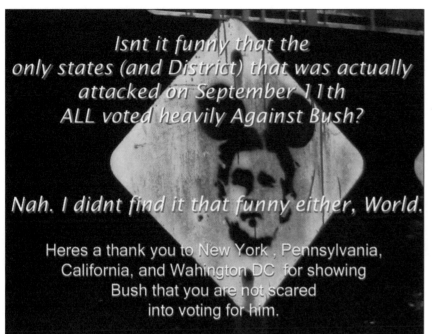

Isnt it funny that the only states (and District) that was actually attacked on September 11th ALL voted heavily Against Bush?

Nah. I didnt find it that funny either, World.

Heres a thank you to New York , Pennsylvania, California, and Wahington DC for showing Bush that you are not scared into voting for him.

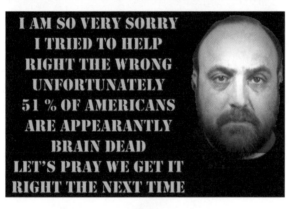

I AM SO VERY SORRY I TRIED TO HELP RIGHT THE WRONG UNFORTUNATELY 51 % OF AMERICANS ARE APPEARANTLY BRAIN DEAD LET'S PRAY WE GET IT RIGHT THE NEXT TIME

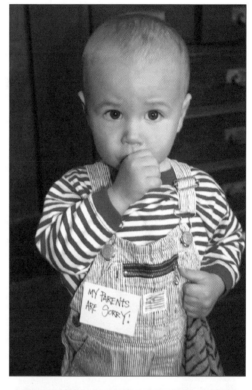

MY PARENTS ARE SORRY!

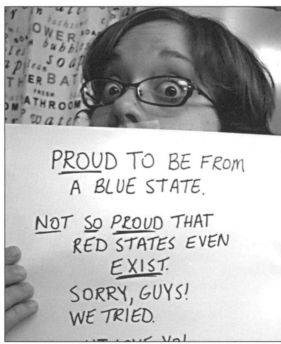

PROUD TO BE FROM A BLUE STATE.

NOT SO PROUD THAT RED STATES EVEN EXIST.

SORRY, GUYS! WE TRIED.

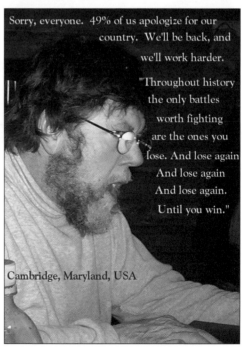

Sorry, everyone. 49% of us apologize for our country. We'll be back, and we'll work harder.

"Throughout history the only battles worth fighting are the ones you lose. And lose again And lose again And lose again. Until you win."

Cambridge, Maryland, USA

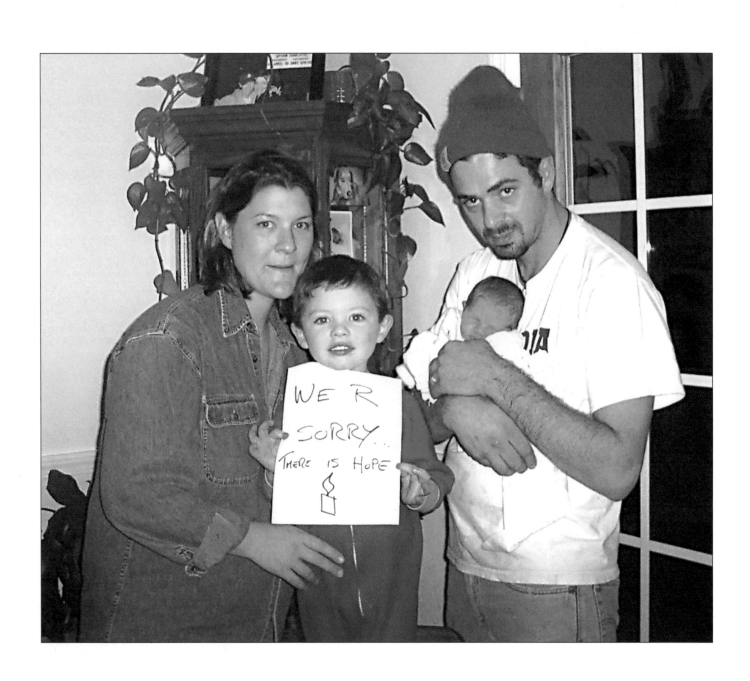

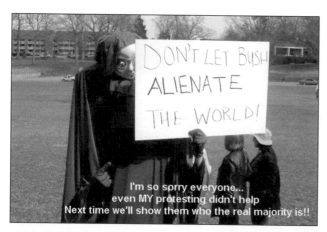

I'm so sorry everyone...
even MY protesting didn't help
Next time we'll show them who the real majority is!!

Sorry about that, world. Our bad.
Here's a llama to cheer you up. :)

Global Warming / Kyoto Treaty, Geneva Conventions, Nuclear Non Proliferation Treaty, Comprehensive Test Ban Treaty, 1972 Anti-Ballistic Missile Treaty, 1972 Biological and Toxin Weapons Convention, Chemical Weapons Convention, International Nuclear Test Ban Treaty, Biodiversity Treaty, START and ABM Treaties, 1979 UN Convention on the Elimination of All Forms Against Discrimination Against Women, UN International Covenant on Economic, Social and Cultural Rights, International Criminal Court, U.N. Agreement to Curb the International Flow of Illicit Small Arms, International Covenant on Civil and Political Rights, U.N. Charter, 1907 Hague Conventions, Forrest Protection Treaty...

To All of the People of the World - I Am Sorry - Travis in Indiana

Sorry Everybody,

California is a "blue" state.
We're totally bummed too.

Nobody around here voted
for Bush!

Love and peace in 2005...

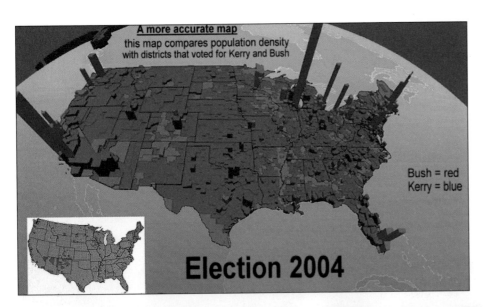

A more accurate map
this map compares population density
with districts that voted for Kerry and Bush

Bush = red
Kerry = blue

Election 2004

I've been to some of the world! I know it's cool!
I'm horribly sorry, angry, depressed and surly!
"The arc of history is long, but it bends toward
 justice." -- Martin Luther King Jr.

 Let's fucking hope so.

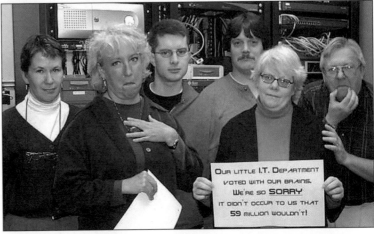

Our little I.T. Department voted with our brains. We're so SORRY it didn't occur to us that 59 million wouldn't!

Sorry Beautiful World~ I voted Blue in Arizona. Now I just feel blue! Lo siento, Je suis desole, Es tut ich Leid, Ik ben droevig, Sono Spiacente!! Love~the almighty guru in California XOXOXOXO

Ps- will paint your portrait for a peace-loving country to stay in! pray 4 us!!

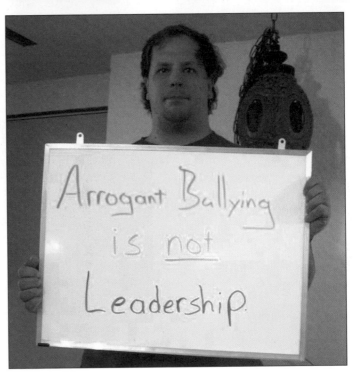

Arrogant Bullying is not Leadership.

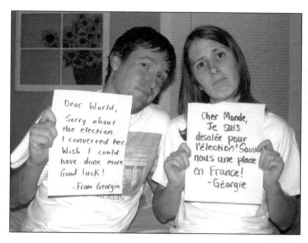

Dear World,
Sorry about the election. I converted her. Wish I could have done more. Good luck!
-From Georgia

Cher Monde, Je suis, désolée pour l'élection! Sauvez nous une place en France!
-Géorgie

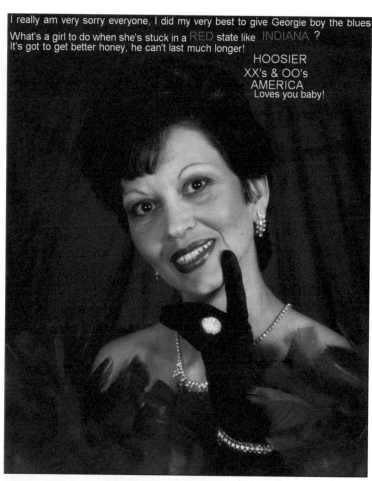

I really am very sorry everyone, I did my very best to give Georgie boy the blues
What's a girl to do when she's stuck in a RED state like INDIANA ?
It's got to get better honey, he can't last much longer!

HOOSIER
XX's & OO's
AMERICA
Loves you baby!

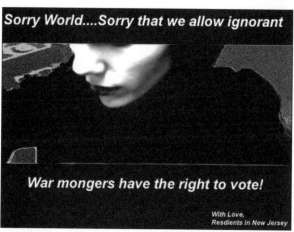

Sorry World....Sorry that we allow ignorant

War mongers have the right to vote!

With Love,
Resdients in New Jersey

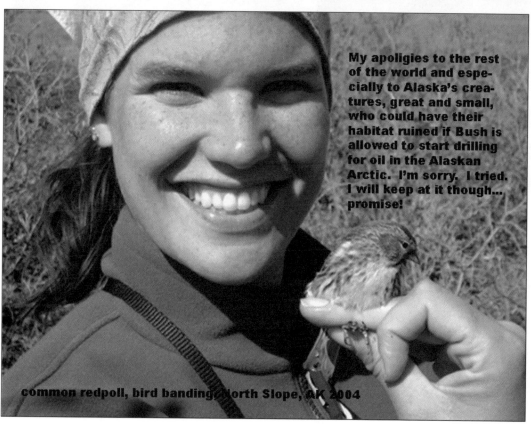

My apoligies to the rest of the world and especially to Alaska's creatures, great and small, who could have their habitat ruined if Bush is allowed to start drilling for oil in the Alaskan Arctic. I'm sorry. I tried. I will keep at it though... promise!

common redpoll, bird banding, North Slope, AK 2004

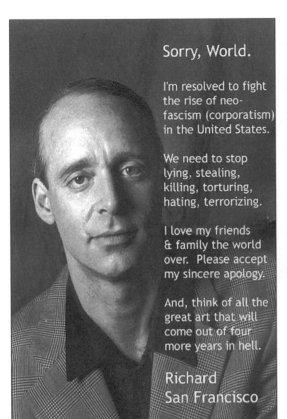

Sorry, World.

I'm resolved to fight the rise of neo-fascism (corporatism) in the United States.

We need to stop lying, stealing, killing, torturing, hating, terrorizing.

I love my friends & family the world over. Please accept my sincere apology.

And, think of all the great art that will come out of four more years in hell.

Richard
San Francisco

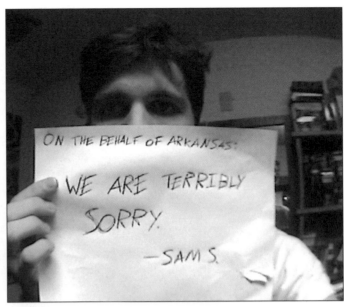

ON THE BEHALF OF ARKANSAS:
WE ARE TERRIBLY SORRY.
—SAM S.

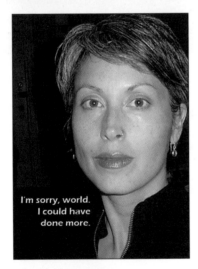

I'm sorry, world. I could have done more.

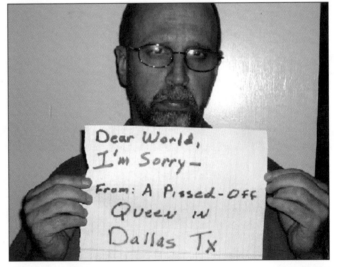

Dear World,
I'm Sorry—
From: A Pissed-Off
Queen in
Dallas Tx

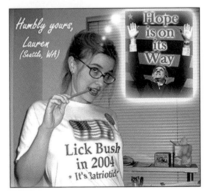

Humbly yours,
Lauren
(Seattle, WA)

Hope is on its Way

Lick Bush in 2004
* It's Patriotic

So sorry.

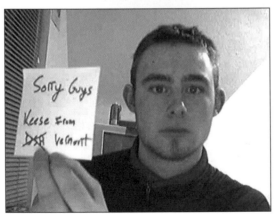

Sorry Guys
Keese From
DSA Vermont

236

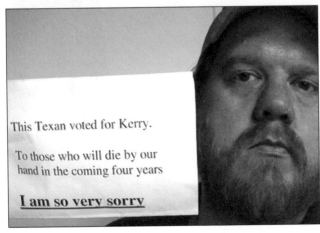

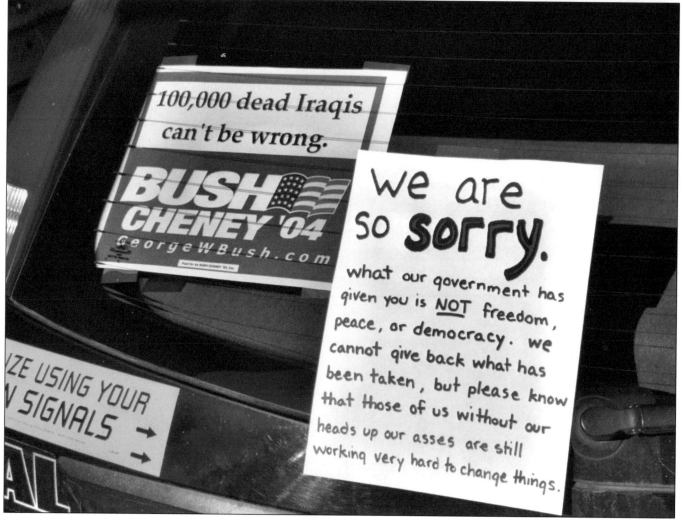

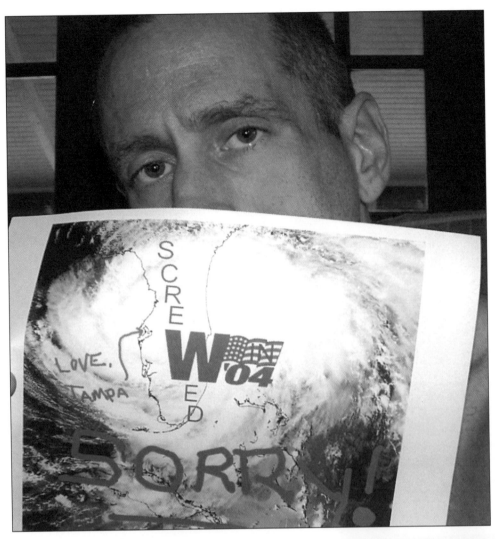

52% of Burrillville R.I. is very sorry

désolé tout le monde

spiacente tutti

sorry everybody

arrepentido todos

Erbärmlich jeder

жаль каждый

sorry world

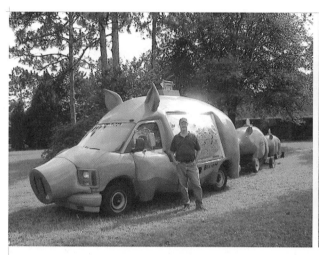 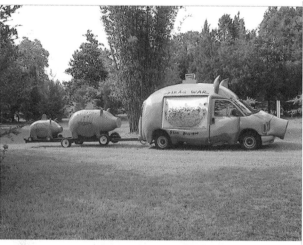

I drove these pigs all over Florida and all I got was a lousy President! Sorry!

Blue in a Red State
From Kentucky, live in Texas, Bush does NOT represent me nor most of my friends!

49% of voting Americans are appalled at the insensitivity of the other 51% of voting Americans.

We don't accept that the majority of Americans are represented by Bush. We will mobilize the rest of the opposition by 2008.

We believe in the principles of our founding fathers: equality, self-determination, peace and justice for ALL.

my 6 italian american granddaughters and my daughter all voted for Kerry

we came to this country because we were impressed by its benevolence, not its violence.
We're sorry

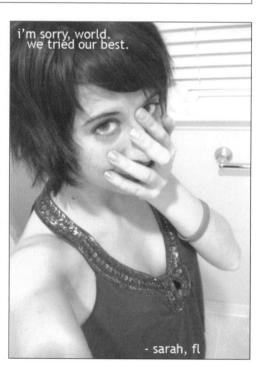

i'm sorry, world.
we tried our best.

- sarah, fl

Toast is sorry that he could not vote because he is not a US citizen. Oh yeah, and because he's a piece of bread.

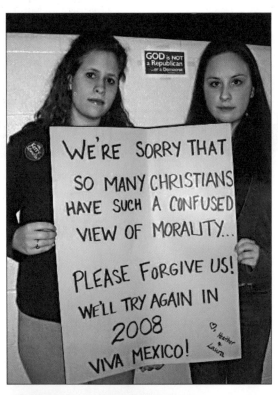

242

Sleepless
(for the next 4 years)
in Seattle

We're SORRY!

WE ARE SORRY IN VENTURA

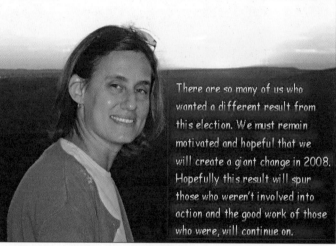

There are so many of us who wanted a different result from this election. We must remain motivated and hopeful that we will create a giant change in 2008. Hopefully this result will spur those who weren't involved into action and the good work of those who were, will continue on.

Dear World,
My Mom, Dad, and I worked on John Kerry's campaign. I'm so sorry we lost.
We can still

have fun together.

Love,

Morgan

WE'RE SO SORRY, AMERICA!
GROUP HUG!
(We Did Our Best!)

243

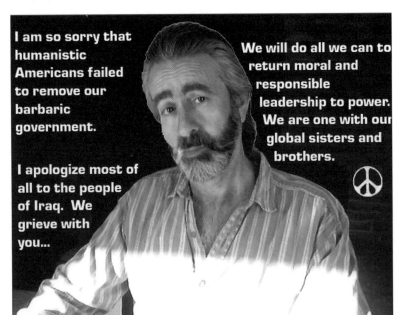

I am so sorry that humanistic Americans failed to remove our barbaric government.

I apologize most of all to the people of Iraq. We grieve with you...

We will do all we can to return moral and responsible leadership to power. We are one with our global sisters and brothers.

San Diego, California

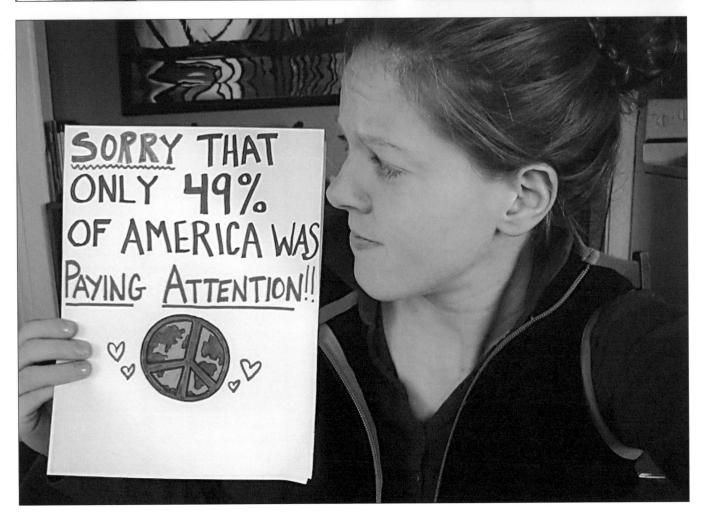

SORRY THAT ONLY 49% OF AMERICA WAS PAYING ATTENTION!!

Please accept our most sincere apologies for the actions supported by the other half of our country.
-Mary and the bright side of America

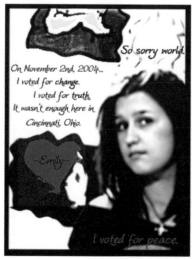

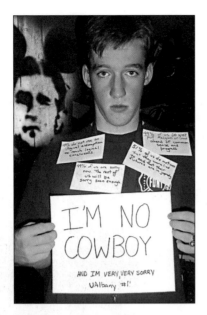

I'M NO
COWBOY

AND I'M VERY VERY SORRY
UAlbany #1!

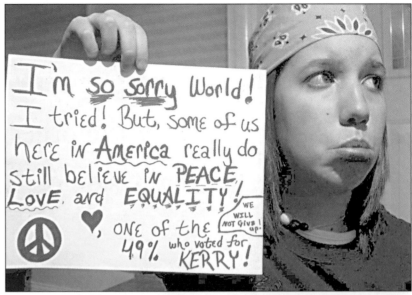

I'm so sorry World!
I tried! But, some of us
here in America really do
still believe in PEACE,
Love, and EQUALITY!
♥, ONE of the
49% who voted for
KERRY!

WE
WILL
NOT GIVE
up.

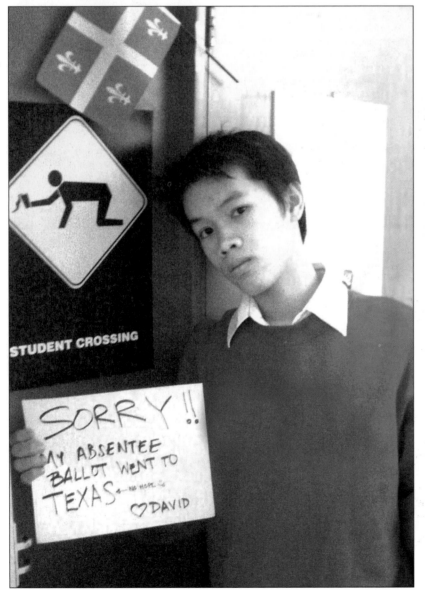

STUDENT CROSSING

SORRY!!
MY ABSENTEE
BALLOT WENT TO
TEXAS ← no hope :(
♥DAVID

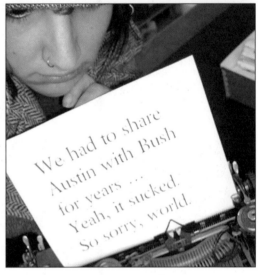

We had to share
Austin with Bush
for years ...
Yeah, it sucked.
So sorry, world.

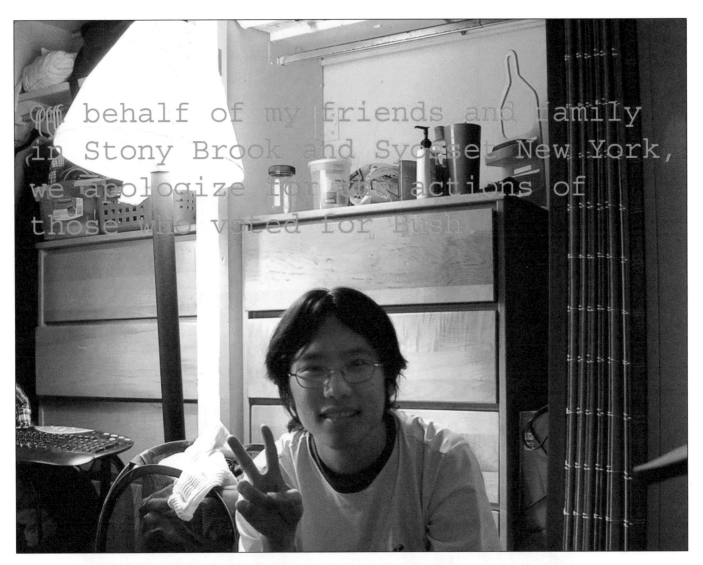

On behalf of my friends and family
in Stony Brook and Syosset New York,
we apologize for the actions of
those who voted for Bush.

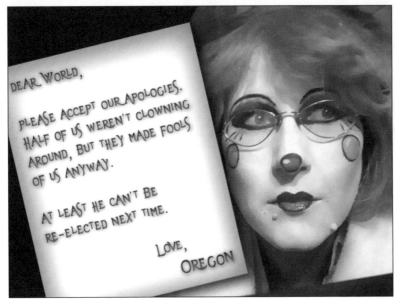

DEAR WORLD,

PLEASE ACCEPT OUR APOLOGIES.
HALF OF US WEREN'T CLOWNING
AROUND, BUT THEY MADE FOOLS
OF US ANYWAY.

AT LEAST HE CAN'T BE
RE-ELECTED NEXT TIME.

LOVE,
OREGON

Leslie Sarah Carolyn

Cleveland, MO is Sorry
Boise, ID is Sorry
K.C. MO is Sorry
We tried our best

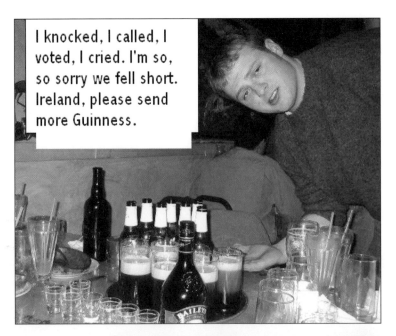

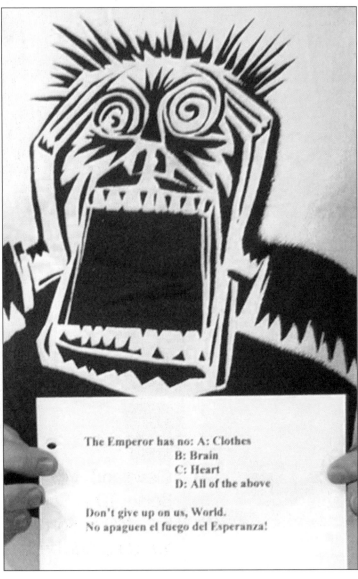

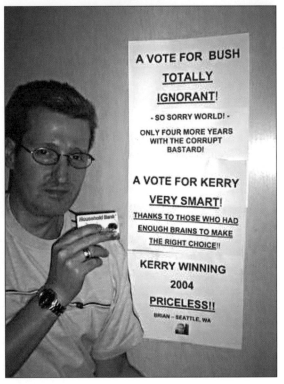

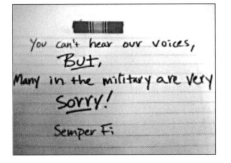

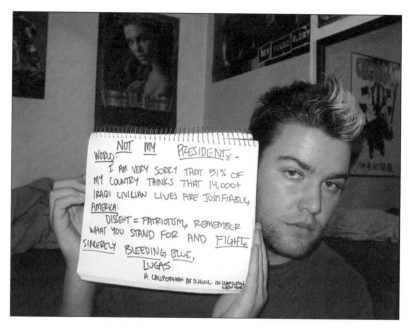

WORLD: <u>NOT</u> <u>MY</u> <u>PRESIDENT</u> -
I AM VERY SORRY THAT 51% OF
MY COUNTRY THINKS THAT 14,000+
IRAQI CIVILIAN LIVES ARE JUSTIFIABLE.
AMERICA:
DISSENT = PATRIOTISM, REMEMBER
WHAT YOU STAND FOR AND <u>FIGHT</u>
SINCERELY BLEEDING BLUE,
LUCAS
A CALIFORNIAN AT SCHOOL IN HAMILTON NEW YORK

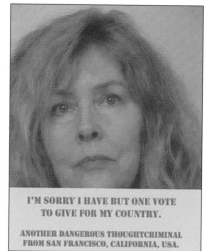

I'M SORRY I HAVE BUT ONE VOTE
TO GIVE FOR MY COUNTRY.

ANOTHER DANGEROUS THOUGHTCRIMINAL
FROM SAN FRANCISCO, CALIFORNIA, USA.

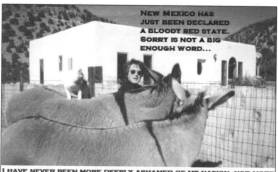

NEW MEXICO HAS
JUST BEEN DECLARED
A BLOODY RED STATE.
SORRY IS NOT A BIG
ENOUGH WORD...

I HAVE NEVER BEEN MORE DEEPLY ASHAMED OF MY NATION, NOR MORE
FRIGHTENED FOR IT/BY IT. WE ARE SUCH A YOUNG, INSULAR COUNTRY
WITH LITTLE SENSE OF HISTORY–EVEN OUR OWN. IN PAST TIMES OF
MASS INSANITY, OUR BEDROCK PRINCIPLES, SUCH AS FREEDOM OF
SPEECH, HAVE ENSURED THAT, EVENTUALLY, THE VOICES OF REASON
WOULD BE HEARD AND HEEDED. NOW, I FEAR THIS SECOND KING
GEORGE IS SEEKING TO SILENCE ALL OPPOSING VOICES. MAY WE
AWAKEN IN TIME...

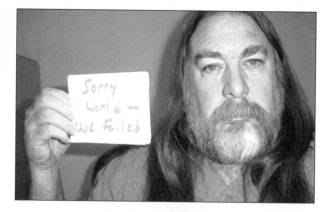

Sorry
World —
We Failed

SORRY WORLD

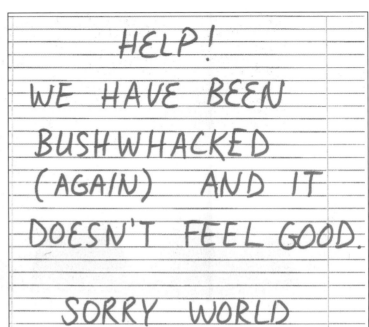

HELP!
WE HAVE BEEN
BUSHWHACKED
(AGAIN) AND IT
DOESN'T FEEL GOOD.

SORRY WORLD

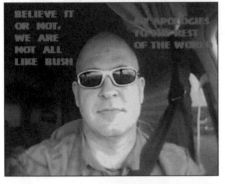

BELIEVE IT OR NOT, WE ARE NOT ALL LIKE BUSH

APOLOGIES TO THE REST OF THE WORLD

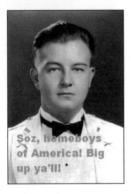

Soz, homeboys of America! Big up ya'll!

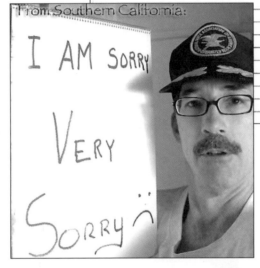

From Southern California:

I AM SORRY VERY Sorry :(

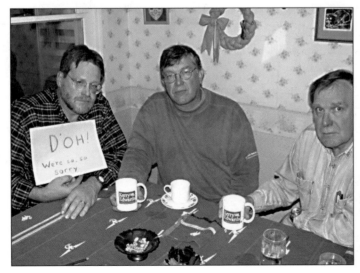

D'OH!
Were so, so sorry

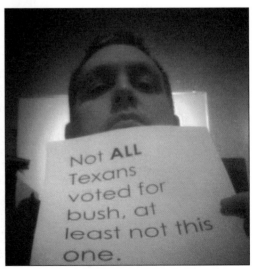

Not ALL Texans voted for bush, at least not this one.

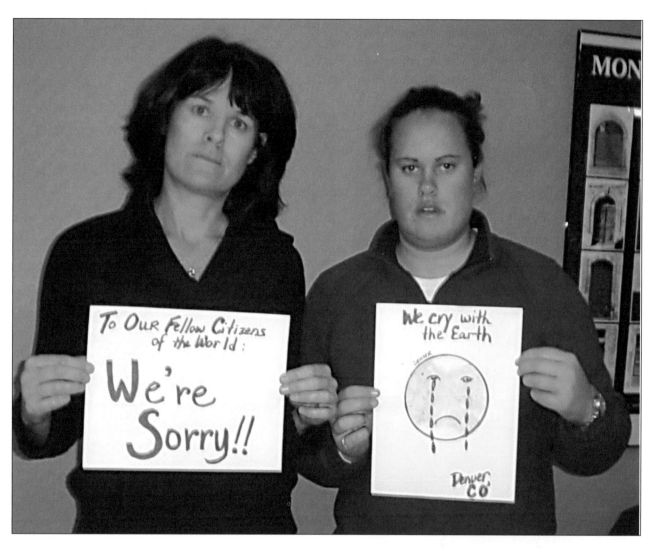

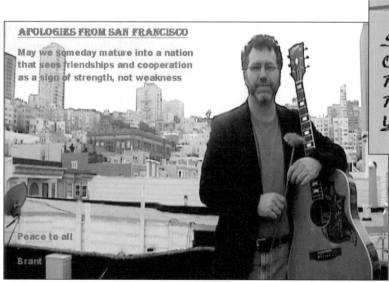

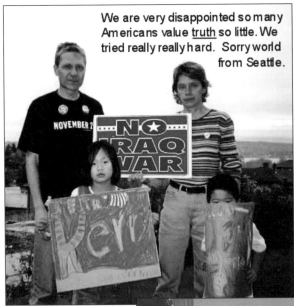

We are very disappointed so many Americans value <u>truth</u> so little. We tried really really hard. Sorry world from Seattle.

Our hearts go out to the people of Iraq. We are so very sorry.
Pam and Grant in Texas

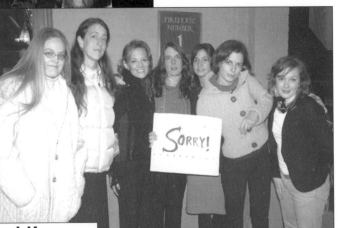

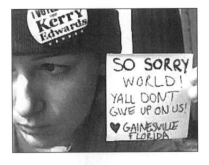

SO SORRY WORLD! YALL DONT GIVE UP ON US! ♥ GAINESVILLE FLORIDA

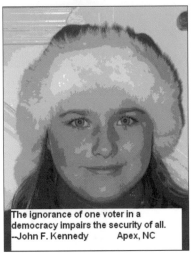

The ignorance of one voter in a democracy impairs the security of all.
--John F. Kennedy Apex, NC

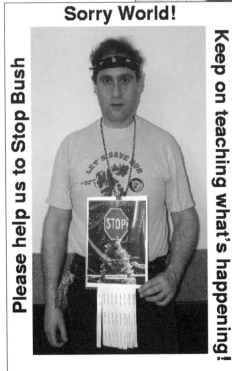

Sorry World!

Please help us to Stop Bush

Keep on teaching what's happening!

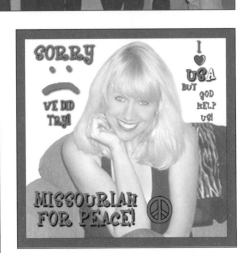

SORRY WE DID TRY! I ♥ USA BUT GOD HELP US! MISSOURIAN FOR PEACE!

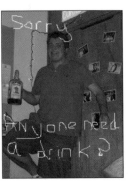

Sorry
Anyone need a drink?

252

WE'RE SORRY

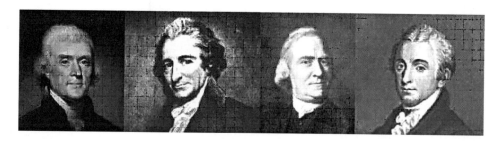

This isn't quite what we had in mind 230 years ago. It all started with the damn Federalists and, well, things have gone pretty much downhill ever since then. We'll do our best to inspire this current generation of American patriots but it's an uphill struggle that's for damn sure.

DOWN WITH THE EMPIRE!
SAVE THE REPUBLIC!

We are so sorry.

We did our best.

Please forgive us.

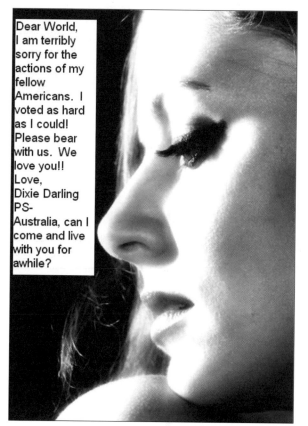

Dear World,
I am terribly sorry for the actions of my fellow Americans. I voted as hard as I could! Please bear with us. We love you!! Love, Dixie Darling PS- Australia, can I come and live with you for awhile?

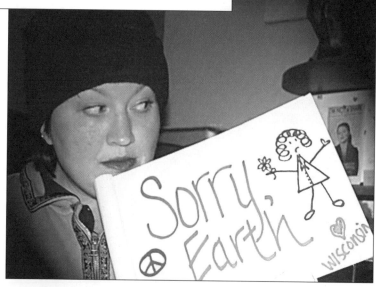

Sorry, Earth

Wisconsin

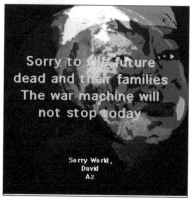

Sorry to the future dead and their families The war machine will not stop today

Sorry World, David Az

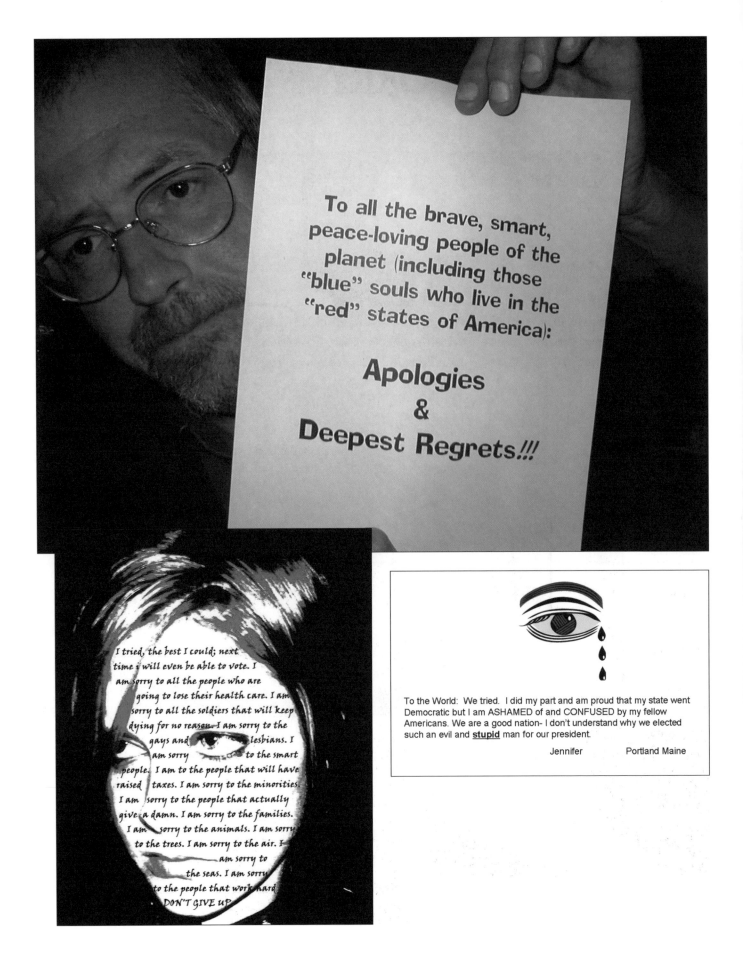

To all the brave, smart, peace-loving people of the planet (including those "blue" souls who live in the "red" states of America):

Apologies & Deepest Regrets!!!

I tried, the best I could; next time i will even be able to vote. I am sorry to all the people who are going to lose their health care. I am sorry to all the soldiers that will keep dying for no reason. I am sorry to the gays and lesbians. I am sorry to the smart people. I am to the people that will have raised taxes. I am sorry to the minorities. I am sorry to the people that actually give a damn. I am sorry to the families. I am sorry to the animals. I am sorry to the trees. I am sorry to the air. I am sorry to the seas. I am sorry to the people that work hard. DON'T GIVE UP

To the World: We tried. I did my part and am proud that my state went Democratic but I am ASHAMED of and CONFUSED by my fellow Americans. We are a good nation- I don't understand why we elected such an evil and **stupid** man for our president.

Jennifer Portland Maine

254

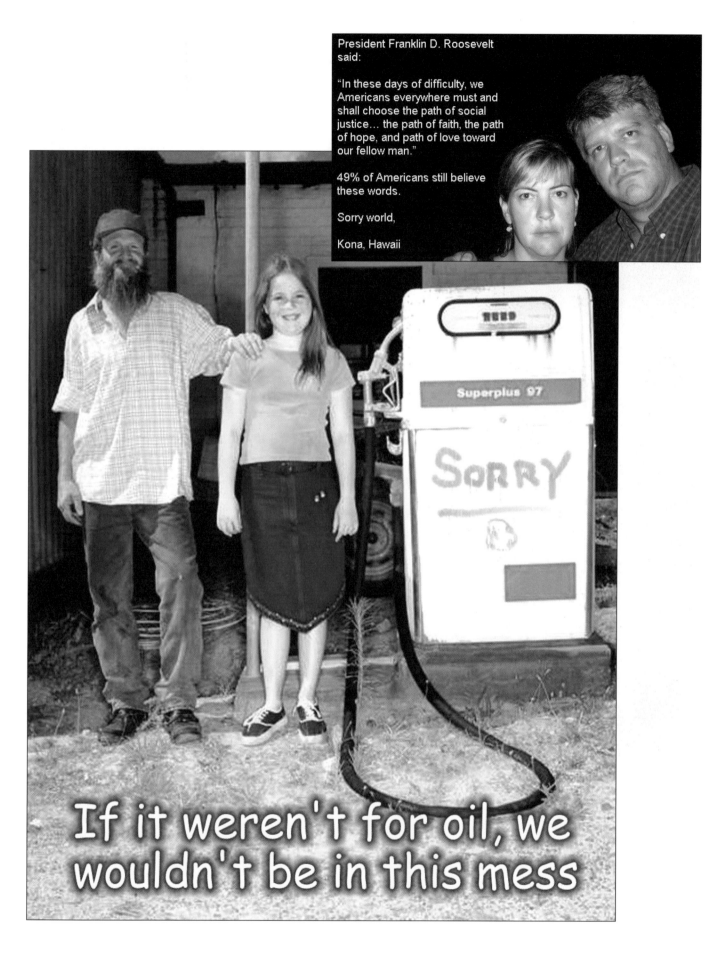

President Franklin D. Roosevelt said:

"In these days of difficulty, we Americans everywhere must and shall choose the path of social justice... the path of faith, the path of hope, and path of love toward our fellow man."

49% of Americans still believe these words.

Sorry world,

Kona, Hawaii

Superplus 97

SORRY

If it weren't for oil, we wouldn't be in this mess

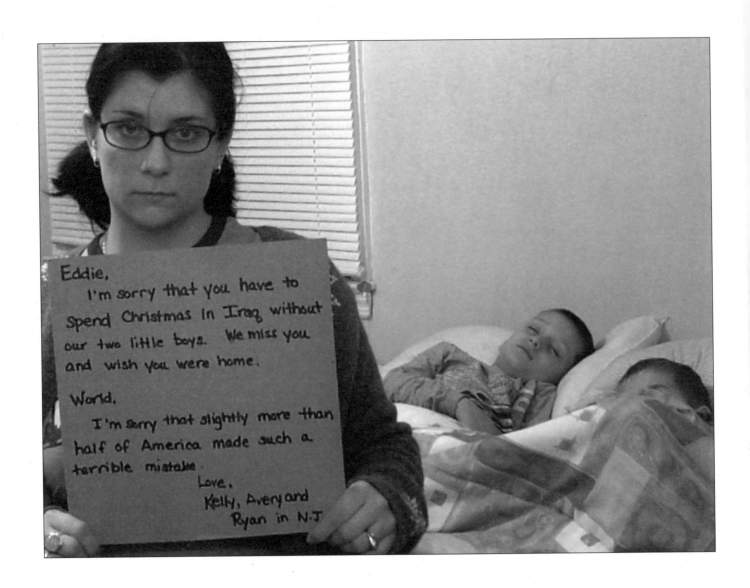